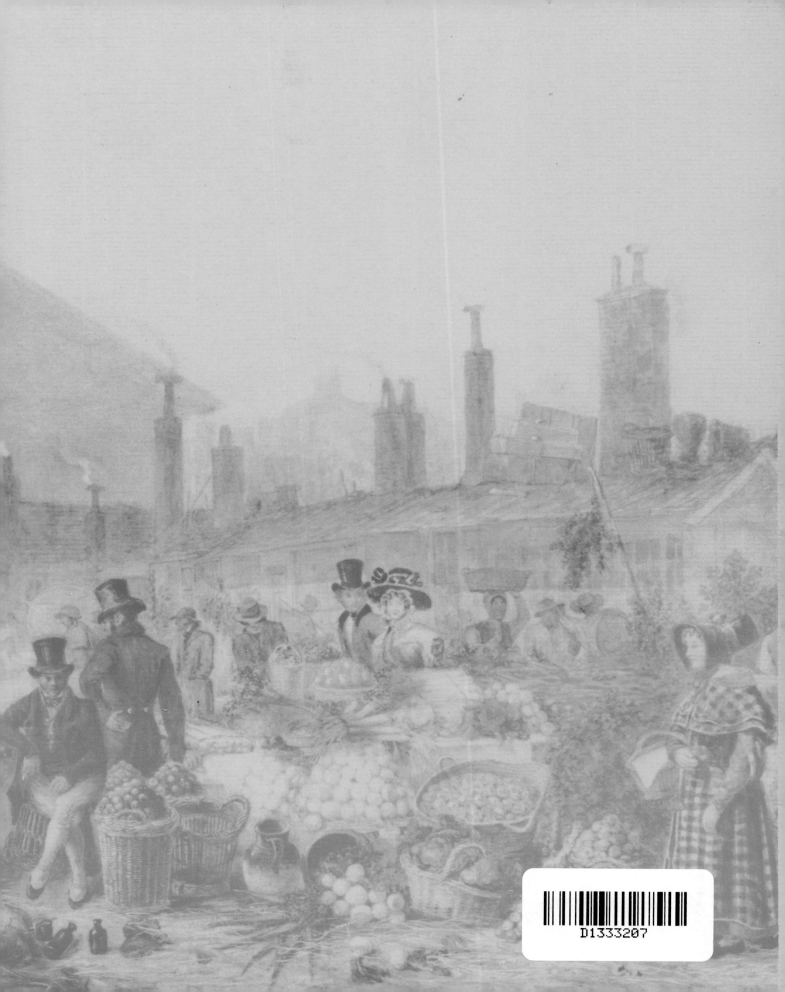

The
Dictionary
of
BRITISH WATERCOLOUR
ARTISTS
up to 1920
Volume III

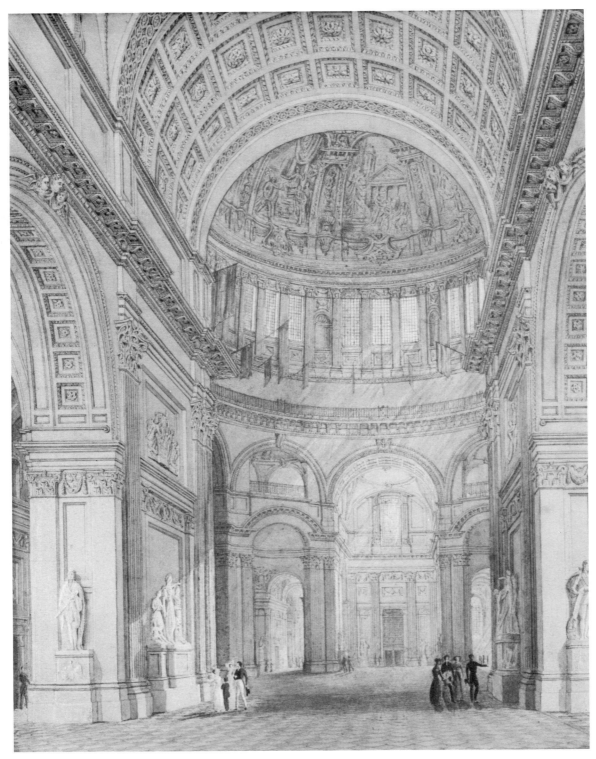

Frontispiece: Augustus Charles de Pugin, Interior of St. Pauls.

The Dictionary

of

BRITISH WATERCOLOUR ARTISTS

up to 1920
Volume III

H. L. Mallalieu

Published for the Antique Collectors' Club
by the Antique Collectors' Club Ltd.

British Library CIP Data

Mallalieu, H.L. (Huon Lancelot) 1946-
 The dictionary of British watercolour artists up to 1920. Vol. 3
 1. British watercolour paintings — Biographies — Collections.
 I. Title
 759 . 2

ISBN 1 85149 111 2

Endpapers: *Covent Garden Market* by George Sidney Shepherd 1829

Printed in England by the Antique Collectors' Club Ltd.
5 Church Street, Woodbridge, Suffolk

CONTENTS

Introduction .7

Part One .9

Introduction to Part One .11

The Haldimand Collection. Volume I15

The Haldimand Collection. Volume II.35

The Haldimand Collection. Volume III.55

Weeds on the Wall .75

Autres Herbes, Autres Murs83

Part Two .89

ANTIQUE COLLECTORS' CLUB

The Antique Collectors' Club was formed in 1966 and now has a five figure membership spread throughout the world. It publishes the only independently run monthly antiques magazine *Antique Collecting* which caters for those collectors who are interested in widening their knowledge of antiques, both by greater awareness of quality and by discussion of the factors which influence the price that is likely to be asked. The Antique Collectors' Club pioneered the provision of information on prices for collectors and the magazine still leads in the provision of detailed articles on a variety of subjects including regular discussion of the price trends of antique furniture.

It was in response to the enormous demand for information on 'what to look out for and what to pay' that the Price Guide series was introduced in 1968 with the first edition of *The Price Guide to Antique Furniture* (completely revised 1978 and 1989), a book which broke new ground by illustrating and describing in detail the more common types of antique furniture, the sort that collectors could buy in shops and at auctions, rather than the rare museum pieces which had previously been used (and still to a large extent are used) to make up the limited amount of illustrations in books published by commercial publishers. Many other Antique Collectors' Club Price Guides have followed, all copiously illustrated, and greatly appreciated by collectors for the valuable information they contain, quite apart from prices. The Antique Collectors' Club also publishes other books on antiques, including horology and art reference works. A full book list is available on request.

Club membership, which is open to all collectors, costs £17.50 per annum. Members receive free of charge *Antique Collecting*, the Club's magazine (published every month except August), which contains well-illustrated articles dealing with the practical aspects of collecting not normally dealt with by magazines. Prices, features of value, investment potential, fakes and forgeries are all given prominence in the magazine.

Among other facilities available to members are private buying and selling opportunities, the longest list of 'For Sales' of any antiques magazine, an annual ceramics conference and local antique collectors' clubs where members can meet and talk. There are over eighty of these in Britain and more than a dozen overseas. Members may also buy the Club's publications at special pre-publication prices.

As its motto implies, the Club is an amateur organisation designed to help collectors get the most out of their hobby: it is informal and friendly and gives enormous enjoyment to all concerned.

For Collectors — By Collectors — About Collecting

The Antique Collectors' Club, 5 Church Street, Woodbridge, Suffolk

6

INTRODUCTION

The major part of this volume, Part Two, is organized in the same manner as its precursor, Volume II of *The Dictionary of British Watercolour Artists,* that is to say alphabetically by artists referred to in the first volume of text. As in Volume II the only additional or emended information concerns names and dates, and most of the illustrations are of works that have appeared on the market during the last decade or so. In general the credit is to the owners of the copyright in the photographs, who may or may not be the people or institutions who currently own the watercolours. I have tried to provide illustrations for artists whose biographies were included for the first time in the 1986 revision of *Volume I, The Text,* but this has by no means always been possible. Naturally, I have also tried to avoid repetition between the two volumes of illustrations, showing other aspects of an artist's work here to what appeared there. Once again there has been little point in trying to do justice to a Turner or a Cox, but at least in having a second shot, a little more of their great diversity can be shown.

It would be a pity, however, if this were just a supplement, with no independent life of its own. In Part One, therefore, I try to recreate the now dispersed Haldimand Collection in something like its original form, to show what the connoisseurs of the 1820s considered to be the best on offer. As a contrast, I take a group of drawings which have at one time or another been attributed to Girtin, or are close enough to him in style for mistakes to be made (or even imposed). Much of this material is drawn from the record, known as 'Weeds on the Wall', begun by his father and maintained by the present Tom Girtin, to whom I am immensely grateful.

Others to whom I owe especial thanks include the Directors and staff of the relevant departments at numerous museums: in particular the British Museum, the National Gallery of Ireland, the Bristol City Museum and Art Gallery and the National Army Museum, and at the British, Guildhall and London Libraries. Many people have been helpful at a number of salerooms, and take their places on my personal roll of honour, foremost among them Tamsin Hitchins (whose patience was sorely tried) at Sotheby's; Harriet Drummond and Catherine Brandt at Christie's; and Barbara Wheeler at Bearne's. Among dealers and collectors: Chris Beetles and his staff; Simon Carter; Charles Chrestien, both for photographs from his own collection and his photography of others'; Penelope Gregory and Patrick Conner at the Martyn Gregory Gallery; Lowell Libson of Leger; the Maas Gallery; Rachel Moss; Anthony Reed; Dudley Snelgrove; Anthony Spink and Spink & Son; Robert Tear; Andrew Wyld both *in propria persona,* and with Susie Williams at Agnew's.

I must also thank my wife Fenella for ensuring that I had a study to work in, and our daughter Ilaira for occasionally refraining from distracting me. The book is naturally being produced for the latter, in the hope that it will help to keep some sort of a roof over her head.

PART ONE

The Haldimand Collection Volume I *page 15*

The Haldimand Collection Volume II *page 35*

The Haldimand Collection Volume III *page 55*

Weeds on the Wall *page 75*

Autres Herbes Autres Murs *page 83*

INTRODUCTION
TO PART ONE

As must be the case with anyone who writes about or collects English watercolours (or indeed the works of any school in whatever medium), I am often asked to name my favourite artist. On one level it is usually easiest (and true up to a point) to answer 'whoever I have been admiring or studying most recently' but if pressed hard, almost all of us must eventually be able to name the one artist whose work we would have survive were all else to be consigned to the flames, the one we would vote to preserve were he a participant in one of those balloon debates which used to be popular in schools. When he set himself the same task with composers, Bernard Levin came at length, many words and a few sentences later, to the conclusion that it could only be Mozart. That was to be expected, but it was perhaps surprising to many of his readers that Verdi had outlasted Schubert and even Wagner to be runner-up.

In a balloon debate for lovers of English watercolours I suppose that Turner must inevitably start as favourite. There is just so much, and such variety. He is so very obviously (at least with hindsight) a genius, and one so far ahead of his time that he is of and for all time. Somehow, though, the very genius can be rather intimidating, despite the comforting sense that he had his difficulties with those bubble-like figures of his. But still, *would* he have starved had Tom lived? Probably not, but things would certainly have been interesting both for them and for the onlookers. Even though he died so young, Girtin must still be high on one's list. And what of the other short-lived genius, Bonington?

Dear Paul Sandby, whose visions are so serene that it is difficult to remember him to have been also an effective polemicist, how would he fare against the flash of say, John Frederick Lewis? How indeed does one choose between Sandby and his near contemporary Ibbetson, or even Dayes at his best? But there, 'at his best' is disqualification enough, as is 'Callow — but only early Callow'.

For me at last it must be John Robert Cozens, the poet and dreamer. A natural genius, certainly, in the Mozartian sense of providing a conduit for inspiration, but unlike Turner he does not intimidate. He inspires love and wonder together with admiration. He is able to take the very simplest of materials and the most limited of palettes and produce something heart-wrenching. As Constable recognised, he is *the* poet of the school.

Other people will naturally disagree with this choice, even though most today would accord him a very high place. It would not always have been so during the last two hundred years, and indeed the perception of our artists and assessment of their qualities has often changed with fashion and as society's perception of itself changed and evolved. This is what makes certain of the best private collections so valuable, because more than the accumulations of museums, whether planned or random, they tell us something of the taste of the collector and his time. Particularly valuable in this respect was one that was most regrettably broken up in 1980.

Sophia Charlotte, Mrs George Haldimand, was one of the eleven children of Alderman John Prinsep (1746-1831) a successful India merchant, and her husband was a Governor of the Bank of England and M.P. for Ipswich. He and his brother William were the entrepreneurs who employed George Basevi to build Belgrave Square, and he and Sophia lived at No.31. Three of her brothers, William, James and Thomas, were accomplished watercolourists, as was Emily, one of her two sisters (see Part Two), and she herself produced a few drawings, although they cannot really be called accomplished. However, she obviously had a sincere regard for the medium, and she commissioned George Fennel Robson to form a collection for her which would include one example (for the most part) of the most esteemed practitioners of the day. This he did between 1826 and 1828, although a few laggards like George Delamotte, and most reprehensibly Paul Sandby Munn, failed to meet their deadlines and had to submit old work. Even so, the collection provides not only a unique microcosm of the taste of the 1820s, but an especially valuable one because it was chosen with the eye of an expert by a fellow artist.

The watercolours were to measure on average 7¼in. x 10in., and they were to be mounted in three volumes. The reason for this division becomes obvious when one turns away from the purely alphabetical 1980 catalogue. Volumes I and III were for watercolours of landscape format, and II contained the upright, mostly figure, subjects. In fact, eventually there were four volumes, the fourth being devoted to contemporary French watercolourists in the year 1833.

While all the greatest names were there, including Bonington, Constable, Cox, de Wint and Turner, the selection also included a good many people who have largely disappeared from view. Felix Ferdinand Frederick Raffael Fielding, or Frederick F. Fielding as he called himself professionally, is there together with two of his younger brothers, Copley and Thales, although 1826 was the last year in which he exhibited, and until recently his existence had been almost entirely forgotten. The eldest and the youngest of the bretheren, Theodore Henry Adolphus, and Newton Smith Limbird, do not appear. There seems to be no reason for the exclusion of the former, but Newton may have escaped Robson's net because in 1827 he went to run the family studio in Paris. Frederick gave up professional painting to read for the bar, to which he was called in 1832. Ten years later he married an heiress.

Another forgotten contributor, at any rate as far as watercolours are concerned, is the Claudean Philip Hutchins Rogers (1786-1853) and Harriet Barret, John Byrne, Edmund Dorrell, Joseph Kenny Meadows, William Walker and Andrew Wilson are none of them names that readily spring to mind.

On June 21, 1861, I believe following Mrs Haldimand's death, the album (as the three volumes were compositely known) was sold at Christie's, going to Agnew. The French album was bought by Vokins and presumably dispersed. The handsome 'rosewood occasional table, on carved pillar and plinth, with rising top and drawer with Bramah lock. Made by Messrs Gillow to contain the album', was bought by Henry Thoby Prinsep, brother of Sophia and father of Val, the

future R.A. By 1883 the English album had also been acquired by Vokins, who broke it up, framing the watercolours in pairs and triplets. However, he sold the collection as one, and most of it remained together until it returned to Christie's in 1980.

At that point, regrettably I feel, the decision was taken to split it up and sell each watercolour individually. Three had left the collection after it had been exhibited in the early 1960s: the Cristall, George Jones and Linnell, leaving a total of ninety-seven. Again regrettably, thirteen of these were not illustrated in the catalogue, which is thus not the complete memorial that might have been wished. The artists were also offered in strict alphabetical order, although they were not quite arranged in that manner in the original album.

For all these reasons I feel that it is worthwhile to try to reconstruct the approximate look of the Haldimand album here. The 1820s, after all, are generally regarded as falling within the classic period of the English watercolour School, and they cannot be represented better. I had tracked down one of the three strays, Linnell's *Braywood, near Windsor,* which by chance passed through Christie's hands on a separate occasion, when it was photographed, and also four which were not illustrated in 1980: those by Dorrell, Thomas Heaphy, Charles Wild and Andrew Wilson. I had also found fairly suitable substitutes for the remainder, when just before the manuscript left me for the publisher, Dudley Snelgrove supplied photographs of all that were missing, having seen and recorded the collection in the 1960s. I am therefore doubly grateful to him and to the owners of the other strayed sheep.

In the descriptions I have taken titles from the 1861 catalogue and the further details from that of March 18, 1980. The drawings may either have been mounted one to a page or, as here, in pairs.

It would seem that the drawing which was assumed to be the title page in 1980 did not actually have a place in the album, and it is not mentioned in the 1861 catalogue. Perhaps it was kept loose in the cabinet. It is illustrated on page 14.

James Prinsep's gift to his sister was evidently drawn after the completion of the collection, perhaps during a home visit from India. James trained as an architect and draughtsman under the elder Pugin, but with failing eyesight he had to give up hopes of practice, and he became Assay Master of the Calcutta Mint and a famous Oriental scholar and numismatist (see also Part Two).

James's monument is in any case a further indication of the taste, and 'order of merit' of the time: Glover is given pride of place, while Turner and Cox are among the generality in the middle of the column. The rounds of stone which have yet to be hoisted into place show Nicholson, Stothard, Mackenzie and Hunt on the one side, and in front and to the left the painting members of the Prinsep clan itself: Emily, William, Thomas and James. Sophia is cut into the capital to crown the whole. It is a charming conceit, and perhaps someone should build it.

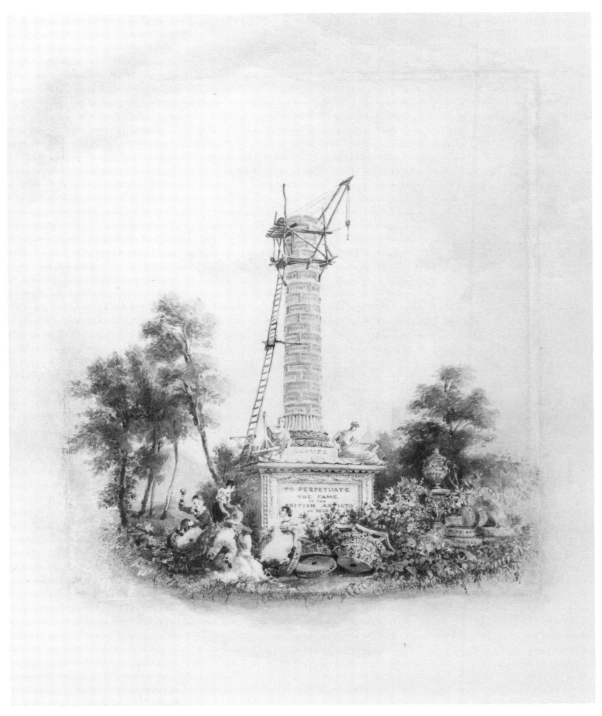

JAMES PRINSEP (1799-1840). A Monument to Perpetuate the Fame of the British Artists of 1828. *Signed, inscribed with the names of the artists, and dated July 1830; watercolour, 14in. x 10⅞in.*

THE HALDIMAND COLLECTION
Volume I

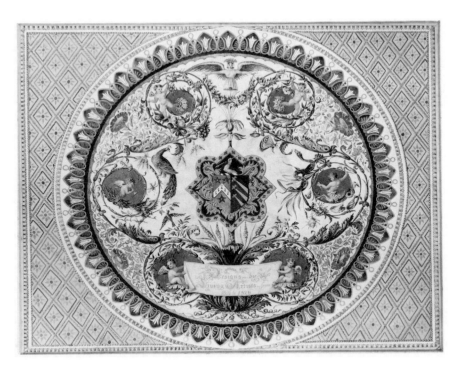

The actual title-page is described as:
'Illuminated title-page, with arms and arabesque borders. Designs by living Artists, from 1826 to 1828.'

Volume I

The Haldimand arms are those granted to George's great uncle, Sir Frederick, who had been Governor General of Quebec, 'and all the descendants of his late father Lewis Haldimand of Yverden in the Canton of Berne in Switzerland, Esquire.' Sir Frederick died unmarried, but his elder brother had a son who was a merchant of London and Hampstead and married a Miss Pickersgill of Watford in 1768. Most of their large family died young, but three sons survived, George, William and Frederick.

George was born in 1781 and died in 1850, having married Sophia Prinsep in 1807. At that time the Prinsep arms were not officially registered, but unofficially they are recorded in 1830 and again in 1875 as shown here: Sable issuant from the sinister in bend three piles flory at the point or.

SAMUEL AUSTIN (1796-1834)
Liverpool. *Signed and dated 1827, watercolour, 7¼in. x 10⅛in.*

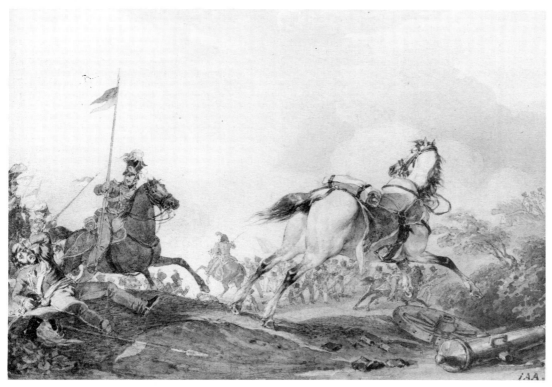

JOHN AUGUSTUS ATKINSON (1775-c.1833)
A Battle. *Signed with initials, pen and ink and watercolour, 7¼in. x 10¼in.*

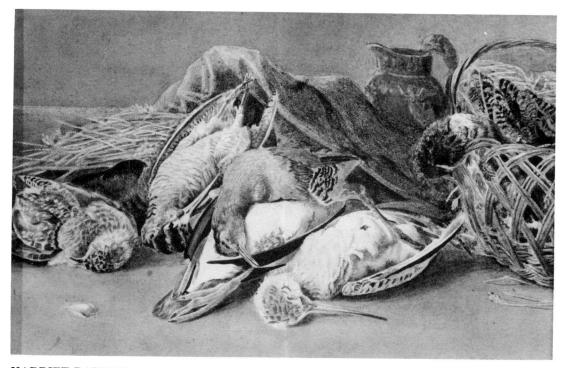

HARRIET BARRET
Dead Birds. *Signed, watercolour, 9⅞in. x 7⅛in.*
Harriet (or Harriett according to the 1861 catalogue) was one of the numerous artistic children of George Barret, R.A., but unlike her brothers George, Yr. and James, and her sister Mary, she seems to have left hardly a record behind her. Another very obscure member of the family was C.P. Barret, active in the 1830s and '40s. The trimming of the signature probably indicates that the specified measurements had to be adhered to in the construction of the album.

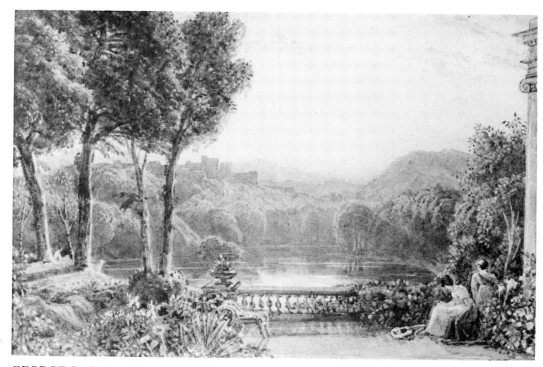

GEORGE BARRET, Yr. (1767-1842)
A Composition; Sunset. *Signed and dated 1827, watercolour, 7¼in. x 10⅛in.*

19

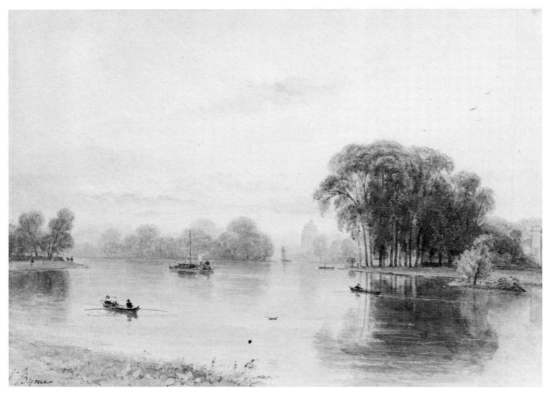

JOHN BYRNE (1786-1837)
Twickenham. *Signed, watercolour, 7⅜in. x 10¼in.*

ANNE FRANCES BYRNE (1775-1837)
Wild Flowers. *Signed, watercolour heightened with white, 7½in. x 10in.*

20

SIR AUGUSTUS WALL CALLCOTT (1779-1844)
Sheerness. *Signed with initials, watercolour, 6⅞in. x 10in.*

WILLIAM COWEN (1797-1861)
Olivano, near Rome. *Signed, watercolour, 6¾in. x 10⅛in.*

WILLIAM COLLINS (1788-1847)
A Sea-Shore. *Signed with initials and dated 1827, watercolour, 7⅜in. x 10⅛in.*

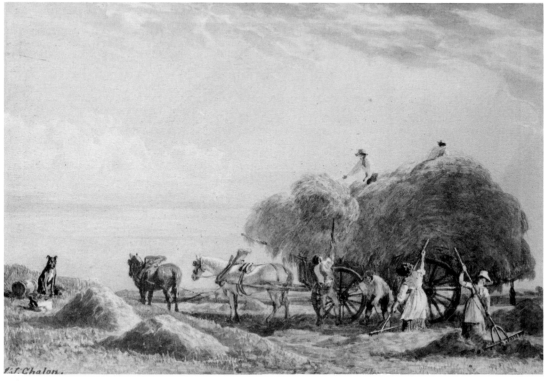

JOHN JAMES CHALON (1778-1854)
Haymakers. *Signed, watercolour, 7¼in. x 10⅜in.*

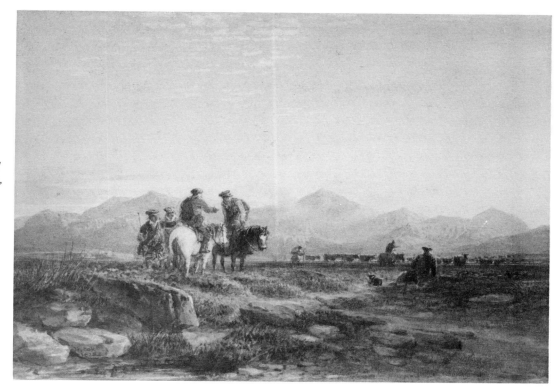

DAVID COX (1783-1859)
Scotch Drovers. *Signed and dated 1828, watercolour, 7¼in. x 10⅛in.*

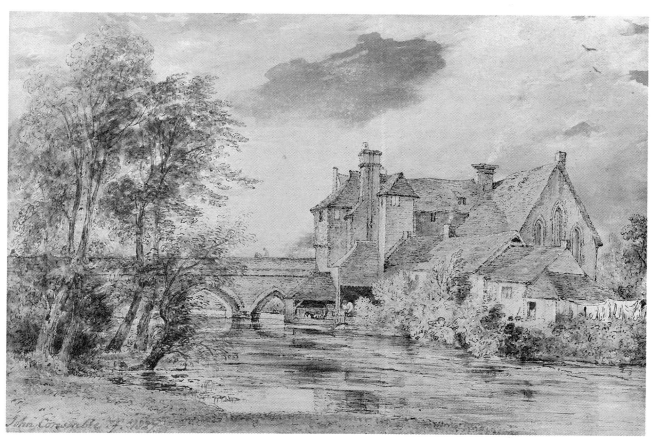

JOHN CONSTABLE (1776-1837)
Scene in Salisbury. *Signed and dated 1827, pen and grey ink and watercolour, 7¼in. x 10½in.*

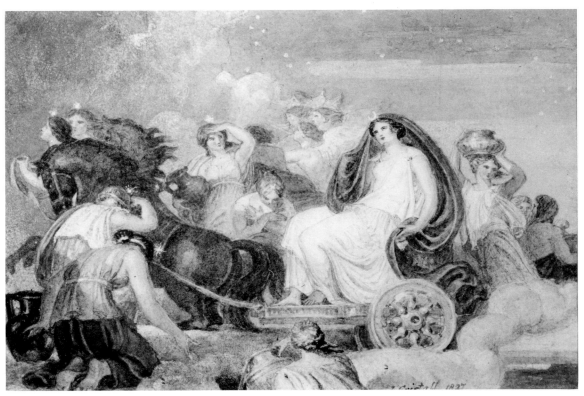

JOSHUA CRISTALL (1767-1847)
Diana, with attendant Zephyrs. *Signed and dated 1827, pen and brown ink and watercolour, approx. 7¼in. x 10in.*
(Dudley Snelgrove)

LUKE CLENNELL (1781-1840)
The Village of Melrose. *Signed, watercolour, 7⅞in. x 10⅞in.*

WILLIAM DANIELL (1769-1837)
A View on the Ganges. *Signed and dated 1828, watercolour, 7½in. 10⅛in.*

STEPHEN POYNTZ DENNING (1795-1864)
Children at Play. *Signed with initials, watercolour heightened with white, 6¾in. x 8¾in.*

EDMUND DORRELL (1778-1857)
A Forest Scene. *Watercolour, 8½in. x 10⅞in.* *(Sotheby's)*

PETER DE WINT (1784-1849)
View near Lincoln. *Signed and indistinctly dated, watercolour, 6⅜in. x 10in.*
This is a very rare example of a De Wint with a genuine signature; unfortunately it is not clear in the photograph.
The 1980 catalogue claimed that the date was 1820, but I suspect that 1827 or 28 is actually the case, and that
De Wint was not one of the 'sluggards'.

FRANCIS DANBY (1793-1861)
Amphitrite. *Signed, watercolour, 7⅜in. x 10in.*

WILLIAM EVANS of Eton (1798-1877)
View near Eton. *Signed and dated 1828, watercolour, 7in. x 10in.*

ANTHONY VANDYKE COPLEY FIELDING (1787-1855)
Brisk Gale. *Signed and dated 1828, watercolour, 7¼in. x 10in.*

(Dudley Snelgrove)

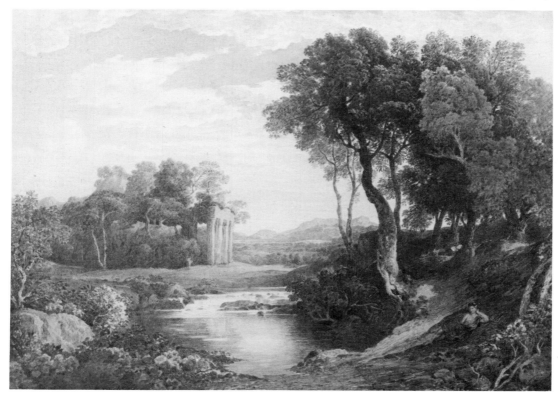

FRANCIS OLIVER FINCH (1802-1862)
Composition. *Signed, watercolour, 7¼in. x 10⅛in.*

FELIX FERDINAND FREDERICK RAFFAEL FIELDING (c.1784-1853)
Haymakers. *Signed, watercolour, 6⅞in. x 9⅜in.*

FRANÇOIS LOUIS THOMAS FRANCIA (1772-1839)
Steamboat off Calais. *Signed, watercolour, 7¾in. x 10¾in.*

THALES FIELDING (1793-1837)
A Cattle Piece. *Signed and dated 1827, watercolour, 7¼in. x 10⅜in.*

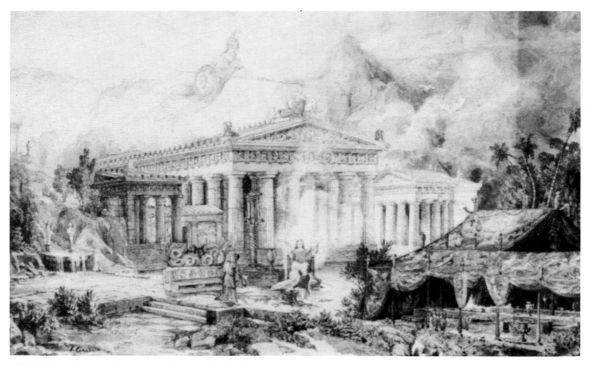

JOSEPH MICHAEL GANDY (1771-1843)
The Temple of Apollo at Delphi. *Signed, pencil and watercolour, 7in. x 10in.*

HENRY GASTINEAU (1791-1876)
On the Ouse, near York. *Signed and dated 1826, watercolour heightened with white, 7¼in. x 10¼in.*

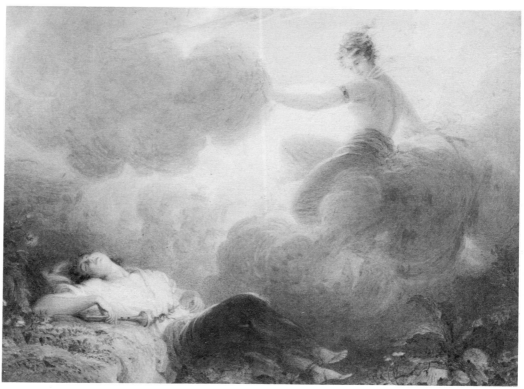

JAMES GREEN (1771-1834)
Diana and Endymion. *Signed, watercolour heightened with white, 7¼in. x 9⅝in.*

JOHN GLOVER (1767-1849)
View on the Arno. *Signed and dated 1827, watercolour, 7½in. x 9in.*

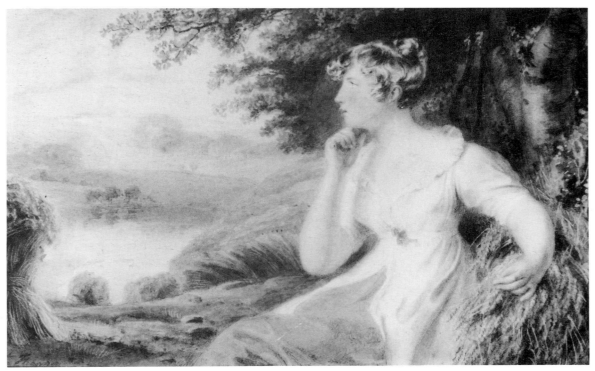

THOMAS HEAPHY (1775-1835)
A Girl contemplating the Decline of Day. *Signed and indistinctly dated, watercolour, 6⅝in. x 9¾in.*

(Sotheby's)

32

WILLIAM HAVELL (1782-1857)
View of the Thames. *Signed and dated '27, watercolour heightened with white, 7¼in. x 10¼in.*
Havell repeated this successful composition of the river seen from the woods of Park
Place, near Henley. However, the 1861 catalogue calls him 'W. Hewett'.

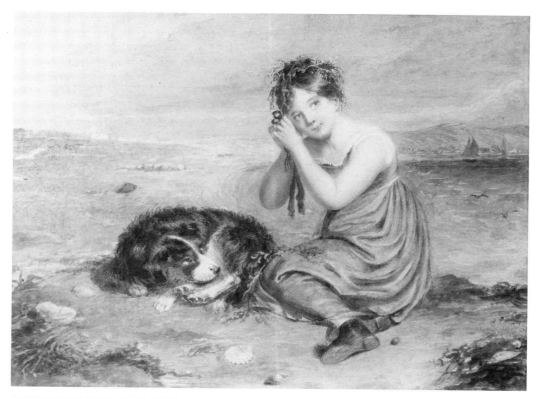

JAMES HOLMES (1777-1860)
A Girl with Shells on a Sea-Shore. *Watercolour heightened with white, 7⅛in. x 9¾in.*

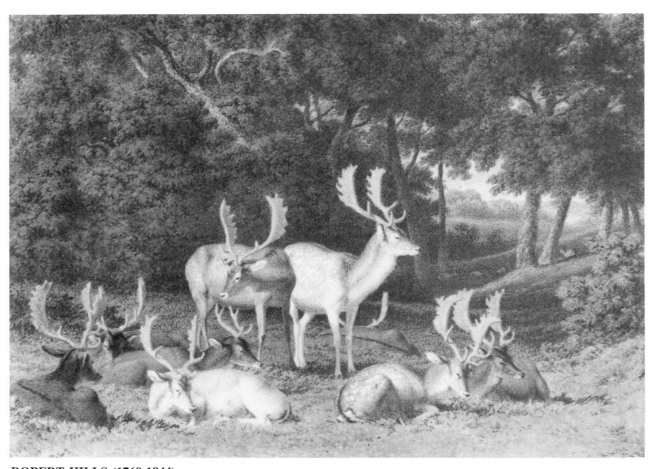

ROBERT HILLS (1769-1844)
Fallow Deer. *Signed and inscribed 'to G F R', watercolour, 7⅛in. x 10⅛in.*

The final page of the volume was taken up by the signatures of the artists. The 1861
catalogue says thirty-two, although there are thirty-three in the volume.

THE HALDIMAND COLLECTION
Volume II

Volume II

This title-page drawing was accompanied by a cartouche with the quotation:

'It is an Art
That paragons description and wild fame;
And, in the essential vesture of creation,
Does bear all excellency.'

Othello, Act II, Sc.i.

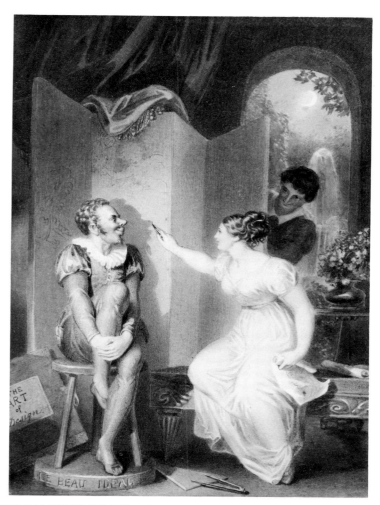

HENRY JAMES RICHTER (1772-1857)
The Art of Design. *Inscribed, watercolour heightened with white. 10¼in. x 7¼in.*

GEORGE ARNALD (1763-1841)
The Boar that killed Adonis brought to Venus. *Signed and indistinctly dated, watercolour heightened with white. 9¾in. x 7in.*

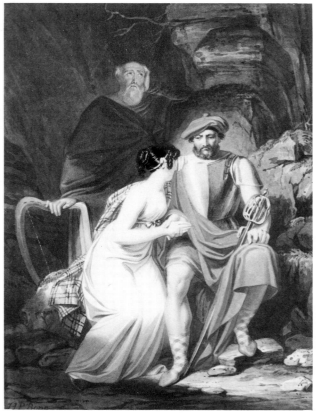

HENRY PIERCE BONE (1779-1855)
Douglas and Ellen in the Cave. *Signed and dated 1827, watercolour, 9⅞in. x 7⅛in.*

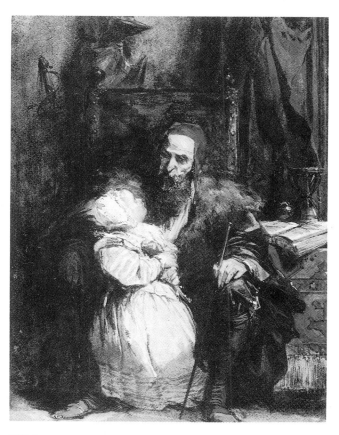

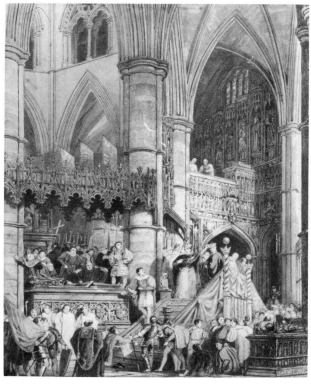

RICHARD PARKES BONINGTON (1802-1828)
Grandpapa. *Signed with initials, water and bodycolour.*
7½in. x 5½in.
There is another version of this in the Wallace Collection,
and a good copy, perhaps by Liverseege, was on the
London market in 1988.

GEORGE CATTERMOLE (1800-1868)
Funeral of Henry V. *Signed, watercolour, 9¾in. x 7¾in.*

JOHN SELL COTMAN (1782-1842)
Rouen. *Pen and brown ink and watercolour, 9⅜in. x 7¼in.*

ALFRED EDWARD CHALON (1780-1860)
Beatrice and Benedick. *Signed and dated 1826, watercolour heightened with white, 10in. x 7in.*
To be pedantic, the subject is actually Beatrice and her waiting women.

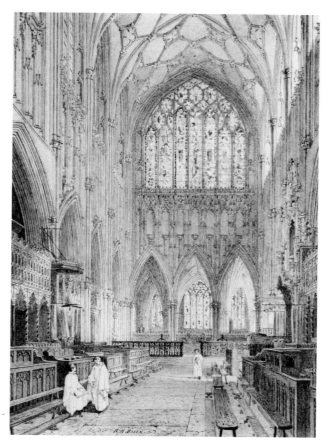

GEORGE DELAMOTTE
The island of Corfu. *Signed and dated 1817, watercolour heightened with white, 10⅛in. x 7⅜in.*
This is presumably George Orleans Delamotte (or De La Motte), the brother of the better known William Alfred (1775-1863) — who is a surprising omission from the collection.

RICHARD HAMILTON ESSEX (1802-1855)
The Choir of Wells Cathedral. *Signed and dated 1826, pencil and watercolour, 10⅛in. x 7in. (Dudley Snelgrove)*

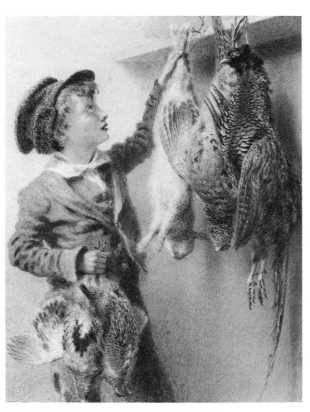

WILLIAM HENRY HUNT (1790-1864)
A Boy with Game. *Signed and dated 1827, watercolour, 10¼in. x 7⅜in.*

JAMES DUFFIELD HARDING (1797-1863)
Chatillon Val d'Aosta. *Signed, watercolour, 9¾in. x 7in.*

HENRY HOWARD (1769-1847)
Titania Sleeping. *Signed, watercolour, 10⅛in. x 7⅜in.*

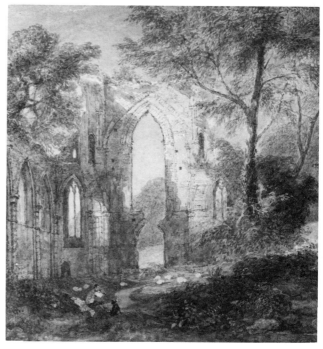

JOSEPH MURRAY INCE (1806-1859)
Netley Abbey. *Watercolour, 7⅜in. x 6½in.*

GEORGE ROBERT LEWIS (1782-1871)
Ayez Pitié du pauvre Aveugle. *Signed and dated 1828, watercolour, 10⅛in. x 7⅛in.*
For another use of this subject by Lewis, see Part II.

JOHN FREDERICK LEWIS (1805-1876)
Tyrolese Hunters. *Signed, watercolour heightened with white, 10¾in. x 7⅞in.*

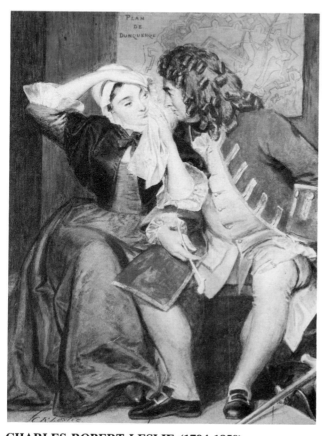

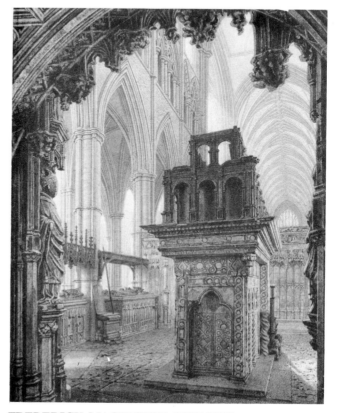

CHARLES ROBERT LESLIE (1794-1859)
The Watch-Box. *Signed, watercolour heightened with white, 10½in. x 7½in.*
Leslie used this subject of Uncle Toby and the Widow Wadman from *Tristram Shandy* several times for oil paintings, and two of them were engraved.

FREDERICK MACKENZIE (1787-1854)
The Chapel of Edward the Confessor. *Watercolour, 9⅝in. x 7½in.* (Dudley Snelgrove)

WILLIAM MULREADY (1786-1863)
A Shepherd Boy. *Signed and dated 1828, watercolour,
10in. x 6¾in.*

PAUL SANDBY MUNN (1773-1845)
Westmoreland Cottages. *Signed and dated 1809, pencil
and watercolour, 10⅞in. x 8½in.*

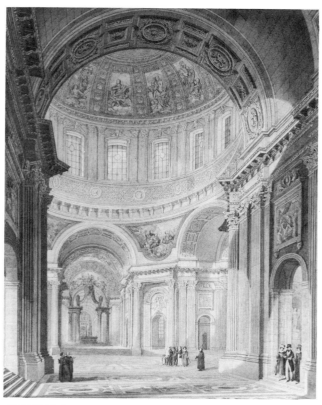

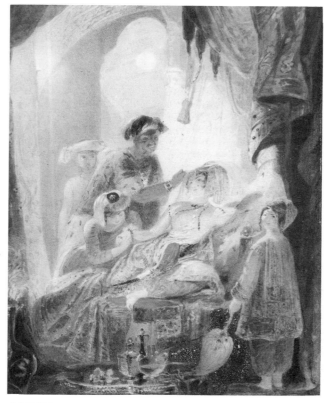

CHARLES MOORE (1800-1833)
The Dome of the Invalides. *Signed and dated 1827, pen and brown ink and watercolour heightened with white, 9⅝in. x 7½in.*

JOSEPH KENNY MEADOWS (1790-1874)
A Sultana at the Toilette. *Signed and dated 1827, pen and ink and watercolour heightened with white and gum arabic, 9½in. x 7in.*

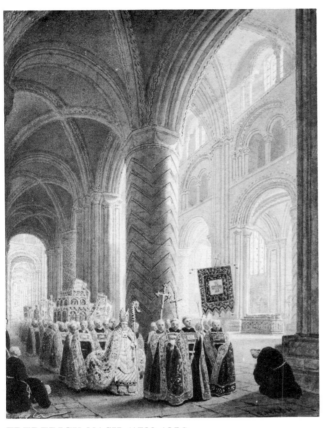

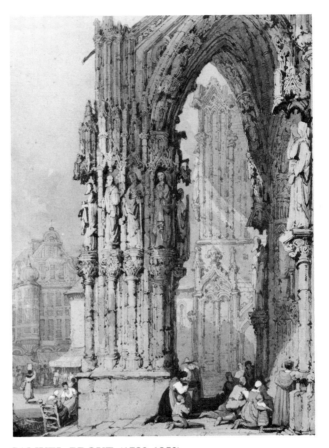

FREDERICK NASH (1782-1856)
Durham Cathedral; procession of St. Cuthbert. *Signed, watercolour heightened with white, 9⅝in. x 7½in.*
(Dudley Snelgrove)

SAMUEL PROUT (1783-1852)
A Church Porch at Ratisbon. *Signed with initials, reed pen and watercolour, 9½in. x 7in.*
(Dudley Snelgrove)

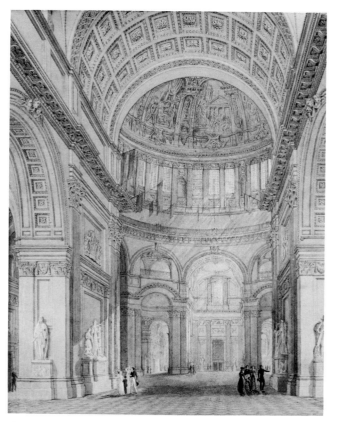

AUGUSTUS CHARLES DE PUGIN (1762-1832)
Interior of St. Paul's. *Pencil and watercolour heightened with white, 9⅛in. x 7in.*

HENRY JAMES RICHTER (1772-1857)
Anne Page and Slender. *Signed with initial, watercolour heightened with white, 9⅞in. x 7¼in.*

THOMAS STOTHARD (1755-1834)
From Boccaccio. *Pen and brown ink and watercolour,
10⅜in. x 7⅜in.*
Another version of this subject, *the Eighth Day of the
Decameron,* is in the British Museum. It is reproduced in
Hardie, Vol.I, pl.140.

JAMES STEPHANOFF (c.1786-1874)
King James the First of Scotland, a Prisoner at Windsor,
discovers Lady Jane Beaufort in the Gardens. *Signed and
dated 1827, pencil and watercolour, 9¼in. x 7¼in.*

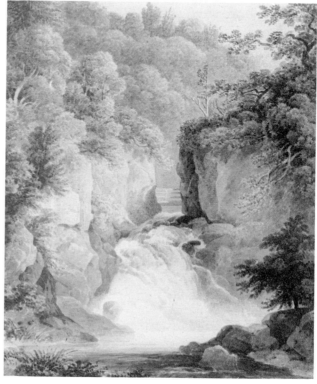

THOMAS UWINS (1782-1857)
Going to School. *Watercolour heightened with white,*
11in. x 8⅛in.

ANDREW WILSON (1780-1848)
A Cascade. *Watercolour, 10⅛in. x 7⅞in.*
(Private Collection; photograph: Charles Chrestien)

51

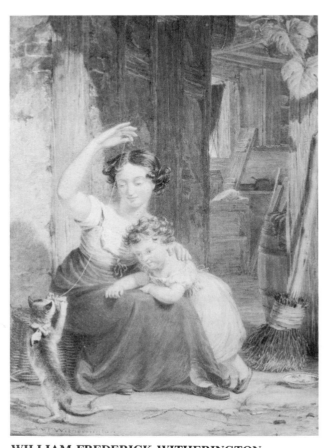

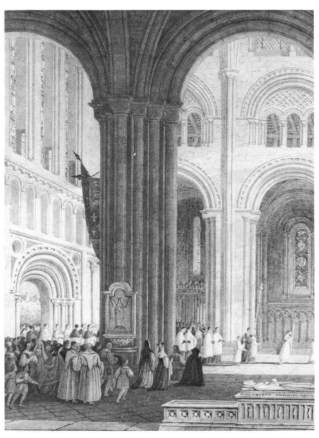

**WILLIAM FREDERICK WITHERINGTON
(1785-1865)**
Cottage-Door. *Signed and dated 1827, watercolour
heightened with white, 10⅜in. x 7⅜in.*

CHARLES WILD (1781-1835)
Old St. Paul's; Jane Shore doing Penance. *Signed and dated
1827, watercolour, 10½in. x 7¼in.*

JOHN MASEY WRIGHT (1777-1866)
Falstaff and Mrs. Ford. *Watercolour, 8⅝in. x 7¼in.*

RICHARD WESTALL (1765-1836)
Saint Kevin. *Signed with initials and dated 1826, pencil and brown ink and watercolour, 10⅛in. x 7½in.*
It is remarkable how little Westall's style changed over the years — see Volume II.

PENRY WILLIAMS (1798-1885)
Children in the Campagna of Rome. *Signed and inscribed 'Rome' and dated 1828, watercolour, 11⅜in. x 8⅝in.*

There then followed thirty-four autographs of the artists.

THE HALDIMAND COLLECTION
Volume III

Volume III

This title-page appears to have been composed as follows: the architecture by Charles Wild; the figures by John Masey Wright; the landscape by George Fennel Robson; the framed painting by the younger George Barret; and the bouquet of flowers beside it by Anne Frances Byrne. This division begs the question of who provided the *trompe-l'oeil,* and perhaps other cartouche decorations on the title-pages. It might have been Byrne in this case, but one feels that Sophia herself, or one of her siblings, is more likely.

WILD, WRIGHT, ROBSON, BARRET and BYRNE
Figures on a terrace at Richmond. *Watercolour, surrounded by an inscribed* trompe-l'oeil *decoration. The watercolour: 7⅜in. x 10⅜in.*

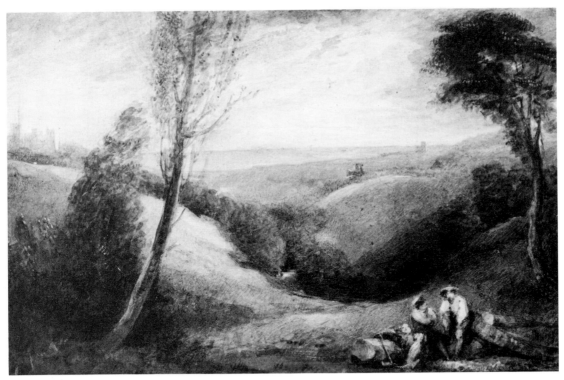

JOHN JACKSON (1778-1831)
Mulgrave Castle. *Watercolour, 7¾in. x 10¾in.*
On the evidence of this, Jackson was quite right to stick to portraiture, where he could be very good
indeed. *(Dudley Snelgrove)*

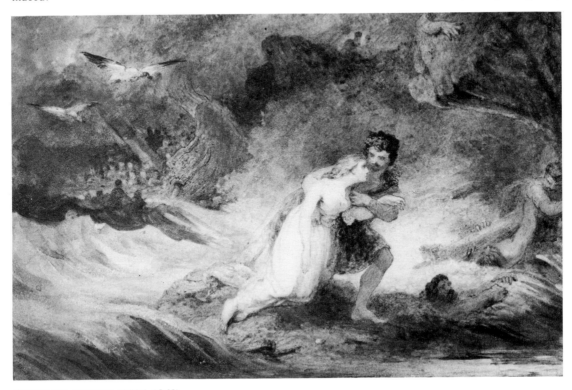

GEORGE JONES (1786-1869)
Shipwreck of Menelaus and Helen. *Pen and ink and watercolour, approx. 7½in. x 10¼in.*
(Dudley Snelgrove)

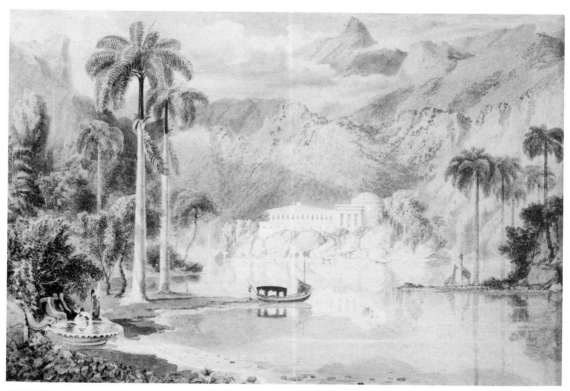

SAMUEL JACKSON (1794-1869)
The happy Valley. *Signed, watercolour, 7¼in. x 10¼in.*

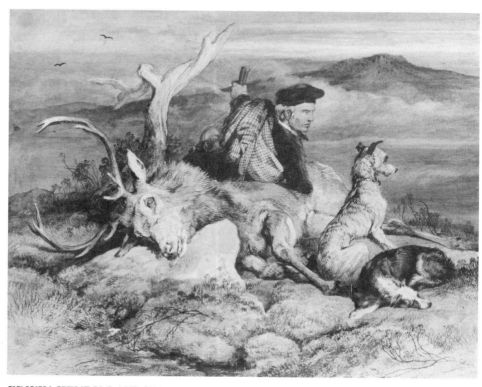

EDWIN HENRY LANDSEER (1802-1873)
Deer-stalking in the Highlands. *Signed with initials and dated 1828, watercolour heightened with white, 7⅞in. x 9⅞in.*

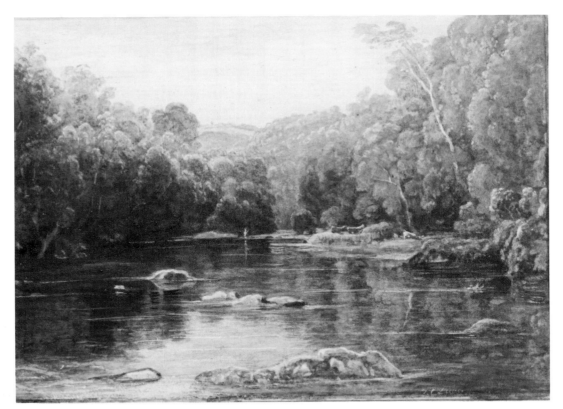

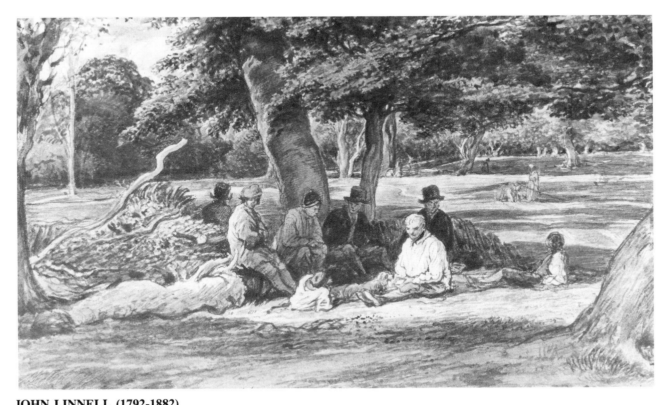

JOHN LINNELL (1792-1882)
Braywood, near Windsor. *Signed and dated 1827, pen and brown ink and watercolour, 6½in. x 10⅝in.*
This is one of the three watercolours which left the collection prior to 1980. Luckily it passed through Christie's subsequently.

60

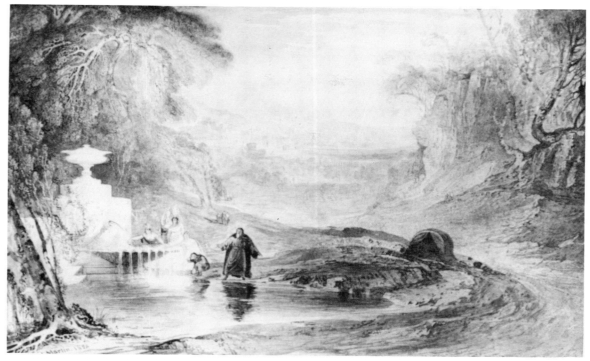

JOHN MARTIN (1789-1854)
Diogenes throwing away his Cup. *Signed and dated 1826, watercolour, 6¾in. x 10⅛in.*

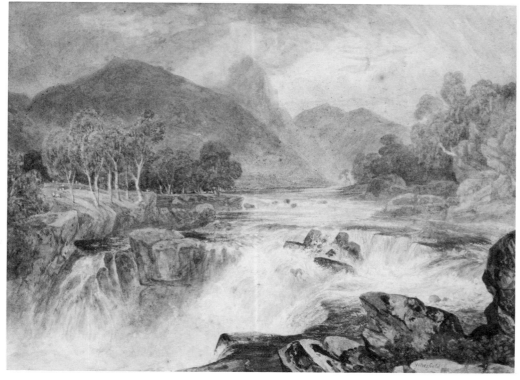

WILLIAM ANDREWS NESFIELD (1793-1881)
Fall of the Tummel in Perthshire. *Signed, watercolour, 7¼in. x 9⅞in.*
Nesfield made a larger version of this subject, which was sold by Christie's on October 1, 1973, lot 127.

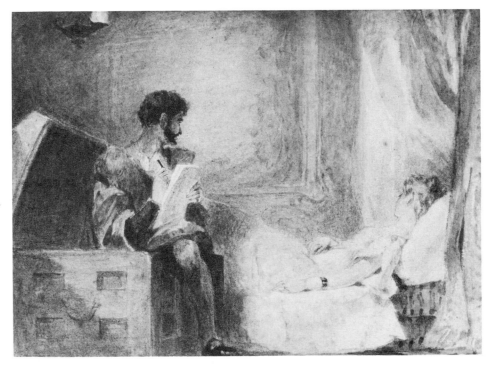

GILBERT STUART NEWTON (1795-1835)
Cymbeline: Imogen sleeping. *Watercolour, 7in. x 9⅜in.*
Newton, who was born in Nova Scotia, is hardly thought of as a watercolourist nowadays.
He was a nephew of Gilbert Stuart and painted portraits in oil. However, his literary and
'humorous subject-pieces' are good in a Boningtonian manner. He had studied in Paris.

FRANCIS NICHOLSON (1753-1844)
View near Scarborough. *Signed and dated 1826, watercolour, 7⅛in. x 10¼in.* *(Dudley Snelgrove)*

SAMUEL OWEN (1768-1857)
Off Dover. *Signed and perhaps dated, watercolour, 7⅛in. x 10in.*

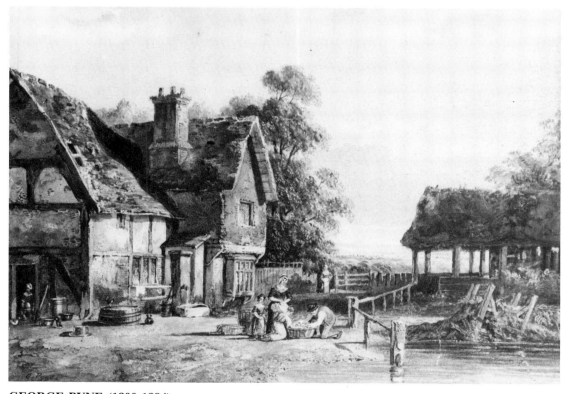

GEORGE PYNE (1800-1884)
A Farm-yard. *Signed, watercolour, 7⅜in. x 10¼in.*
Pyne is very much 'doing a Daddy' here, rather than working in his own well-known manner.

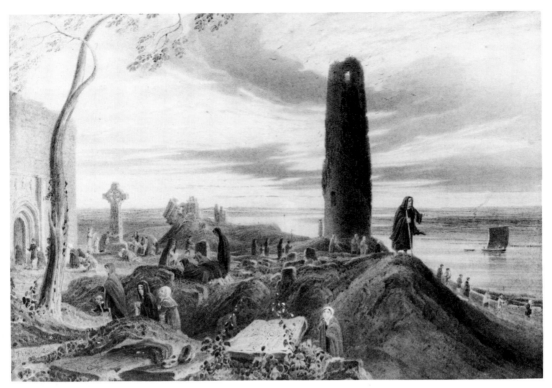

GEORGE PETRIE (1790-1866)
The last Circuit of the Pilgrims. *Signed and dated 1828, watercolour heightened with white, 7⅛in. x 9⅞in.*
There is a similar watercolour in the National Gallery, Ireland, the subject being pilgrims at Cluain-MacNois.

WILLIAM HENRY PYNE (1769-1843)
Fishermen on the Coast. *Signed and dated 1828, pencil and watercolour, 7⅜in. x 10¼in.*

RAMSAY RICHARD REINAGLE (1775-1862)
Composition. *Signed, watercolour, 7⅛in. x 10⅛in.*

GEORGE PHILIP REINAGLE (1802-1835)
The East Indiaman *Windsor. Signed, watercolour heightened with white, 7¼in. x 10¼in.*

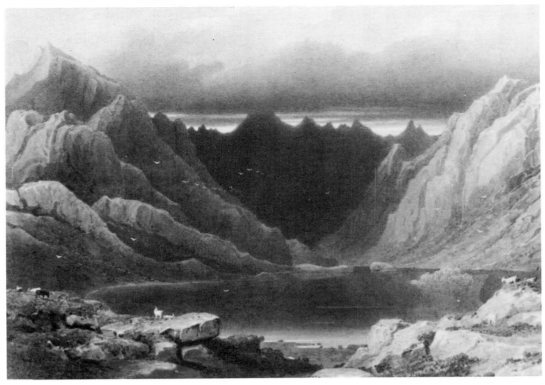

GEORGE FENNEL ROBSON (1788-1833)
Corwisk, the Water of the Hollow. *Signed and dated Aug. 1828, watercolour, 7¼in. x 10in.*

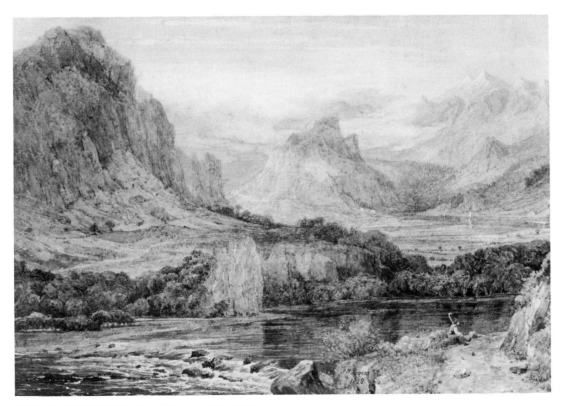

PHILIP HUTCHINS ROGERS (1786-1853)
The Vale of Terascon. *Signed and dated 1828, watercolour heightened with white, 7⅜in. x 10⅛in.*

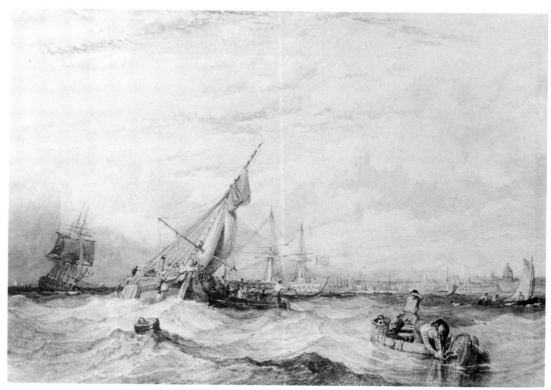

CLARKSON STANFIELD (1793-1867)
Portsmouth Roads. *Signed and dated 1828, watercolour, 8⅛in. x 11¼in.*

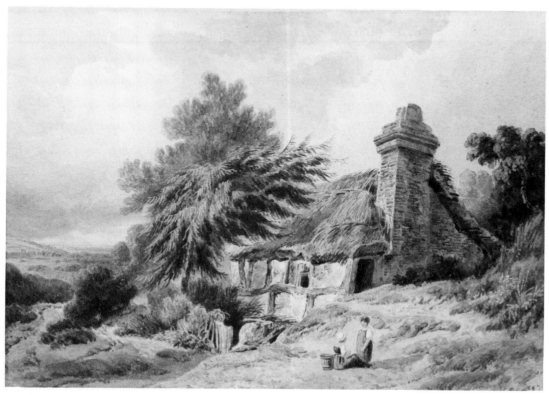

WILLIAM HENRY STOTHARD SCOTT of Brighton (1783-1850)
A Cottage in Sussex. *Signed, watercolour, 7⅜in. x 10½in.*

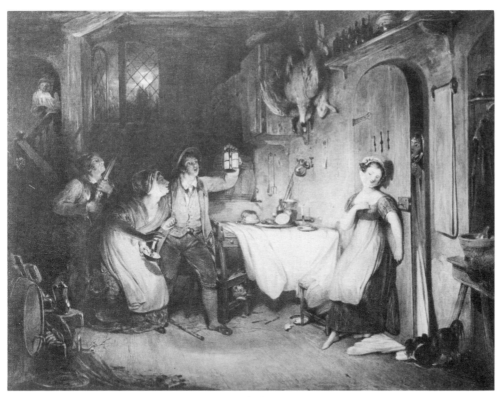

FRANCIS PHILIP STEPHANOFF (1788-1860)
Laying the Ghost. *Signed, watercolour heightened with white, 8⅛in. x 10in.*

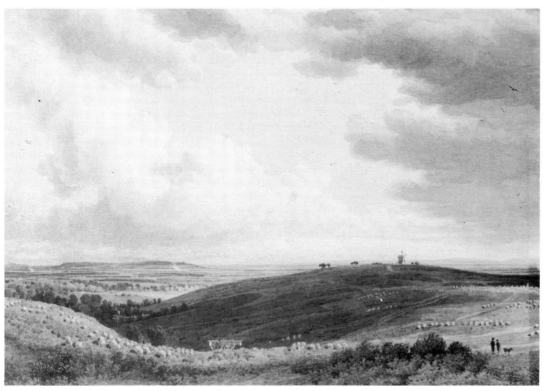

WILLIAM TURNER of Oxford (1789-1862)
Shotover Hill. *Watercolour, 7¼in. x 9⅞in.*

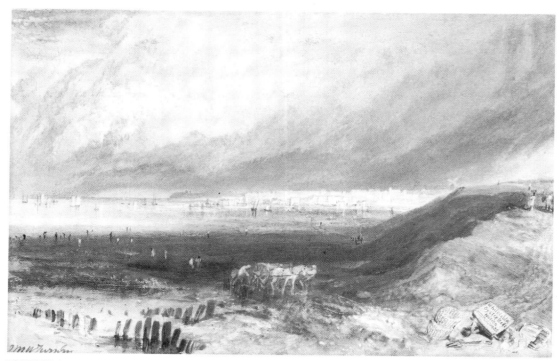

JOSEPH MALLORD WILLIAM TURNER (1775-1851)
Oyster-beds, Whitstable. *Signed and inscribed, watercolour heightened with white, 6⅜in. x 9⅝in.*

JOHN VARLEY (1778-1842)
Harlech Castle. *Signed and dated 1826, watercolour, 7¼in. x 10in.*

69

CORNELIUS VARLEY (1781-1873)
An Irish Cow-shed. *Signed and dated 1828, watercolour heightened with white, 7½in. x 10⅜in.*

WILLIAM WESTALL (1781-1850)
Winter Scene in Yorkshire. *Signed and dated 1826, pencil and watercolour, 7¼in. x 10½in.*

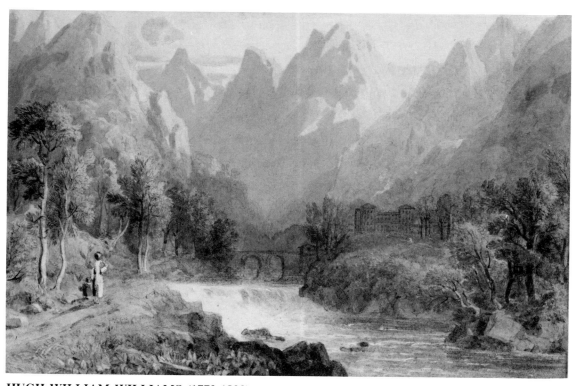

HUGH WILLIAM WILLIAMS (1773-1829)
Scene near Mossa, in Tuscany. *Signed and dated 1827, pencil and watercolour heightened with white, 6in. x 8¾in.*

WILLIAM WALKER (1780-1868)
Port of Argostoli, Cephalonia. *Watercolour, 7⅜in. x 10½in.*
Walker had visited Greece in 1803, and he made a living from it thereafter.

71

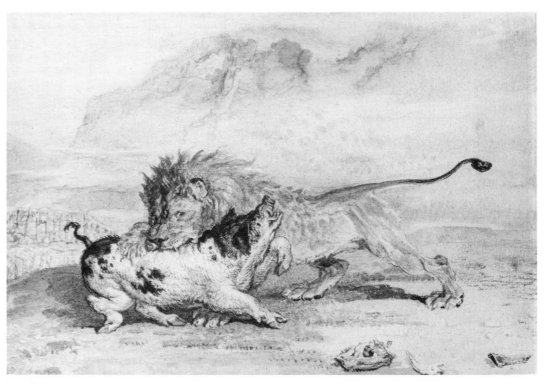

JAMES WARD (1769-1859)
A Lion seizing a Boar. *Signed with monogram, pencil and watercolour, 7⅛in. x 10¼in.*

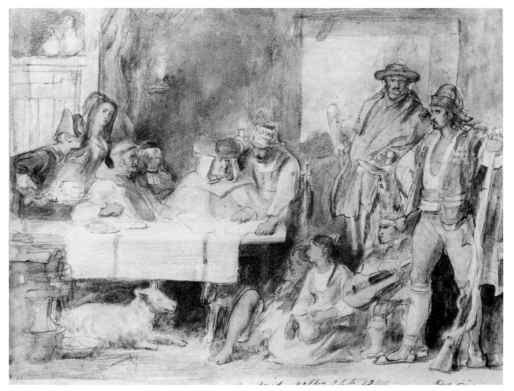

DAVID WILKIE (1785-1841)
A Spanish Posada. *Signed, inscribed 'Madrid' and dated 'Octb. 24th 1827', pencil and watercolour, 6¾in. x 8⅜in.*
This is an early study, made in Madrid (where Wilkie remained from October 1827 to the following May) for the painting in the Royal Collection.

72

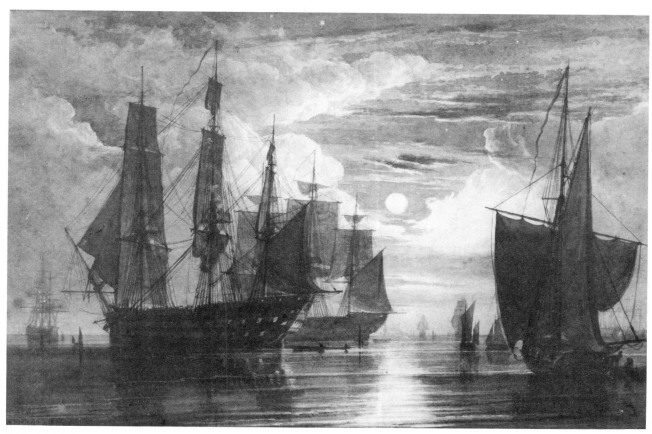

JOHN MAYLE WHICHELO (1784-1865)
Sea-piece, Moonlight. *Signed and dated 1827, watercolour, 6¾in. x 10in.* *(Dudley Snelgrove)*

Thirty-one autographs of artists.

As a matter of record, here is the 1861 list of contents of the French Album: *Collection des Aquarellistes Français, Artistes vivants, Année 1833* — although one or two of them were not by any means *'vivant'*.

H. Garnerey — Frontispiece
Coutan — Repos à la Fontaine — *bistre*
J. Coignet — Le rocher de La Croix
Grandville — Avez-vous diné, Messieurs?
E. Isabey — Souvenier de Caen
Robert Fleury — L'Ouragan
Vander Burch — Ferme champenoise
C. Gudin — Grève de Trouville — *bistre*
Aline Alaux — Les Armes de France
Siméon Fort — Ma chaumière — *bistre*
Pigal — Cabinet de Lecteur
Dumée — Mare de Moulineau
O. Guet — Départ pour la Pêche
Giraud — Hampstead
Bouton — Chapelle Latérale
Gué — Le Hameau
Ciceri — Maison du Garde
H. Lescot — Le dernière Resource du Joueur
Granet — Rachat d'Esclaves
O. Gué — Eglise de Village
L. Leprince — Marché aux Porcs

Le Poittevin — Retour de la Pêche
C. Roqueplan — Quilleboeuf
Decamps — Le Chariot — *bistre*
Jules Dupré — Les Enfans du Nocher
Hubert — Foret, Ravins, et Montagnes
Justin Ouvriè — Montmartre — *bistre*
Fragonard — Missive d'Amour
Renoux — Ruines Mauresques — *bistre*
A. Larguet — Les deux Lutins
Villeret — Eglise de Nemours
L. Vernet — Bestiaux à l'Abreuvoir
Deveria — Une bonne Mère — *bistre*
Bellange — Présentez Armes
H. Vernet — Chasse au Marais — *bistre*
A. Johannot — Arrestation de Charles I
A. Colin — Pêcheurs de coquillage
Eug. Deveria — Heureux Damoiselles
H. Lecomte — Massaniello
Beaume — Les Trois Ages
H. Garnerey — Restes gothiques de Rouen
Charlet — Les Tableaumanes
Redoute — Fleurs

WEEDS ON THE WALL

'Weeds on the Wall, or Girton Excused' is the title given to an album of photographs begun by the late Tom Girtin (co-author with David Loshak of *The Art of Thomas Girtin,* the *catalogue raisonné* of the work of his ancestor), and continued by his son and namesake. It contains 'worthless daubs' and also near misses, which have appeared on the market, or in museum and study collections over the years. Many are easily identified as being by friends, pupils and disciples, in particular the John Hendersons, father and son, Cotman, De Wint, William Pearson and F.J. Manskirch. Others, however, are spurious copies of the soft ground etchings and of S.W. Reynolds' mezzotints after Girtin. Still others are deliberate in-the-manner-of creations by the notorious 'Holborn School of Faking' which flourished in the 1920s, or by still more contemporary masters.

To spare the blushes of the owners — even of the museums who rashly demand acknowledgement — I will not give further credit to these photographs, except for the first seven, which come from other sources and serve to set the context.

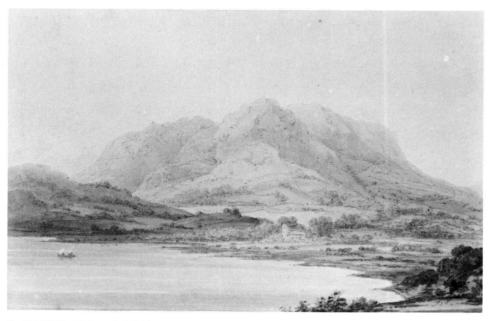

1. DAYES, Edward (1763-1804)
Grasmere. *Pencil and watercolour, 5½in. x 8½in.*
This is one of the blue-grey landscapes which have often been called early Turner in the past, and sometimes Girtin and Turner. Now, on the authority of Andrew Wilton and other Turner scholars they are given to Dayes, who was Girtin's master and Turner's early inspiration.
(Lawrence of Crewkerne)

2. GIRTIN, Thomas (1775-1802) and TURNER, Joseph Mallord William (1775-1851)
The Road from Ireton towards Stye Head, Cumberland. *Pencil and watercolour, 6¼in. x 9in.*
A Monro School drawing, of the kind which is supposed to have been outlined by Girtin and washed by Turner. Obviously controversy will continue over this and the previous group, but they are close enough to what they should be for precision in attribution not to matter greatly. *(Spink & Son)*

3. GIRTIN, Thomas (1775-1802)
A View from Braunton Marsh towards Instow and Appledore on the River Taw. *Signed, watercolour, 11¾in. x 20½in.*
This is a splendid example of Girtin in about 1798 or '99 when he was approaching what, sadly, turned out to be the height of his powers. *(Leger Galleries)*

4. HENDERSON, John (1764-1843)
Fell Foot from the Ascent of Wrynose. *Signed, dated July 20 1806 and inscribed on the reverse, watercolour, 8½in. x 17¾in.*
Were it not for the evidence of the reverse, one might well have thought from the sense of distance and the highlit middle ground 'William Pearson' — for whom see below and *Volume II,* pages 477 and 478. Henderson was a friend and neighbour of Monro, and he also kept open house to the group of young artists on the same terms. He was an assiduous worker in the manner of Girtin, and a copyist of the etchings. His wife Georgina was the daughter of George Keate (see Part II) and she, like their sons John, yr., and Charles Cooper, was a painter. *(Sotheby's)*

5. CURTIS, John Digby (c.1775-1837)
York and Orleans Houses, Twickenham. *Inscribed 'Girtin', water and bodycolour, 13½in. x 18¼in.*
I am not certain on what ground this is given to Curtis, but he was a copyist and worker-up of the efforts of others. In this case it is possible that a composition of Dayes may have been the inspiration. *(Sotheby's)*

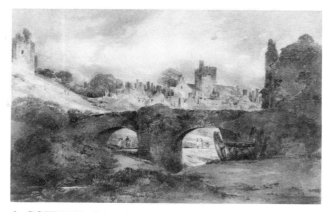

6. COTMAN, John Sell (1782-1842)
Brecknock. *Watercolour, 14¾in. x 21½in.*
There is no evidence as to whether Cotman ever actually met Girtin, but he joined the Girtin-Francia sketching club, 'The Brothers' a little before or very shortly after the death of the master. Certainly he was under Girtin's influence from the time of his first visit to London in 1798 (transposed to a precocious 1789 in Volume I), and perhaps even before — see No.13. *(Private Collection)*

7. PEARSON, William
Farmhouse at Drumra. *Watercolour, 5in. x 7½in.*
Presumably this is a view near the County Tyrone hamlet, although the landscape looks much like Pearson's native north country. *(Simon Carter)*

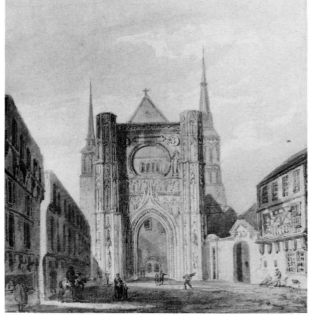

9. HENDERSON, John (1764-1843)
The Church of St. Corneille de Compiègne. *Watercolour, approx. 12in. x 10in.*
A dangerous head-on composition for an amateur to attempt.

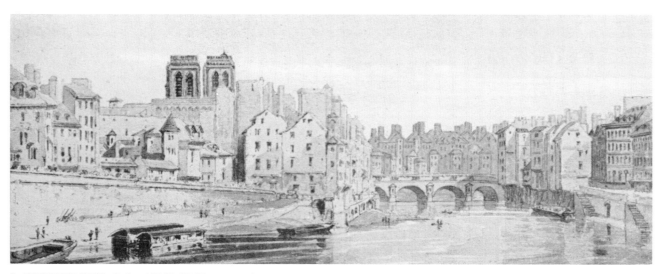

8. HENDERSON, John (1764-1843)
The Pont St. Michel from the Pont Neuf. *Pen and brown wash, 7in. x 17½in.*
This is copied fairly directly from the etching and aquatint in Girtin's *Twenty Views.* It was in the collection of both John Hendersons, as were many of their own efforts which have since been given to Girtin.

10. HENDERSON, John (1764-1843)
A Village Street. *Watercolour, 6¼in. x 10½in.*
It was suggested by the elder Tom Girtin that this was probably a copy of an outdoor sketch by Girtin.

11. MANSKIRCH, Franz Joseph (1768-1830)
The Ferry. *Watercolour, size unknown.*
Manskirch was an honest, if woolly, worker in the manner of.

12. FRANCIA, François Louis Thomas (1772-1839)
A Lane and Cottages. *Watercolour, 12in. x 16⅜in.*
This is a copy of a Girtin sketch, by his fellow member of the Brothers. Francia also produced a soft-ground etching of it in reverse.

13. Perhaps COTMAN, John Sell (1782-1842)
Norwich. *Watercolour, 8¼in. x 12¾in.*
Cotman was painting from a very early age, sometimes making copies of other peoples' drawings and prints, and sometimes trying original compositions. This view, which if by him would be juvenile rather than merely early, shows very little sense of composition, but there are passages, as below the bridge, which promise well. The figures also resemble a formula used in very early Cotman drawings.

14. ANON
Tynemouth.
*Watercolour,
12½in. x 16in.*
This is a direct
copy of the
mezzotint after
Girtin by
S.W. Reynolds.

15. ANON.
Richmond Castle. *'Signed' Girtin and dated 1802, watercolour, size unknown.*
This is a loose copy of a Girtin in the Leeds City Art Gallery, although that is dated 1800, and this very poor effort at a signature has also been placed differently.

16. ANON
Hilly Landscape with Waggon. *Water-colour, 11¾in. x 15¾in.*
This specimen, despite the nice cartridge paper, was dismissed by the elder Tom Girtin as *'dud* of a particularly noisome sort.' Several others by this hand are known, including at least two of Kirkstall Abbey taken from a composition by Dayes, which may, of course, have been copied by Girtin in between whiles. It is possible that the group derives from one of Girtin's Yorkshire patrons/pupils. It is also possible that it is no older than the 1920s.

AUTRES HERBES
AUTRES MURS

A final group of odds and ends is included to show a diversity of traps, pitfalls and innocent errors. They are presented in chronological order.

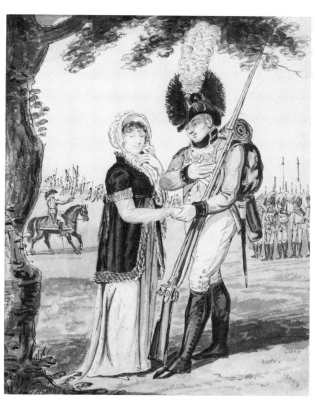 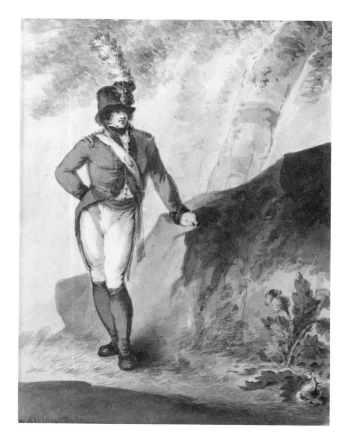

1. CRUIKSHANK, Isaac (1756-1811)
The Soldier's Farewell. *Pen and black ink and watercolour, 9½in. x 7⅛in.*
(Martyn Gregory)

2. ALSTON, W.
An Officer of Irish Yeomanry. *Signed, pencil and watercolour heightened with white, 13¼in. x 9⅛in.*
(Christie's)

These two are, of course, perfectly genuine, and very nice of their kind. They are here merely to show that there were many obscure painters who seem not to be recorded but who can look really very like better known artists.

Alston is quite unknown — to me at least — and while the subject and pose put one in mind of Cruikshank, the style could also suggest Ibbetson, or, with his Irish connection, Wheatley.

3. ROWLANDSON, Thomas (1756-1827)
Orpheus and Euridice. *'Signed', pen and reddish ink and watercolour, size unknown.*
This excellent Rowlandson bears a partly effaced signature in a well-known hand. It purports to belong not only to Rowlandson, but equally to many other people who were long dead when it was active. *(Sotheby's)*

4. 'BONINGTON, Richard Parkes'
Two Women. *'Signed', pencil and watercolour, 8in. x 5in.* Perhaps this drawing dates from the middle of the 19th century, which is more than can be said for the signature — another well-known hand. *(Simon Carter)*

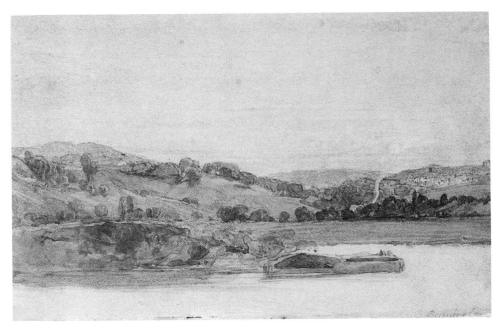

5. BONNINGTON, Richard Parkes
The River Seine near St. Cloud. *'Signed, and inscribed' on the reverse, pen and brown ink and watercolour, 7¾in. x 10⅛in.* It is rather sad that the hand which signed and inscribed this 20th century watercolour did not belong to a head which knew how to spell Bonington.
(Private Black Collection)

84

5a. BONNINGTON, 'signature'

Attributable to:

Louisa, Marchioness of WATERFORD
(1818 - 1891)
Drawing in Pencil & watercolour, with
touches of Chinese White:
"Hanging birds' nests in Mrs Syers(?)
garden, Barrackpore - Calcutta 20th
June '42"

Barrackpore used to be the country residence
of Governors-General & Viceroys, about 15
miles from Calcutta (see article in Country
life, "An English Mansion in Bengal",5/2/70,
by Mark Bence-Jones). The Governor-General in
1842 would have been Edward Law, 1st Earl of
Ellenborough.

6. PROMISING LABELS from the backing of the
following drawing.

8. SYER, John (1815-1885)
A Fisherman — *detail*.
The person who appended this poor Cox 'signature' did not even
bother to remove the genuine J. Syer beneath it.

(Private Black Collection)

7. Hanging Birds Nests in Mr. Syer's Garden, Barrackpore. *Dated June 20"/42, and inscribed on backing paper, pencil and brown wash heightened with white, 10⅞in. x 7⅝in.*
A nice drawing, but in style it has little in common with the work of Lady Waterford, or even of her sister Lady Canning, who at least went to India — as wife of the Governor-General in 1855. As it happens, her tomb is at Barrackpore. It is in fact by a much less eminent figure in British India, one Nicholas Vibart.

(Private Collection)

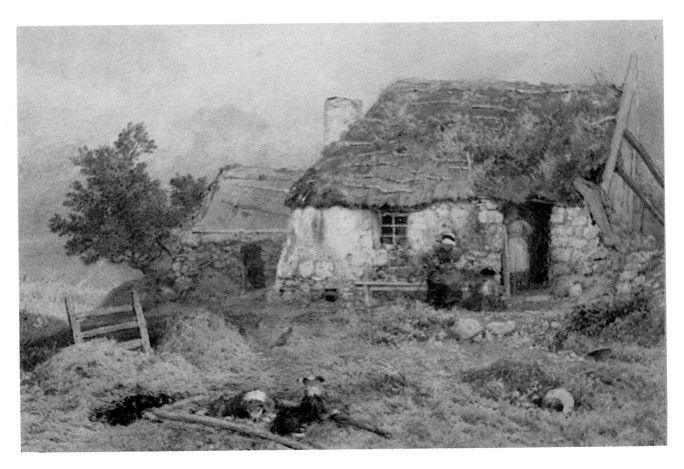

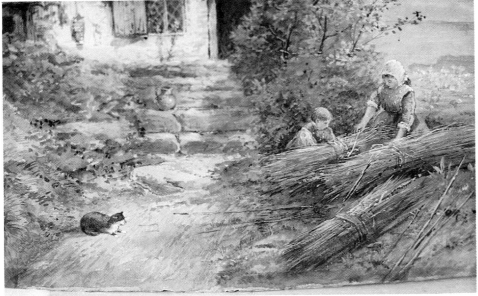

9. FOSTER, Myles Birket (1825-1899)
A Croft at Ardessie. *Signed with monogram, pencil and heightened with white, size unknown.*
(Richard Ivor)

10. After FOSTER
Binding Reeds outside a Cottage. *Watercolour heightened with white. Detail.*

The second of these is almost certainly copied from one of the chromolithographs after Foster. The feebleness of the drawing is an insult to him, which, for once, has not been compounded by the addition of the monogram. *(Private Black Collection)*

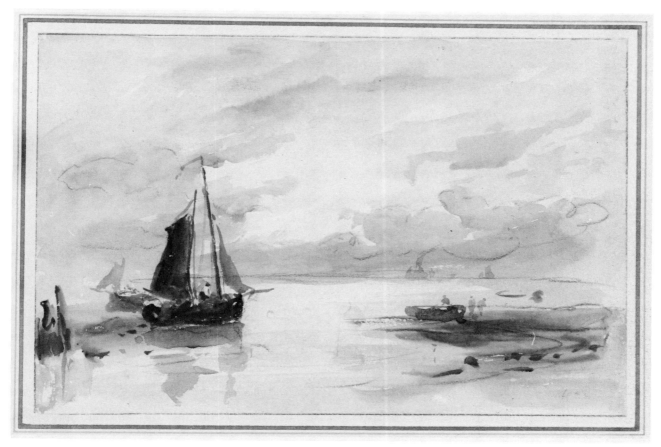

11. BROWN, Hugh Boycott (b.1909)
Fishing Boats by the Shore. *Signed with initials, pencil and watercolour, approx. 6in. x 10in.*
Not the H.B.B. that one, and many a buyer, might have expected. This one is still at work
in the manner of his initialsake. *(Martyn Gregory)*

It is to be hoped that there will be no such problematic entries in Part II of this
volume. However, it is quite possible that one or two will slip in. Advancing
knowledge often makes the certain attributions of one period the howlers of the
next; an example from *Volume II* is the drawing on page 494 then attributed to
James Roberts. In fact it is by William Wellings, the silhouette and miniature
painter, who also produced theatrical portraits. Ruskin is another whose accepted
oeuvre seems to change quite often. Thus the *Lanercost Priory* given to him in
Volume II is now held to be by W.J. Blacklock.

PART TWO

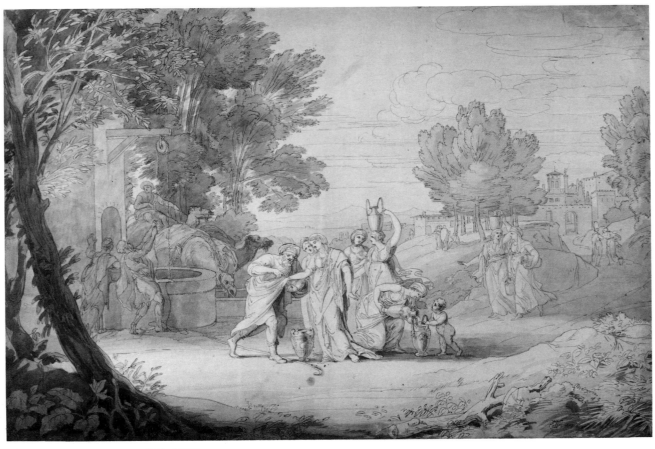

ABBOTT, John White (1763-1851)
Rebecca and Eleazar. *Signed with monogram and dated 1807, pen and grey ink and brown wash, 13¼in. x 19¾in.*
Abbott's figures are as neat and cool as his landscapes. *(Christie's)*

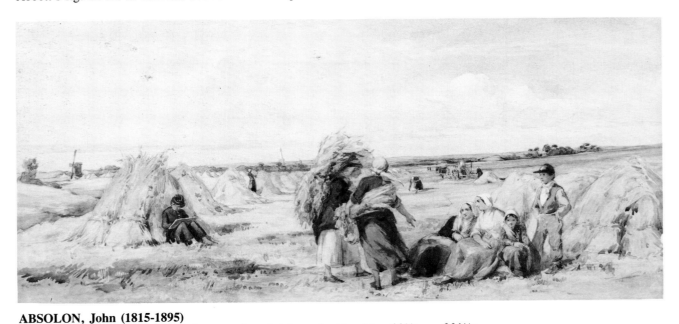

ABSOLON, John (1815-1895)
The Harvesters' Rest. *Pencil and watercolour heightened with white, 11½in. x 23¼in.*
Absolon seems to have been very much of a family man, and often includes himself and his kin in his compositions. The
figure sketching against a stook is no doubt one of the sons. *(Christie's)*

(Above) ACLAND, Sir Henry Wentworth (1815-1900)
The Cathedral at Aghadoe. *Pencil, pen and black ink and wash, heightened with white, size unknown.*
Acland was a good friend and sketching companion of Ruskin, but although his drawing is quite good, he is not in the same artistic league. *(Christie's)*

(Right) ALDRIDGE, Frederick James (1850-1933)
Making Port. *Signed with initials and dated 83, watercolour, 14in. x 10in.*
Although repetitive and limited, Aldridge's formuli can be well done. *(Simon Carter)*

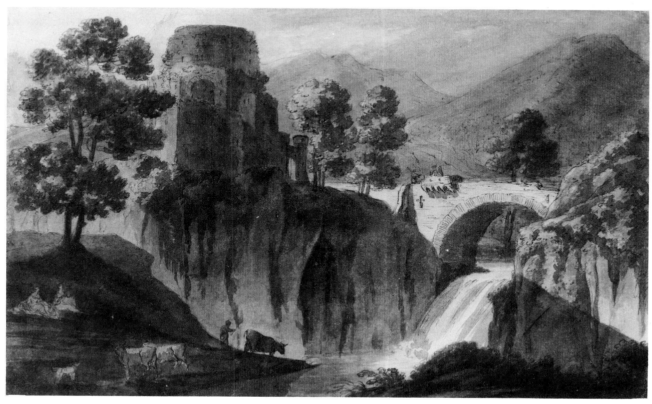

ADAM, Robert (1728-1792)
Romantic landscape composition. *Pen and ink and watercolour, 8in. x 12½in.* *(Martyn Gregory)*

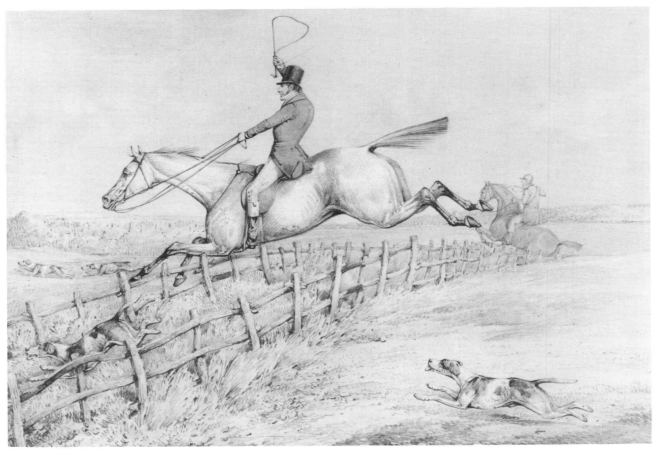

ALKEN, Henry Thomas (1785-1851)
Full Cry. *Pencil and watercolour, 9⅜in. x 13in.*
As well as the dangerously raised whip-hand, in fact a hallmark which his relatives sometimes copied, the sheer nervous
quality of Alken's horses and hounds sets them apart from the family school. *(Christie's)*

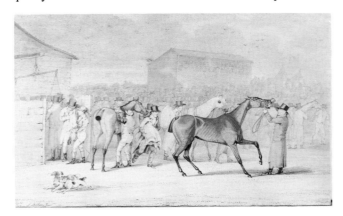

(Above) ALKEN, Samuel, Yr. (1784-1825)
Weighing-in. *Signed and dated 1808, pencil and water-
colour on thin card, 13⅞in. x 20⅝in.*
For once H.T. Alken's elder brother has differentiated his
signature from that of their father. *(Christie's)*

(Right) ALLAN, Sir William (1782-1850)
Tartar Brigands sharing the Spoil. *Pencil and watercolour
heightened with gum arabic, 14½in. x 11¾in. (Sotheby's)*

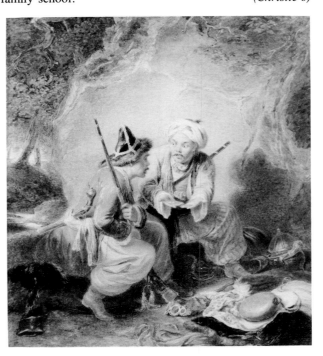

92

ALLBON, Charles Frederick (1856-1926)
Off the Dutch Coast. *Signed, pen and ink and watercolour heightened with white, 9½in. x 26in.*
Not at all a bad example of T.B. Hardysme.

(Christie's)

ALLINGHAM, Helen, Mrs (1848-1926)
The Fields in May. *Signed, water and bodycolour, 12in. x 9⅜in.*
Helen Allingham was a brilliant portraitist as well as a garden and cottage painter. She does not seem entirely happy with genre. This was for a book, *Flower Pieces*.

(Chris Beetles)

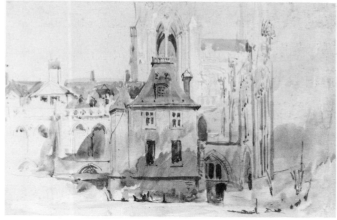

ALLOM, Thomas (1804-1872)
Rouen Cathedral. *Signed and inscribed, watercolour heightened with white, 9¼in. x 13½in.* *(Martyn Gregory)*

ANDREWS, George Henry (1816-1898)
A Dutch Fishing Boat in a Squall. *Signed and dated '51, pencil and watercolour heightened with white, 8½in. x 14¼in.*
Andrews has a number of styles, of which this free and splashy one is by no means the least attractive. *(Sotheby's)*

93

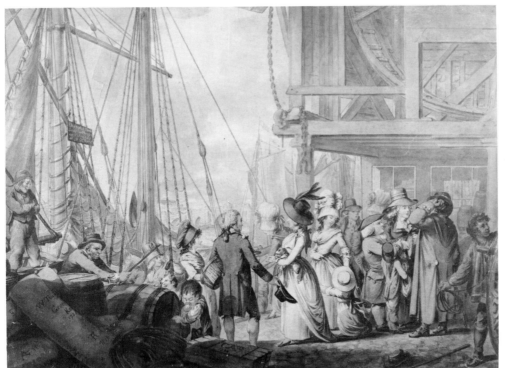

**ANSELL, Charles
(c.1752-)**
Embarking at Dice Quay
for Margate. *Signed with
initials and dated 1788,
pencil and watercolour
with touches of white,
15⅞in. x 20¾in.*
Isn't this both handsome
and fascinating. A stylistic
cross hybrid with Dighton,
Ibbetson and Nicholson in
the mix, and a social
document of some value.
Note for instance, the
gantry crane operated by a
treadmill. Dice Quay was
at Billingsgate. *(Christie's)*

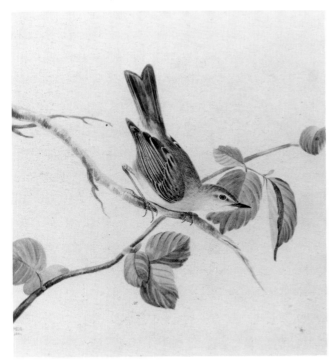

ARDEN, Margaret Elizabeth, Lady (1769-1851)
A Whitethroat. *Signed with initials and dated 1804, pencil
and watercolour, 9in. x 7in.*
The birth date given here is correct, rather than 1762 as
given in Volume I. Lady Arden's mother was a Cheney of
Badger. *(Sotheby's)*

ARMOUR, Lt. Col. George Denholm (1864-1930)
Jorrocks and Pigg. *Signed, pencil, water and bodycolour on
linen, 14⅝in. x 12⅞in.*
 (Spink & Son)

ASHFORD, William (1746-1824)
A Mill near Bantry, County Cork. *Signed and inscribed on the reverse, pencil, pen and ink and watercolour, 9½in. x 14½in.* *(Martyn Gregory)*

ATKINS, Samuel (c.1765-? 1808)
Bird Watchers on the Coast. *Signed, watercolour, 11in. x 15¼in.*
Atkins, wisely, does not normally attempt figures.
(Martyn Gregory)

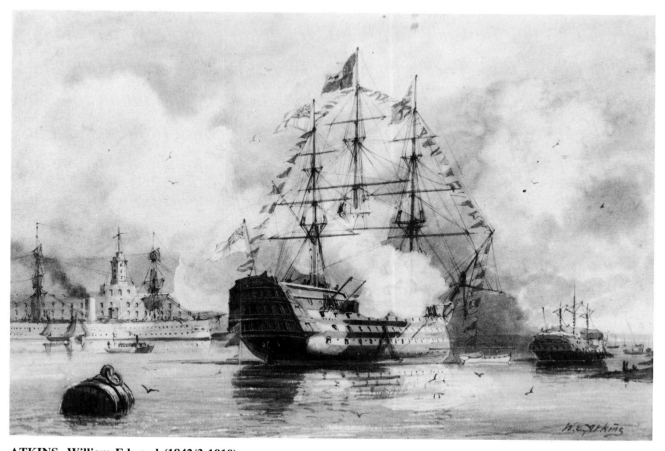

ATKINS, William Edward (1842/3-1910)
H.M.S. Victory at Portsmouth. *Signed, pen and ink and watercolour with scratching, 7in. x 11in.* *(Martyn Gregory)*

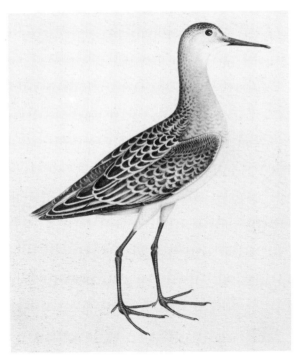

ATKINSON, Rev. Christopher (1754-1795)
Study of a Greenshank. *Inscribed on the reverse with the exact life measurements, pencil, pen and brown ink and watercolour heightened with white, 11in. x 8¾in.*
(Spink & Son)

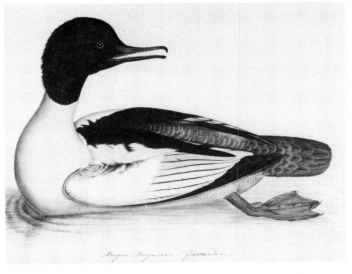

ATKINSON, Rev. Christopher (1754-1795)
A Merganser. *Inscribed, water and bodycolour, 8⅞in. x 11⅛in.*
(Christie's)

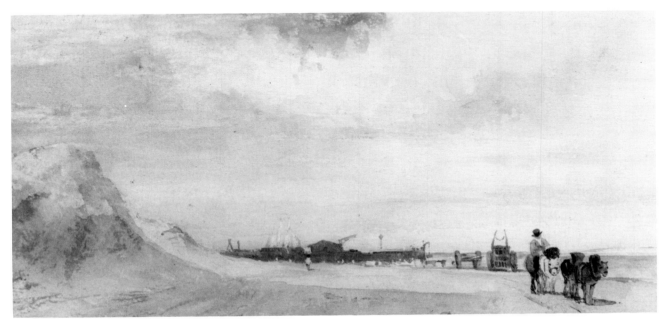

AUSTIN, Samuel (1796-1834)
Carters on a Beach. *Watercolour, 5½in. x 11in.*

(Martyn Gregory)

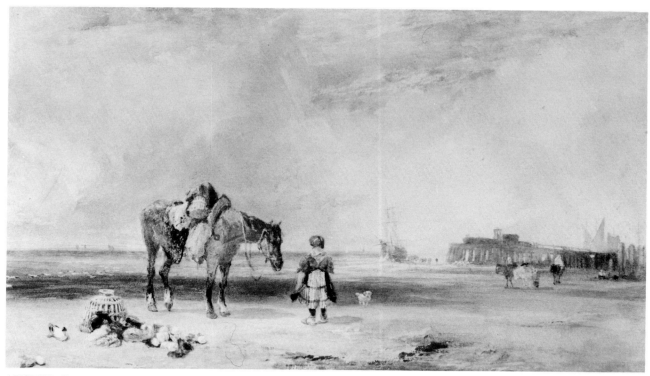

AUSTIN, Samuel (1796-1834)
On the Beach, Ostend. *Watercolour, 10½in. x 18in.*

(Agnew)

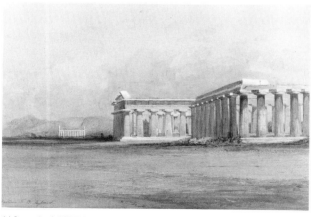

(Above) AYLMER, Thomas Brabazon (1806-c.1856)
Paestum. *Signed and inscribed, pencil and watercolour heightened with white on buff paper, 10¼in. x 14⅝in.*
(Christie's)

(Left) AUSTIN, Samuel (1796-1834)
Study of Trees. *Watercolour, 17in. x 12in.*
In this sketch Austin has thoroughly profited by his three lessons from De Wint. *(Agnew)*

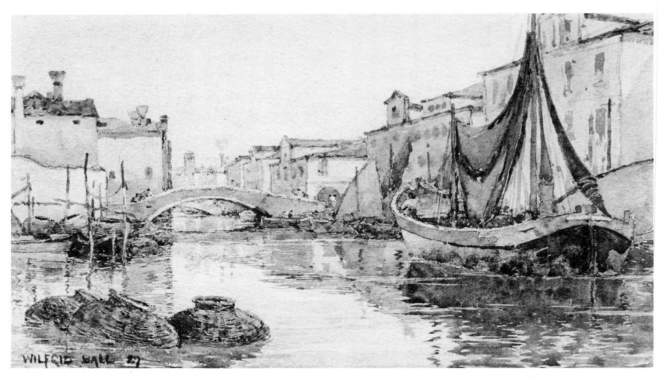

BALL, Wilfred Williams (1853-1917)
Chioggia. *Signed and dated 87, watercolour, 6in. x 9in.* (Simon Carter)

BALLINGALL, Alexander
Leith. *Signed, inscribed and dated 1879, watercolour heightened with white, 10¼in. x 27¾in.*
I wonder if he had seen the Whitby work of E. Cockburn.
(Sotheby's)

BALMER, George (1806-1846)
Low Tide. *Pencil and watercolour heightened with gum arabic, 6¾in. x 9¾in.* (Sotheby's)

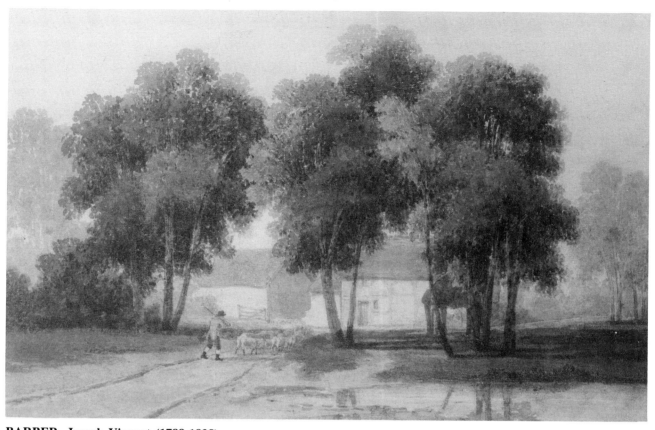

BARBER, Joseph Vincent (1788-1838)
A Shepherd by a Farm. *Pencil and watercolour heightened with gum arabic, 10⅜in. x 15¼in.*
It is hardly surprising that this should look like the work of Cox, who was a fellow pupil of Barber's father Joseph. It is also very like the work of Barber *père*.
(Michael Bryan)

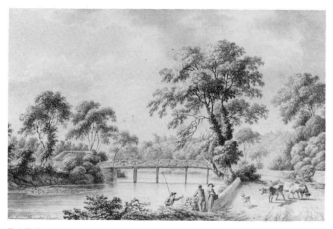

BARRALET, John James (1747-1815)
The Wooden Bridge on the Liffey near Luttrellstown. *Signed, pen and ink and watercolour, 12⅜in. x 16½in.*
(British Museum)

BARRAUD, Charles James (1843-1894)
Lulworth. *Signed, watercolour, size unknown. (Sotheby's)*

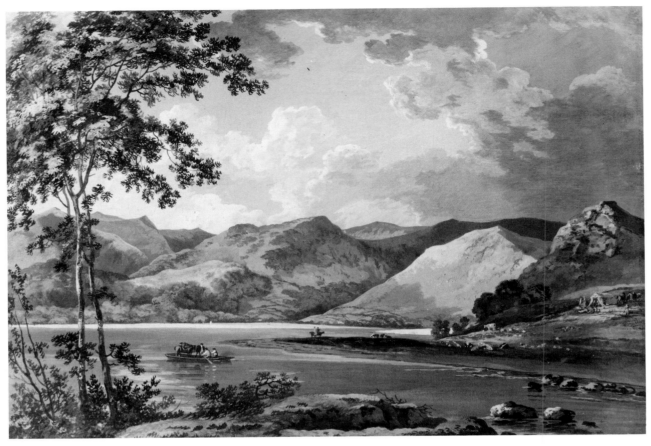

BARRET, George (1728-1784)
A Ferry on a Mountain Lake. *Signed and dated 22 February 1781, watercolour heightened with white, 19in. x 25½in.*
(Leger Gallery)

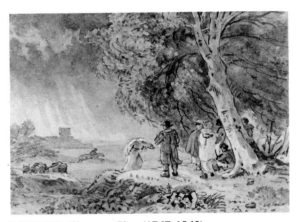

BARRET, George, Yr. (1767-1842)
Sheltering from a Storm. *Reed pen and watercolour, 5½in. x 7¼in.*
In this mood Barret could almost be Sir J.J. Stewart.
(Martyn Gregory)

BARRET, George, Yr. (1767-1842)
Dowdeswell Manor, near Cheltenham. *Inscribed. Pencil and watercolour, 10in. x 6¾in.* *(Martyn Gregory)*

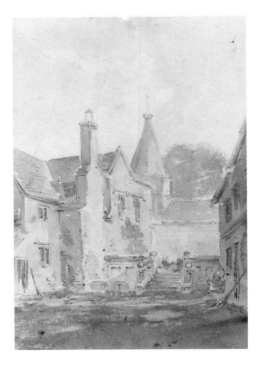

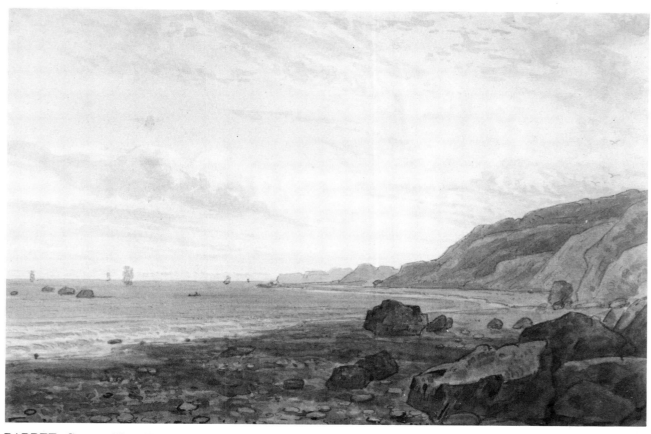

BARRET, George, Yr. (1767-1842)
Keith Bay, Isle of Wight. *Pen and grey ink and watercolour, 5⅜in. x 8¾in.*
Even if one did not know this to be one of Barret's less formal styles, the clouds are very typical of him in many moods.
(*Christie's*)

BARROW, Joseph Charles
Dover Beach. *Signed, pencil and watercolour, 6in. x 9in.*
This is pleasantly informal for Barrow. (*Simon Carter*)

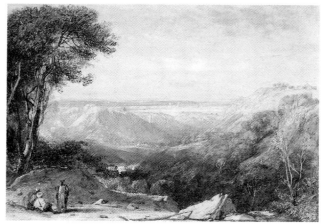

BARTLETT, William Henry (1809-1854)
Arabs on a Hilltop. *Watercolour, 6¼in. x 8⅜in.*
(*Chris Beetles*)

101

**BARTON, Lt. Gen. Ezekial
(1781-1855)**
Huts in the Indian Jungle. *Pencil, grey
and blue washes, 7½in. x 9in.*
(Private Collection)

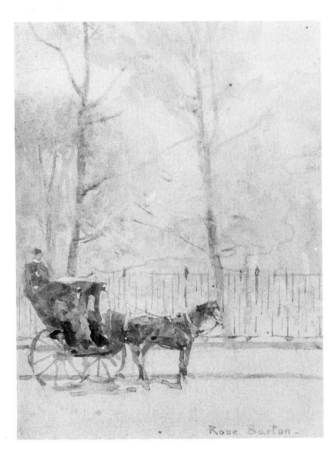

BEAUCLERK, Lady Diana (1734-1808)
Caught — Nymph and Cupid. *Signed with initials, and
inscribed by a 20th century hand, pencil and watercolour,
11⅜in. x 10¼in.*
Mrs Erskine's book, in which this is reproduced, was
published in 1903. *(Christie's)*

BARTON, Rose (1856-1929)
Piccadilly. *Signed, watercolour heightened with white, 6in.
x 4in.* *(Simon Carter)*

102

BEAUMONT, Sir George Howland (1753-1827)
At Lowther. *Inscribed on the reverse and dated 1811, black chalk and grey wash on blue paper, 12in. by 18¾in.*
This drawing descended in the Beaumont family.
(Martyn Gregory)

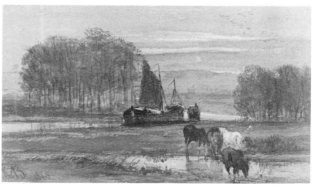

BEAVIS, Richard (1824-1896)
Barges and Tow-horses. *Signed with initials and dated 1869, pencil and watercolour heightened with white, 5in. x 7in.*
(Simon Carter)

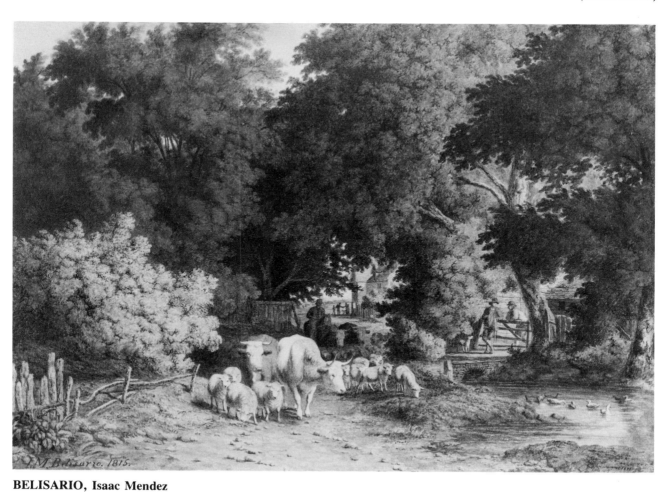

BELISARIO, Isaac Mendez
Cattle, Sheep and herds. *Signed and dated 1815, watercolour, 12¼in. x 17in.*
This watercolour by a close friend and follower of Robert Hills was exhibited at the OWS in 1815. *(Michael Bryan)*

BELLAIRS, Lt. Walford Thomas (c.1794-1850)
Whampoa Pagoda. *Inscribed on the reverse, watercolour,*
4¾in. x 7in. (Martyn Gregory)

BENETT, Newton (1854-1914)
Sandwich, Kent. *Signed with initials and dated 1880, water-*
colour heightened with white, 9¾in. x 14in. (Moss Galleries)

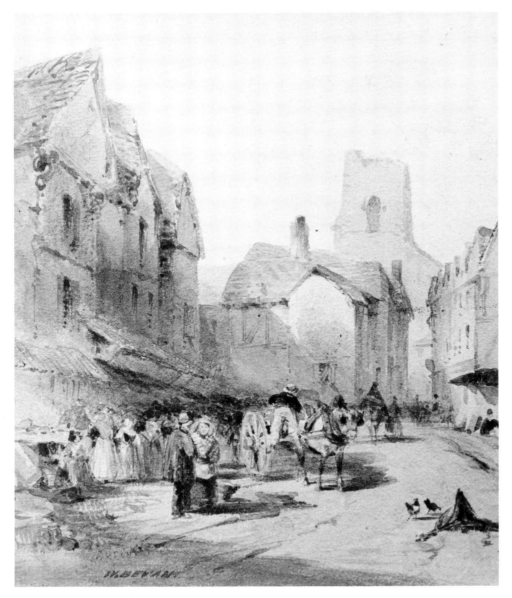

**BEVAN, William
(-c.1848)**
A Street in an old Town.
Signed, watercolour,
7in. x 5in.
Bevan was a drawing
master at Hull, and on the
evidence of this he may
himself have had lessons
from one of the Fielding
Anglo-French school.
(Simon Carter)

BEVERLY, William Roxby (1811-1889)
On the Arun. *Signed with initials, watercolour, 7in. x 12½in.*
Beverly's signature, when in full, generally reads as above, but sometimes, apparently 'Beverley'. *(Charles Chrestien)*

BEWICK, Thomas (1753-1828)
A Vignette. *Watercolour, 3½in. x 4¾in.* *(Christie's)*

BIRCH, Samuel John Lamorna (1869-1955)
Lamorna Cove. *Signed, inscribed and dated 1946, water-colour, size unknown.* *(David Messum)*

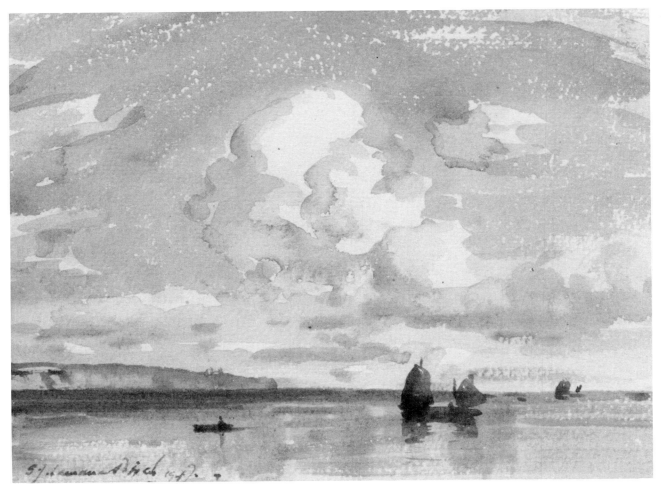

BIRCH, Samuel John Lamorna (1869-1955)
Seascape Sketch. *Signed and dated 1947; watercolour, 5in. x 6¼in.*
Another example of how like Wilson Steer, or perhaps even Seago, Birch could be at the end of his career. *(Bearne's)*

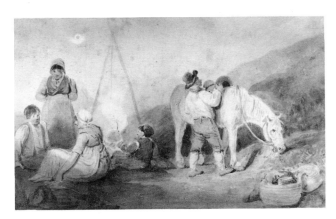

BIRD, Edward (1772-1819)
Gypsies. *Inscribed with attribution on old backing, water-colour, 5in. x 7½in.* *(Martyn Gregory)*

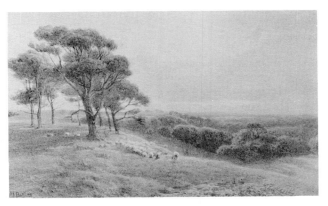

BIRTLES, Henry (1838-1907)
The Downs. *Signed and dated 79, pencil and watercolour, 9in. x 6in.* *(Simon Carter)*

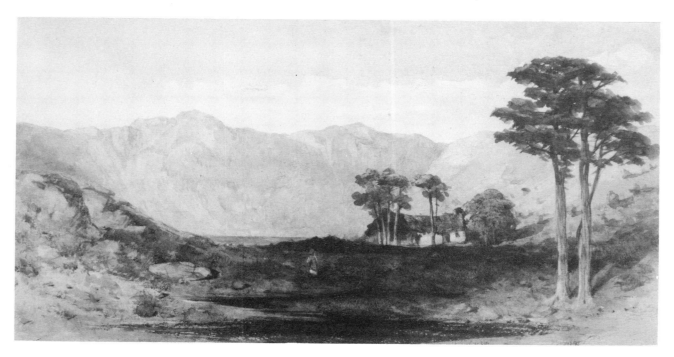

BLACKLOCK, William James (1816-1858)
Cumbrian Fells. *Pencil and watercolour,*
5¾in. x 10¾in. *(Moss Galleries)*

BLACKLOCK, William Kay (b.1872)
A Quiet Read. *Signed and dated 1913, water-*
colour, 24in. x 19in. *(Sotheby's Sussex)*

BLAIR, John
Loch Vennacher and Ben Venue. *Signed and dated 1898, and bears inscription, watercolour, 21in. x 29½in.*
(Sotheby's Chester)

BONINGTON, Richard Parkes (1802-1828)
The Pont de la Concorde with the Tuileries beyond. *Signed and dated 1827, watercolour, 13in. x 21in.* (Martyn Gregory)

BLAKE, Fanny (-? 1851)
The Bearer of sad Tidings. *Signed and dated 1846, pencil and watercolour, 13½in. x 18½in.*
Miss Blake, a pupil of De Wint who developed away from him, was the accomplished artist 'admirable for truth, completeness and delicacy' who organised an exhibition of the work of amateurs in 1851. A Miss F. Blake died in London later that year.
(Sotheby's)

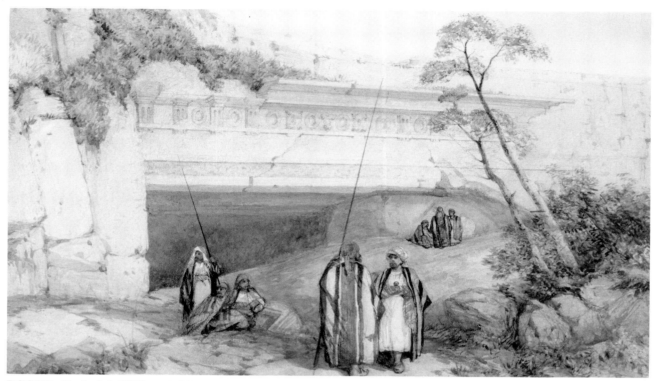

BOOTY, Frederick William (1840-1924)
Arabs by Classical Ruins. *Pencil and watercolour heightened with white, size unknown.* (Charles Chrestien)

BOTHAM, William
Nottingham Castle. *Signed and inscribed on the backing, pencil and watercolour, 14½in. x 18¾in.* (Christie's)

BOUGH, Samuel (1822-1878)
A Royal or Ceremonial Barge approaching a Riverside Castle. *Signed and dated 1878, pencil and watercolour, with touches of bodycolour, 22in. x 33in.* (Martyn Gregory)

109

BOUGH, Samuel (1822-1878)
Highland Landscape. *Pencil and watercolour, 8½in. x 13¼in.* *(Martyn Gregory)*

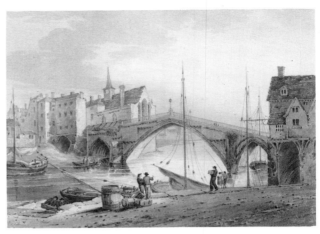

BOURNE, Rev. James (1773-1854)
The Ouse Bridge, York. *Signed, inscribed and with address on the reverse, pencil and watercolour, 11¼in. x 15¼in.* *(Sotheby's)*

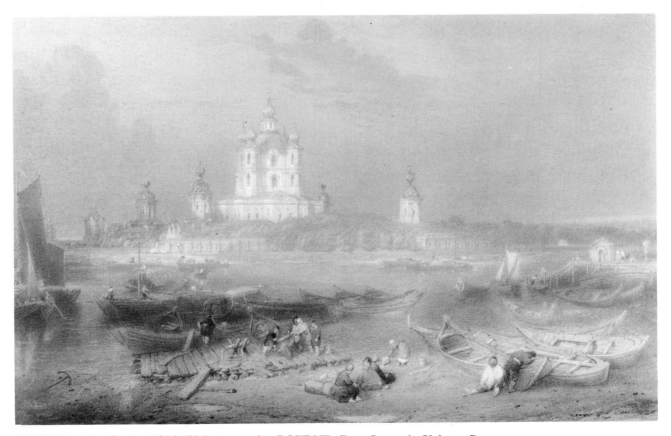

BOURNE, John Cooke (1814-1896) (see under BOURNE, Rev. James in Volume I)
The Smolny Convent and Institute on the Neva, St. Petersburg. *Signed and inscribed on a label, pencil, water and bodycolour, 13in. x 19¾in.*
It is all too easy to assume that all Russian views of the first half of the 19th century by British hands must be by A.G. Vickers. J.C. Bourne normally specialised in the domestic railway system. It would be interesting to know whether he actually visited Russia. *(Sotheby's)*

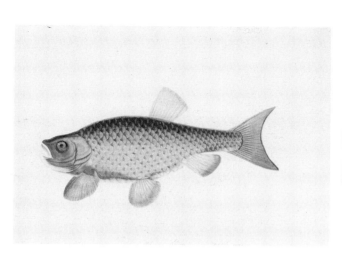

BOWERS, Stephen J.
A Country Lane. *Signed, watercolour, 4in. x 6½in.*
Dear, dear. The surprise about Bowers is not that he is obscure, but that his works were accepted for a number of exhibitions between 1874 and 1891. *(Simon Carter)*

(Above) BOWDITCH, Sarah, Mrs, née Wallis (1791-1865)
A Chub. *Water and bodycolour, further heightened with gum arabic and gold and silver paint, 10¼in. x 13¼in.*
From her exclusively English piscene subject matter Mrs Bowditch might be assumed to have led a somewhat sheltered life, or at least a quiet one. Not so, she travelled to West Africa with her first husband, the explorer, at a time when few European men ventured there. They were succeeded in the Consulate at Cape Coast Castle by Turner's son-in-law and daughter. As Mrs R. Lee, Sarah Bowditch later had a career as a scientific writer for the young. The death date given here seems to be the correct one. *(Sotheby's)*

BOYLE, Hon. Mrs Eleanor Vere (1825-1916)
The Sunbeam stole in to kiss him. *Pencil and watercolour heightened with white, 6in. x 5¼in.*
(Christie's)

111

BOYNE, John (c.1750-1810)
The Country Chronicle — a Scene in the Hen and Chickens, 1808. *Signed, inscribed and with address on the original backing, watercolour, 22¾in. x 28¾in.*
This must rank as a masterwork for Boyne, who is often rather weakly Rowlandsonian. *(Agnew)*

BOYS, Thomas Shotter (1803-1874)
Calais Harbour. *Pencil and watercolour, 3⅞in. x 9⅞in.*
A lovely free sketch of perhaps 1830. *(Anthony Reed)*

BOYS, Thomas Shotter (1803-1874)
The Duke's Bedroom at Apsley House. *Signed and dated 1852, pencil and watercolour, 12¼in. x 16⅞in.*
An impressive contribution by Boys to the memorial volume to the Duke of Wellington, *Apsley House and Walmer Castle*.
However, he suffered the indignity of having some of his drawings rejected in favour of the young whipper-snapper Frank
Dillon (q.v.)
(Sotheby's)

BRABAZON, Hercules Brabazon (1821-1906)
Moored Ships near the Redentore, Venice. *Water and body-colour, 8in. x 11in.* **(Chris Beetles)**

BRABAZON, Hercules Brabazon (1821-1906)
Palazzo Dario, Venice. *Signed with initials, pencil, water and bodycolour, 6¾in. x 5¾in.* **(Chris Beetles)**

BRABAZON, Hercules Brabazon (1821-1906)
Crossing the Desert. *Signed with initials, pencil, water and bodycolour, 7in. x 9½in.*
On the reverse is a portrait head in sepia heightened with white. *(Martyn Gregory)*

BRADFORD, Rev. William (1780/1-1857)
Pass near Villa Franca. *Pen and black ink and watercolour, 7¾in. x 11⅝in.*
This is the original for one of the aquatints in Bradford's *Sketches of the Country, Character, and Costume of Portugal and Spain*, c.1813. *(National Army Museum)*

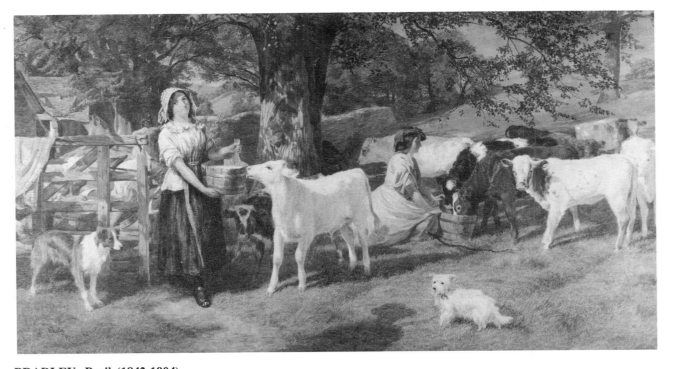

BRADLEY, Basil (1842-1904)
Milking. *Signed, pen and watercolour heightened with white, 24in. x 44in.*
This is a most accomplished production, although the use of outline, as on the figure to the right, is a little surprising.
(Christie's)

BRANDARD, Robert (1805-1862)
A Duckpond by a Farm. *Signed, watercolour, 11in. x 16in.*
(Moss Galleries)

(Right) BRANDARD, Robert (1805-1862)
Selling Fish and Oysters in Drury Lane. *Signed and dated*
1830, pencil and watercolour heightened with white, 12¼in.
x 8⅞in. *(Christie's)*

BREE, Rev. William Thomas (1754-1822)
Maxstoke Priory, Warwickshire.
Watercolour heightened with gum arabic, 10in. x 14in.
(Sotheby's)

115

BREE, Rev. William Thomas (1754-1822)
Maxstoke Priory. *Watercolour heightened with gum arabic,
10in. x 14in.* Another from the same album. *(Sotheby's)*

BREWER, Henry Charles (1866-1943)
Durham. *Signed and inscribed, watercolour, 19in. x 25in.*
(Christie's South Kensington)

BRIGHT, Henry (1810-1873)
Hever Castle. *Water and bodycolour, 12½in. x 18¾in.*

(Martyn Gregory)

BROCAS, William (c.1794-1868)
The Liffey near Dublin. *Signed and inscribed on the mount, watercolour heightened with touches of white, 11½in. x 19½in.*
(Christie's)

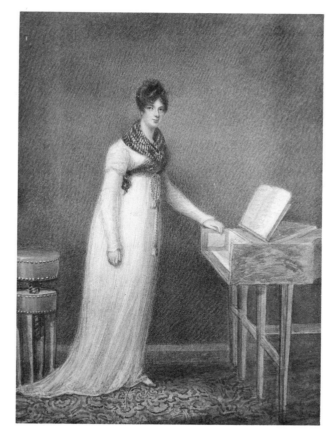

BUCK, Adam (1759-1833)
Mrs. Forster of Dublin. *Inscribed, watercolour, 8in. x 5in.* Presumably, from the dress, this dates from just before Buck's move to London in 1795. The drawing of the hands and furniture is a little tentative, and there are pentimenti around the head. In London his execution became more assured.
(Simon Carter)

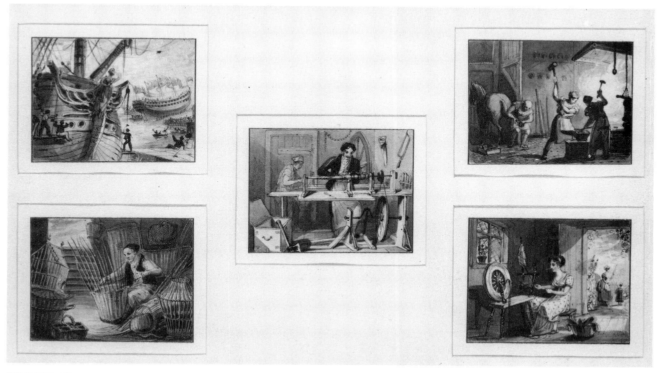

BROOK, William Henry (1772-1860)
Crafts: Shipbuilding; Blacksmithing; Turning; Basket-making; Spinning. *Pencil, pen and brown ink and watercolour, each 2¼in. x 2¾in.*
(Anthony Reed)

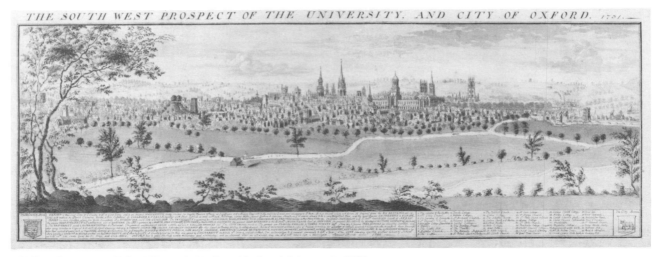

BUCK, Samuel (1696-1779) and BUCK, Nathaniel (-? 1753)
South West Prospect of the University and City of Oxford. *Signed, extensively inscribed and dated 1731, black ink and grey wash, 11¾in. x 30¾in.*
Although only Samuel has signed this drawing, the two brothers were collaborating in much of their production at this time.
(Christie's)

BUCKLER, John Chessell (1793-1894)
St. Katherine's Priory, Gloucester. *Signed and dated 1819, inscribed on the reverse, watercolour, 6in. x 8½in.*
(Martyn Gregory)

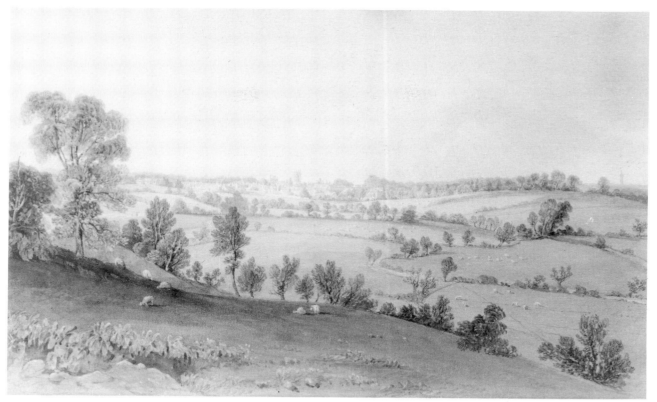

BUCKLER, John Chessell (1793-1894)
North-East view of Woodstock with the roofs of Blenheim. *Signed, inscribed and dated 1821 below the mount, pencil and watercolour, 9⅜in. x 15⅛in.*
This is an unusually ambitious work for Buckler, who generally preferred to take portraits of single buildings in close-up. In some ways it is reminiscent of the topographical work of the young Turner twenty years before. *(Michael Bryan)*

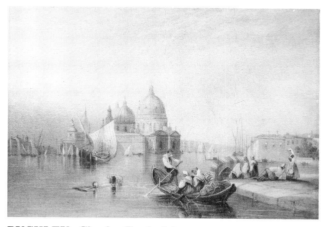

BUCKLEY, Charles Frederick
Santa Maria della Salute and the Dogagna, Venice. *Signed, pencil and watercolour heightened with white and with stopping out, 7¼in. x 10⅛in.* *(Christie's)*

BUCKLEY, John Edmund
Old Rivals. *Signed and dated 1865, water and bodycolour, 17in. x 26½in.*
A most ambitious composition for J.E., whose Christian names, together with those of his relative C.F., are here put on permanent record for the first time. *(Christie's)*

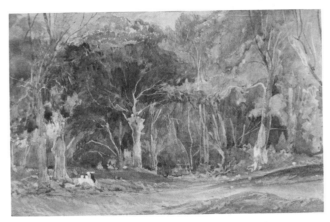

BULWER, Rev. James (1794-1879)
Leigh Woods, near Bristol. *Inscribed, watercolour with stopping out, 8in. x 12in.*
This seems to be an interesting link between the Norwich and Bristol schools — a pupil of Cotman at work in the spot favoured by Jackson, Muller and their friends.
(Simon Carter)

BUCKNER, Richard (1812-1883)
Portrait of Herbert Wilson. *Inscribed on the reverse, pencil and watercolour, 13½in. x 19¾in.*
Buckner had a smoothness of technique and talent, well evident here, which made him particularly successful. A full discussion of his life is found in *Antique Collector*, April, 1989.
(Martyn Gregory)

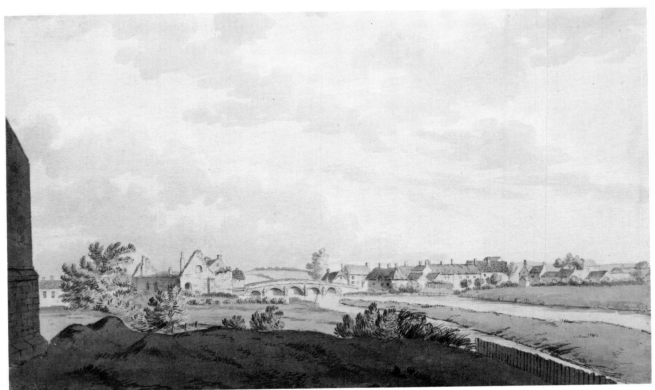

BULMAN, Job (1745-1818)
Ruins by a Bridge. *Bears fake signature 'N. Pocock', pen and ink and watercolour, approx. 9in. x 12in.*
Bulman was a Northumbrian banker, and he travelled widely in Britain.
(Martyn Gregory)

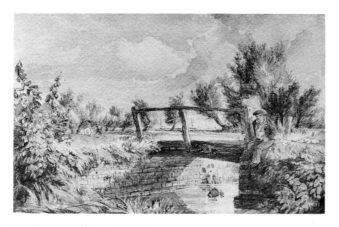

BURGESS, Henry William
Fishing. *Watercolour, 4in. x 6in.*
A rather Coxic production by the son of W., and the father of
J.B., Burgess. *(Simon Carter)*

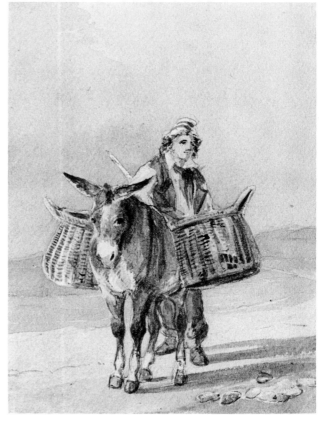

BURGESS, Henry William
A young Fisherman with his Donkey. *Pencil and water-
colour, 5in. x 3in.*
In this sketch he is rather more au Collins. *(Simon Carter)*

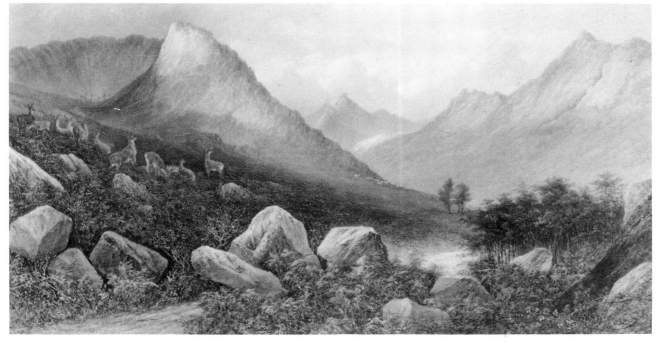

BURGESS, James Howard (1817-1890)
On the Isle of Arran. *Signed, water and bodycolour, 14½in. x 26¾in.* *(Sotheby's)*

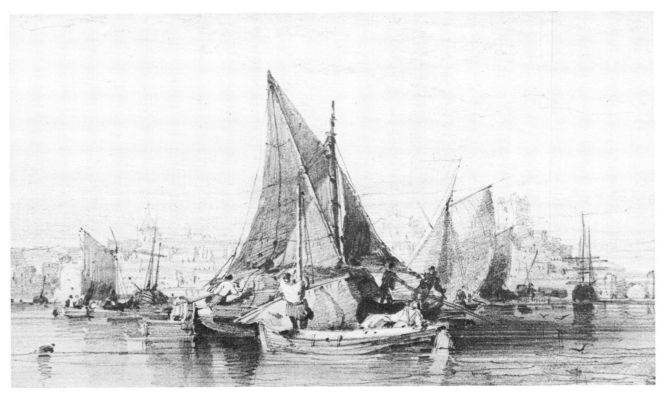

BURGESS, John, Yr. (1814-1874)
Rochester. *Pencil, 2½in. x 4½in.*
John Burgess is really at his strongest with pencil, rather than colour, thus the inclusion of this example. *(Simon Carter)*

BURGESS, William, of Dover (1805-1861)
A Brewer's Dray. *Watercolour, 11⅜in. x 16⅞in.*
Burgess of Dover, friend of T.S. Cooper, is not to be confused with his namesake, patriarch of the painting Burgess clan, to which he does not appear to have been related. *(Leger Galleries)*

BURTON, Sir Frederick William (1816-1900)
The Aran Fisherman's Drowned Child. *Signed and dated 1841, watercolour, 34¾in. x 30⅞in.*
(National Gallery of Ireland)

122

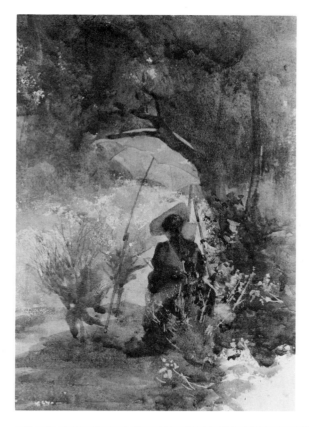

BUTLER, Mildred Anne (1858-1941)
A Lady painting. *Watercolour, 10½in. x 7in.* (Christie's)

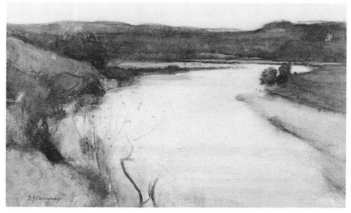

CAMERON, Sir David Young (1865-1945)
A Scottish River at Evening. *Signed, pen and black ink and watercolour, 10in. x 16in.* (Simon Carter)

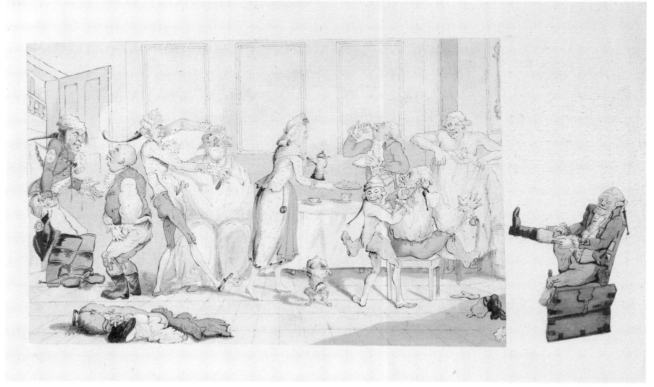

BYRON, Frederick George (1764-1792)
Breakfast at Breteuil. *Pen and grey ink and watercolour, 12½in. x 18½in., mounted with a cut-out figure.*

(Christie's)

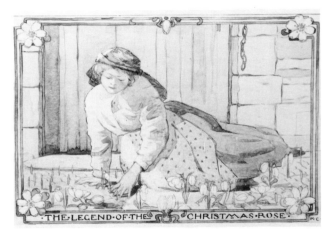

CAMERON, Katharine (1874-1965)
The legend of the Christmas Rose. *Signed with initials and inscribed, watercolour, 7¾in. x 11in.*
Kate Cameron's full name was spelled with a middle 'a', rather than the 'e' which she is universally given. This drawing was reproduced in A. Steedman: *Legends and Stories of Italy,* 1909. *(Moss Galleries)*

CAMPBELL, John Henry (1757-1828)
A Bridge in a Wood. *Blue and grey washes, 5in. x 8in.*
Campbell is here doing something of a Bourne.
(Simon Carter)

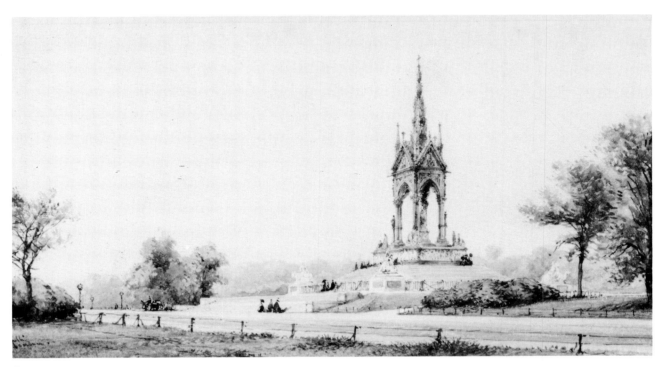

CARELLI, Gabriel (1821-1900)
The Albert Memorial. *Signed and inscribed, watercolour, 9in. x 16¾in.*
This is one of the drawings from the albums made up by Queen Victoria. *(Sotheby's)*

CARLISLE, George Howard, 9th Earl of (1843-1911)
The River Mouth, Tangier. *Numbered 9 and inscribed on the reverse, watercolour heightened with white, 10½in. x 14½in.*
(Sotheby's)

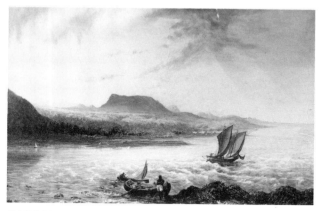

CARLISLE, John Percy
Coastal Natives. *Signed and dated 1870, pencil, water and bodycolour, 17½in. x 26½in.*
(Sotheby's)

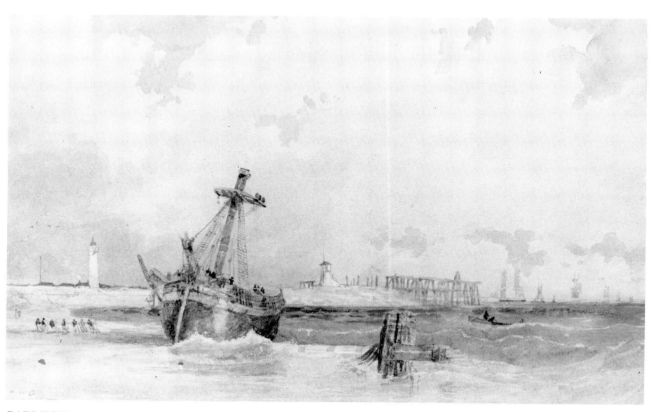

CARMICHAEL, John Wilson (1799-1868)
Sunderland Old Pier. *Signed with initials, pencil and watercolour, 8in. x 12¾in.*

(Martyn Gregory)

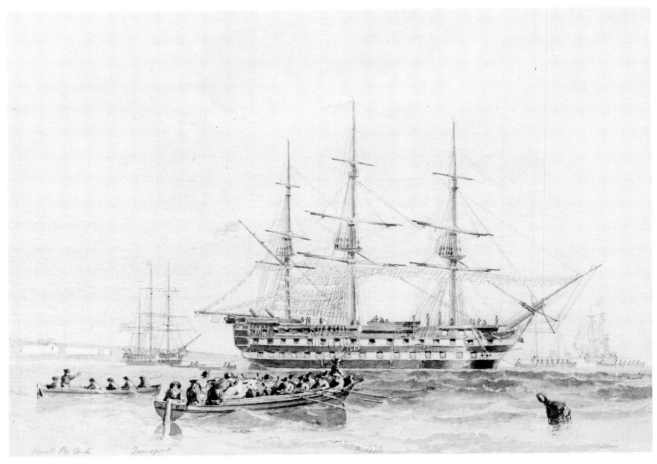

CARMICHAEL, John Wilson (1799-1868)
The Hospital Ship *Belisle* receiving cattle in Faro Sound. *Extensively inscribed on the reverse and dated June 5, 1855, pencil and watercolour, 10in. x 14in.*
This is one of Carmichael's drawings as a war artist for the *I.L.N.*, but it was not used. He was covering the naval campaign in the Baltic, which was a diversion to the Crimea, and thus 'Faro' is the Faroes rather than in Portugal. *(Martyn Gregory)*

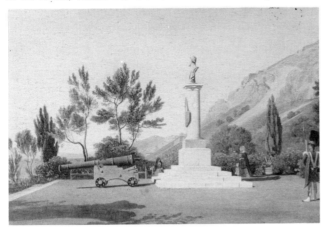

CARTER, Lt. Col. John Money (1811/12-1888)
The Heathfield Memorial, Gibraltar. *Watercolour, 12in. x 16in.*
In the 1830s Carter served, and drew, in Barbados. There are probably prints after his views there, just as there are 13 hand coloured lithographs of *Select Views of the Rock and Fortress of Gibraltar*, 1846. *(Bearne's)*

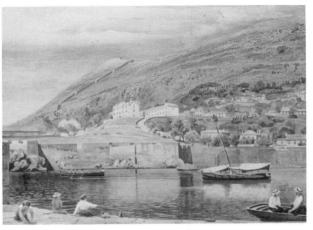

CARTER, Lt. Col. John Money (1811/12-1888)
Rosia Bay, Gibraltar, and the South Barracks. *Watercolour, 11¾in. x 15¼in.* *(Bearne's)*

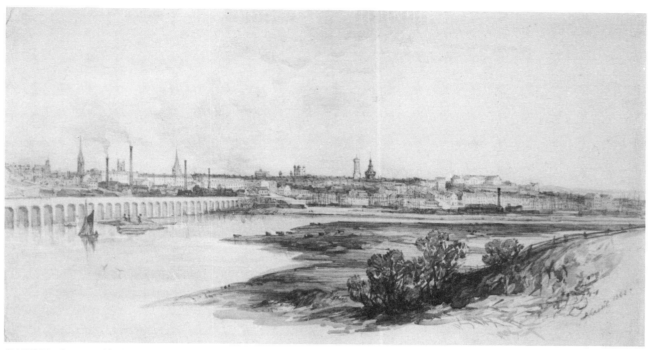

CASSIE, James (1819-1879)
Dundee. *Signed and dated 1862, watercolour, 5in. x 9in.*

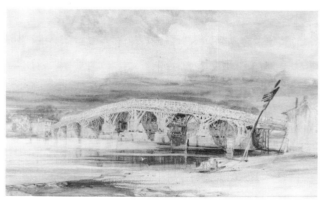

CATTERMOLE, George (1800-1868) (See also under NESFIELD, William Andrews)
Putney Bridge. *Signed with initials, pencil and watercolour, 11in. x 18¼in.*
An example of just how swaggering a landscape painter Cattermole could be. The old Putney Bridge (which can easily be confused with old Battersea Bridge) stood from 1729 to 1884. *(Sotheby's)*

CATTERMOLE, George (1800-1868)
A Blasted Heath. *Signed with initials, watercolour, 4in. x 6in.*
Here there is a suggestion of a combination between Cattermole's loves of landscape and costume. No doubt the subject is King Lear, or perhaps 'The Covenanter's Hideout'. *(Simon Carter)*

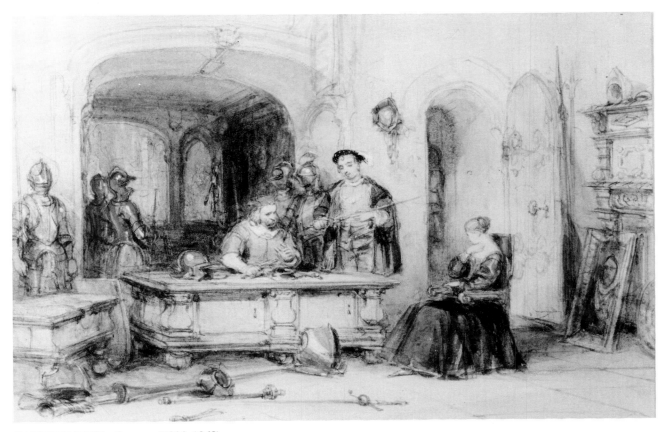

CATTERMOLE, George (1800-1868)
The Armoury at Haddon Hall. *Inscribed on label, pencil and watercolour heightened with white, 5¾in. x 8¾in.*
This shows how dashing Cattermole could be even in his costume work. Usually he leaves the charm to his nephew Charles.
(Sotheby's)

CHALON, Alfred Edward (1780-1860)
A Country House. *Signed and dated 1831, watercolour with scratching out, 6in. x 8in.* *(Simon Carter)*

CHAMBERS, George (1803-1840)
Tilbury. *Signed, inscribed and dated 1838, pencil and watercolour, 6½in. x 11¾in.* *(Martyn Gregory)*

128

CHESHAM, Francis (1749-1806)
The Battle of the Nile. *Watercolour, 10in. x 16in.*
This watercolour was the original for one of a series of
engravings. *(Simon Carter)*

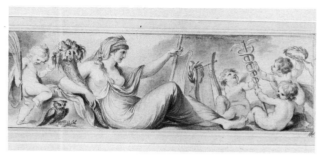

CIPRIANI, Giovanni Baptista (1727-1775)
Design for an Overdoor. *Pen and ink and watercolour, 4in.
x 12¼in.*
The initials at the bottom right of this drawing are those of
the notable collector Wiliam Esdaile. *(Anthony Reed)*

CHURCHYARD, Thomas (1798-1865)
Fishing Boats at Southwold, 1849. *Pencil and watercolour, 4¼in. x 7¼in.* *(Martyn Gregory)*

CLENNELL, Luke (1781-1840)
Fishermen making Baskets on the Isle of Wight. *Inscribed on the reverse, watercolour, 11¾in. x 17¼in.* (Martyn Gregory)

CLEVELEY, Robert (1747-1809)
Under Kew Bridge. *Inscribed on the old mount, pen and ink and watercolour, 4¾in. x 7¾in.* (Sotheby's)

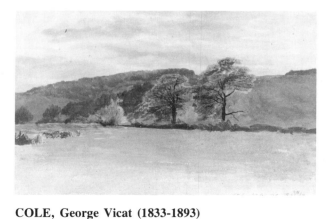

COLE, George Vicat (1833-1893)
Stoke, near Arundel. *Signed with monogram and dated 1869, watercolour, 11¼in. x 18in.*
This informal sketch has an early example of the use of the 'VC' monogram, which became his usual way of signing from the next year. (Martyn Gregory)

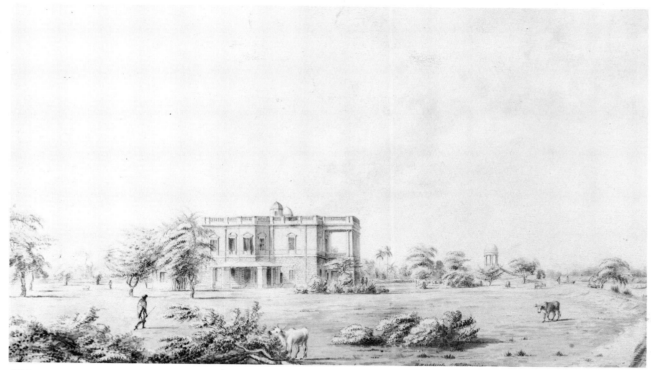

COLEBROOKE, Lt. Col. Robert Hyde (1762-1808)
The Governor General's Garden House on the Ganges. *Signed and dated 1794, and inscribed on the reverse, pencil, grey ink and watercolour, 13in. x 22¼in.*
A comparison of this watercolour with the house in Madras by Justinian Gantz which is illustrated in Volume II, would indicate that Colebrooke was a pupil either of Justinian or of his father John. Certainly he was influenced by prints after their drawings.
(Christie's)

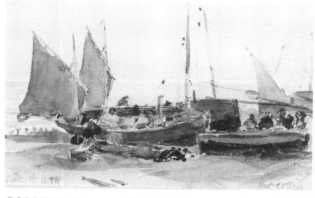

COLLIER, Thomas (1840-1891)
Beached Fishing Boats. *Signed and dated Oct. 21st 1879, pencil and watercolour, 3¾in. x 6¼in.*
The splashy freedom of Collier's style is as well suited to the beach as to the moors. By chance it and the following examples are really rather like the Churchyard of Southwold illustrated on page 129. *(Martyn Gregory)*

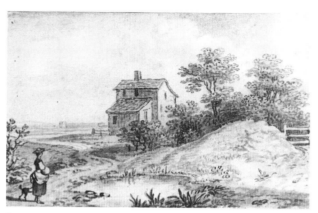

COLLET, John (c.1725-1780)
An Italianate Landscape. *Pencil, reed pen and black ink and grey wash, 3½in. x 5½in.*
Collet is better known as a caricaturist and a natural history draughtsman. His pure landscape work shares rather clumsy characteristics with his other drawings. *(Christie's)*

COLLIER, Thomas (1840-1891)
Southwold. *Signed, pencil and watercolour, 9¼in. x 14in.*
Another most pleasingly untypical subject.　　(*Sotheby's*)

COLLINS, William (1788-1847)
A Boy with a Boat-hook. *Pencil and watercolour on light fawn paper, 10¼in. x 9⅛in.*
This is a study for the oil painting *Prawn catchers* which is now in the Tate Gallery.　　(*Anthony Reed*)

COLLING, James Kellaway
Waterloo Bridge and the Shot Towers. *Signed with monogram and dated 1889, pencil and watercolour heightened with white, 11⅝in. x 20¾in.*
This watercolour, as well as being of topographical interest, extends Colling's known working life by six years. He had been active from at the latest 1844.　　(*Christie's*)

CONDY, Nicholas Matthews (1818-1851)
Shipping. *Watercolour with rubbing out, 3½in. x 5in.*
I am never certain that the boundary between Condy and his
father Nicholas has been correctly mapped. An oddity in this
example is that the dinghy in the foreground appears to be
moving without any means of propulsion. This might well
indicate a juvenile effort by the son. *(Simon Carter)*

CONSTABLE, Lionel Bicknell (1828-1887)
Poplars at Dedham. *Pencil and watercolour with gum arabic
and scratching, 4¾in. x 6½in.*
Daddy's boy indeed. *(Sotheby's)*

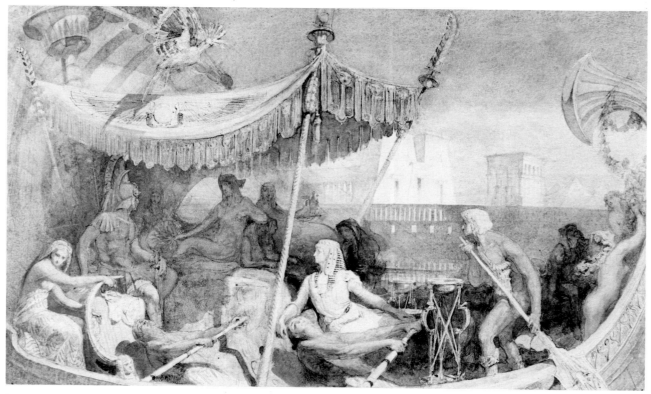

CONRADE, Alfred Charles (1863-1955)
Cleopatra. *Signed, pen and ink and watercolour, 11in. x 18in.*
(Moss Galleries)

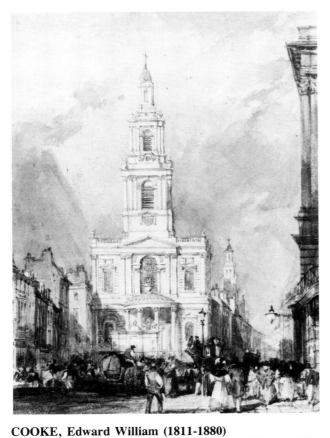

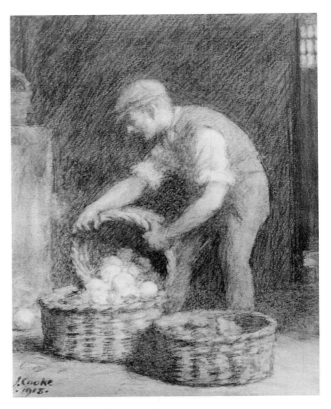

COOKE, Edward William (1811-1880)
St. Mary-le-Strand. *Water and bodycolour, 6¼in. x 4⅝in.*
Cooke's father was *the* engraver of his time, and thus the
young Edward met and studied all *the* leading water-
colourists. Boys was a frequent visitor to their home, and
this watercolour surely shows the influence of the Anglo-
French Boningtonian school at second remove through him.
(Spink & Son)

COOKE, Isaac (1846-1922)
A Fruit Porter. *Signed and dated 1918, black chalk and
watercolour, 10in. x 6in.* *(Simon Carter)*

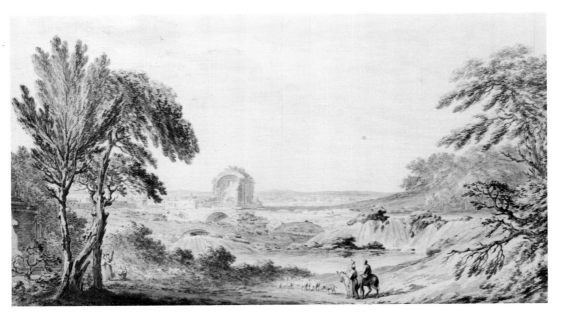

**COOPER,
Richard, Yr.
(1740-1814)**
Near Tivoli.
*Signed,
watercolour,
13⅞in. x
24¾in. (Agnew)*

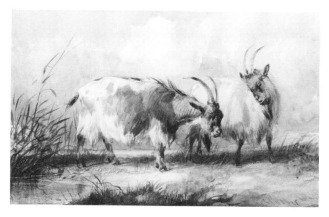

COOPER, Thomas Sidney (1803-1902)
Goats. *Signed, pencil and watercolour with scratching out, 6¼in. x 9½in.*
What a relief to see this admirable artist briefly free of his obsession with cows — even if the setting is much as usual. From the style this was painted under the influence of the Fieldings and the Anglo-French school, and so around 1830.
(Anthony Reed)

COTMAN, John Sell (1782-1842)
The Crystal Pool. *Inscribed by W. Munn, pencil and grey wash, 8¾in. x 12¾in.*
This is a Sketching Club subject from Cunningham's *Poems*, on the reverse it is inscribed: 'J.S. Cotman pinxit — T.R. Underwood. P.S. Munn. W. Alexander. J. Varley. — Visitor W. Munn/May 5th 1802.' This Munn was presumably the print-selling brother of P.S.
(Sotheby's)

CORNISH, Hubert (1778-1832)
Mr. Birch's Garden House at Barraset. *Inscribed on the reverse, pencil and watercolour, 15⅝in. x 21⅛in.*
It is probable that Cornish, like R.H. Colebrooke (q.v.) and many other pre-Chinnery amateur Indian draughtsmen, was influenced by the Gantzes, father and son.
(Christie's)

COTMAN, John Sell (1782-1842)
A Ruined Aqueduct. *Pencil and watercolour, 9¼in. x 14¼in.*
This was a favourite theme of Cotman's, and this example is dateable to the mid-1830s. However, this aquaduct is a capriccio rather than a reminiscence of Chirk from his early days, or of Jumièges in 1831. *(Martyn Gregory)*

COX, David (1783-1859)
Can Office, North Wales. *Inscribed on the reverse, monochrome washes, 6½in. x 9in.*
Despite the inscription this bears little resemblance to Cann Office in Wales. Possibly the inscription referred to the next drawing in the sketchbook, or else this one, which is similar to the drawings he made as teaching exercises, was merely suggested by a remembered scene. *(Martyn Gregory)*

COUTTS, Hubert (-1921)
The Paps of Jura. *Signed, watercolour with scratching out, 11½in. x 17¾in.* *(Private Collection)*

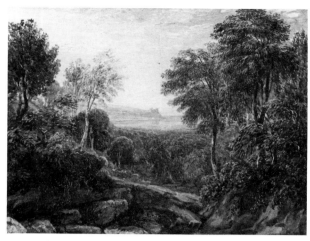

COX, David (1783-1859)
A Bridge. *Pencil and watercolour, 8⅞in. x 13⅜in.*
Bridges of this type were a great favourite with Cox. This one
dates from the early 1830s and is similar to one in the Victoria
and Albert Museum dated 1831. *(Martyn Gregory)*

COX, David (1783-1859)
A distant view of Harlech. *Inscribed and perhaps signed on
the reverse, watercolour, 8in. x 10½in.* *(Martyn Gregory)*

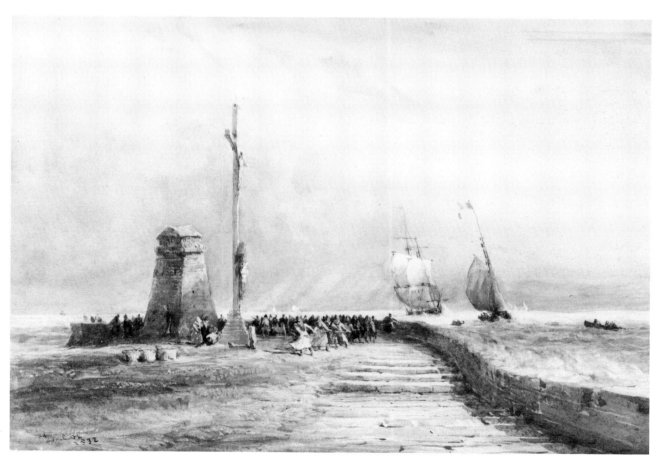

COX, David (1783-1859)
Warping in to Calais Pier. *Signed and dated 1832, watercolour with scratching out, 7¼in. x 10¼in.*
This was the year of Cox's third and final Continental trip. The drawings which derive from these visits (the others were
in 1826 and 1829) are distinctive, and at that period he often uses a splash of bright green as a highlight. *(Spink & Son)*

137

COX, David (1783-1859)
Yews in the Churchyard at Betws-y-coed. *Black chalk and watercolour, size unknown.* (*Albany Gallery*)

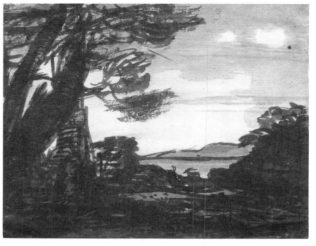

COZENS, Alexander (1717-1786)
Goats and Trees. *Ink and wash, 6½in. x 8¼in.* (*Agnew*)

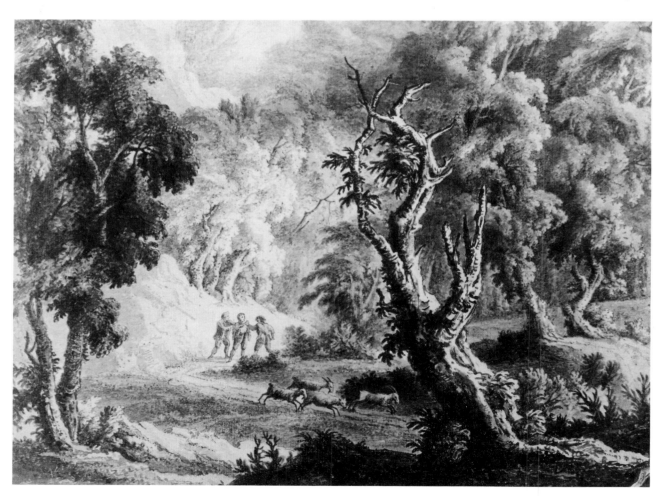

COZENS, Alexander (1717-1786)
Footpads in a Forest. *Ink and washes, 11½in. x 15½in.* (*Agnew*)

138

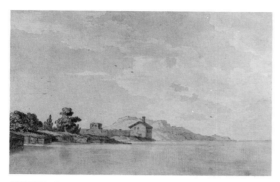

COZENS, Alexander (1717-1786)
On the Coast of Italy. *Pen and grey ink, grey wash,
3¾in. x 6in.* *(Private Collection)*

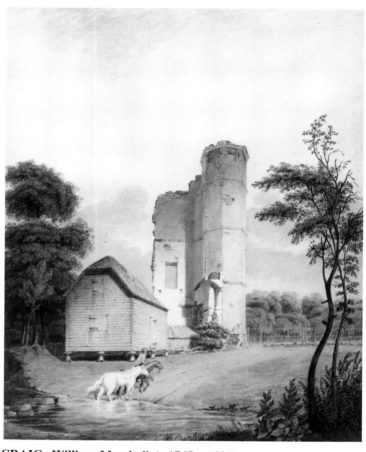

CRAIG, William Marshall (c.1765-c.1834)
A Ruined Castle. *Pencil and watercolour, 16¾in. x 13in.* *(Sotheby's)*

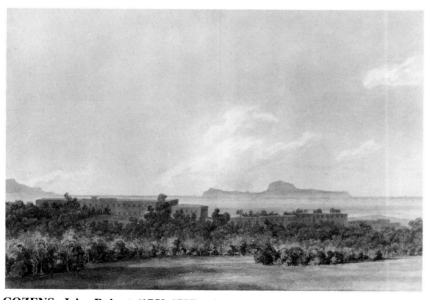

COZENS, John Robert (1752-1797)
Miseno, the Palace and Capri from Sir William Hamilton's Villa. *Inscribed,
watercolour, 10⅜in. x 14¾in.* *(Leger Galleries)*

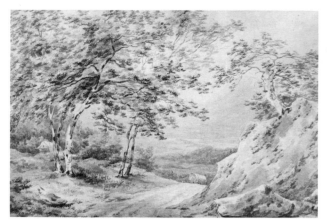

(Above) CREASY, John L.
A Mountainous Landscape. *Signed and dated 1797, pencil and watercolour, 6in. x 10in.*
This is the earliest work by Creasy that I have seen so far, and the only one that is not of ships or bridges on the Thames. *(Simon Carter)*

(Right) CRISTALL, Joshua (1767-1847)
Ladies of Fashion or Fantasy. *Signed, pencil, pen and brown ink and watercolour, 6⅜in. x 9⅛in.*
Presumably this owes its inspiration to the period which Cristall spent at the R.A. Schools in the early 1790s. Fuseli had been made Professor of Painting in 1790. *(Anthony Reed)*

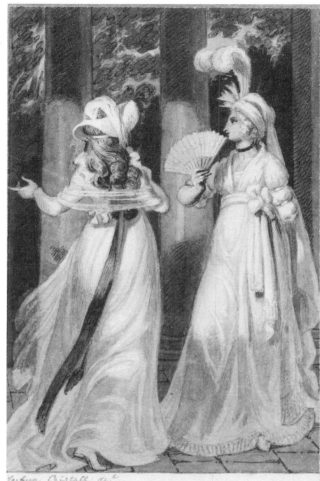

CRISTALL, Joshua (1767-1847)
Aber llan.
Signed, inscribed and dated 1802, pen and brown ink and watercolour on paper watermarked 1799, 7½in. x 12¼in.
Cristall ended a stay of some ten days at the Inn of Capel Curig, with Cotman and Munn, on July 31, 1802, and he returned there the following year.
(Andrew Wyld)

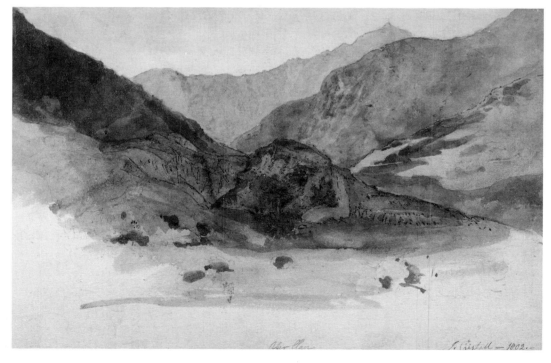

140

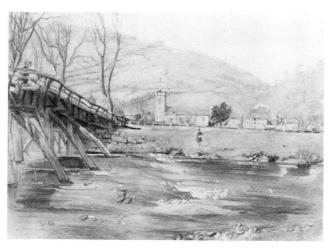

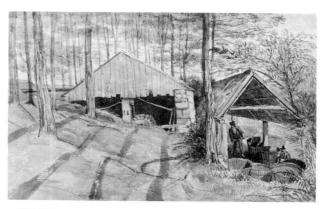

CUMBERLAND, George (1754-1848)
The Entrance to Mr. Praed's Tin Mine at Trevethow. *Watercolour, 5¼in. x 9in.* *(William Drummond)*

CROWE, Eyre (1824-1910)
Meifod, Montgomeryshire. *Signed with initials and dated April 26th 1849, pencil and coloured washes heightened with white on Whatman Turkey Mill paper dated 1847, 8in. x 9¾in.*
Crowe is best known for history and figure painting, but his landscape work is also attractive, and free from whimsy.
(Martyn Gregory)

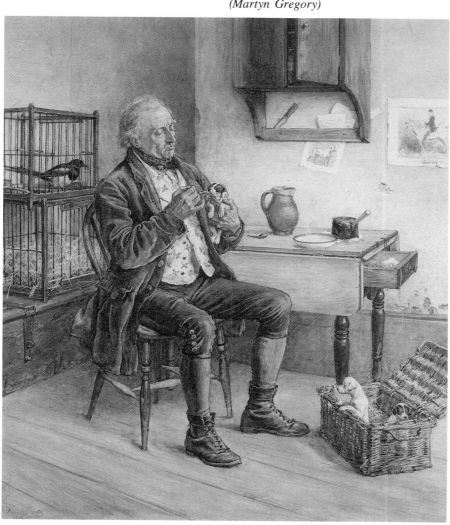

DADD, Frank (1851-1929)
Hand Rearing. *Signed and dated 1888, watercolour, 19in. x 15in.*
How unlike, how very unlike, the home life of dear Uncle Richard!
(Chris Beetles)

141

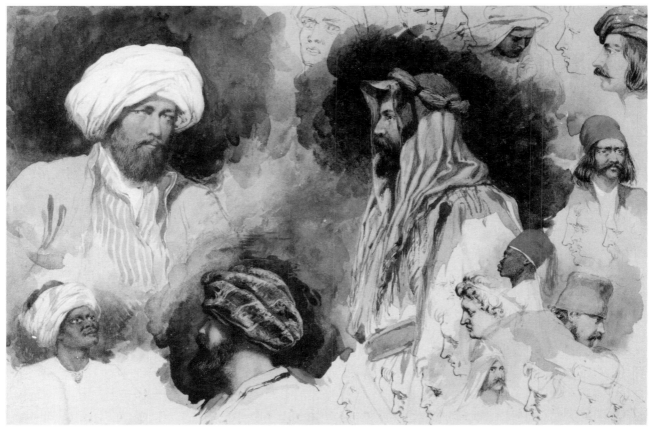

DADD, Richard (1817-1886)
Studies of Eastern Heads. *Pen and brown ink and watercolour heightened with gum arabic, 7in. x 10in. (Winchester College)*

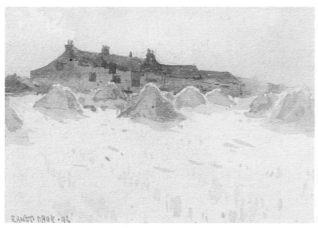

DADE, Ernest (1868-c.1935)
Cottages and Haystacks. *Signed and dated 92, pencil and watercolour, 6in. x 9in.*
The 'Ernst' signature is quite common — although not, one might suspect, after 1914. *(Simon Carter)*

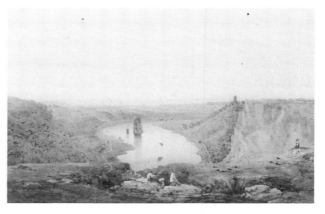

DANBY, Francis (1793-1861)
The Avon Gorge, looking towards the Severn and Cook's Folly. *Signed, pencil and watercolour, 10½in. x 16¾in.*
(Christie's)

DANIELL, Rev. Edward Thomas (1804-1842)
Djebel Serbal. *Inscribed and dated June 19 1841, pen and ink and watercolour, 13⅛in. x 19⅜in.*
The Wilderness of Sinai brought out the best in the amateur Daniell, whose work has been described as 'the perfection of free sketching'. He was also sketching the inner courtyard at the Convent of St. Catherine from June 19 to 21, taking much the same view as had his hero, Roberts, three years earlier.
(Anthony Reed)

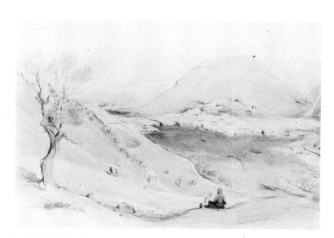

DAVIES, Edward (1843-1912)
Haymakers. *Signed, watercolour, 7in. x 11in.*
(Simon Carter)

DANIELL, Rev. Edward Thomas (1804-1842)
Nablus. *Inscribed, pencil, pen and ink and watercolour, 13⅛in. x 19⅜in.*
Daniell continued through the Holy Land to join the Lycian expedition, on which he died. *(Anthony Reed)*

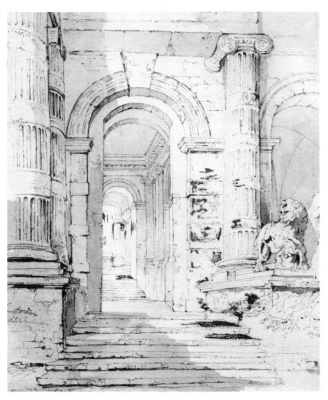

DAVIS, John Scarlett (1804-1844)
The Entrance Steps at the Tuileries. *Signed, inscribed and dated 1831, pencil, pen and brown ink and brown wash on buff paper, 8⅜in. x 6¾in.*
This is rather how one would expect the Tuileries to have looked after 1871, but then there had also been a short sharp revolution in 1830. *(Spink & Son)*

DAVIS, John Scarlett (1804-1844)
The Pavillon de Flore. *Pen and ink and watercolour, 8in. x 6¼in.*
A very nice free sketch. *(Agnew)*

DAYES, Edward (1763-1804)
Lympne Castle, Kent. *Signed and dated 1791 on the mount and inscribed on the reverse, pencil and watercolour, 5½in. x 8½in.*
However unpleasant a man Dayes may have been, he remains a very pleasing artist. It is particularly pleasant to come across work which is definitely his, rather than by one of the ungrateful pupils or disciples — Girtin and Turner.
(Spink & Son)

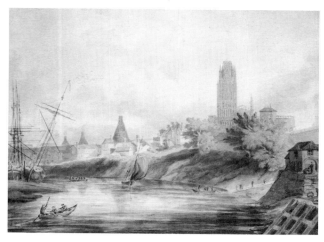

(Above) DELAMOTTE, William Alfred (1775-1863)
Bristol. *Signed and dated 1800, watercolour, approx. 14in. x 20in.* *(Anthony Reed)*

(Left) DE CORT, Henry Francis (1742-1810)
Stourhead. *Signed and inscribed on the reverse, pencil and brown washes, 27in. x 19¼in.*
This was drawn in 1793. *(Sotheby's)*

DE LOUTHERBOURG, Philip James (1740-1812)
Bolney, Sussex. *Signed, pen and ink and watercolour, 10⅜in. x 16⅞in.* *(Leger Galleries)*

145

DETMOLD, Edward Julius (1883-1957)
Gurnard and Pike. *Watercolour, 12in. x 20½in.*

(Peter Haworth)

DEVIS, Anthony (1729-1817)
Country Folk beneath a Tree. *Pencil, pen and black ink and wash, size unknown.* *(Martyn Gregory)*

DEVOTO, John
Design for a Façade with the Royal Coat of Arms. *Pen and brown ink, grey, brown and blue washes, 6in. x 8¼in.*
The Hanoverian Royal Arms would indicate that this is a project for a Theatre Royal. It is not as brightly coloured as many of Devoto's stage and architectural designs.

(Sotheby's)

DE WINT, Peter (1784-1849)
Lincoln Castle from the Cathedral. *Pencil and watercolour, 12¾in. x 19¼in.*
It is satisfying, from time to time, to come across a water-colour which bends the rules. De Wint made many views of Lincoln Cathedral, but few from it; he made many water-colours on a formal set pattern of construction — the St. Andrew's Cross, or whatever. Here he is looking out from the Cathedral tower or roof, and the composition is a cone whose nose has slipped badly to the left. *(Spink & Son)*

DE WINT, Peter (1784-1849)
Still Life. *Pencil and watercolour, 14in. x 11½in.*
De Wint often uses his still lifes in miniature in his hay-making scenes. *(Sotheby's)*

DE WINT, Peter (1784-1849)
Haymaking near Cookham. *Inscribed on the reverse, pencil and watercolour, 9½in. x 18⅛in.*
I include this because it is a lovely De Wint — with what Jeremy Howard has called 'that singing indigo so characteristic of De Wint, but so rarely found because often the first to fade'. It is also a fine memorial to the elms, once so characteristic of the Thames Valley.
(Agnew)

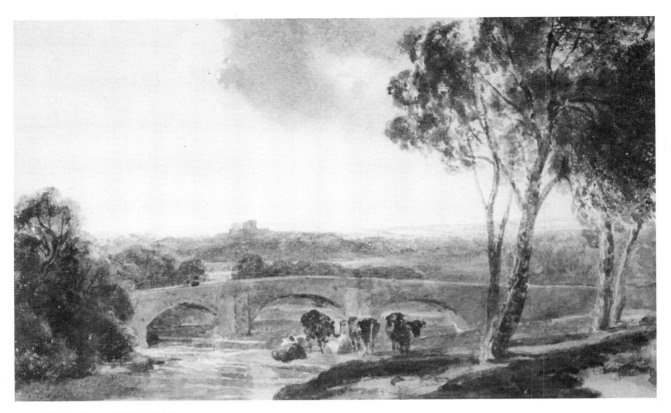

DE WINT, Peter (1784-1849)
A Distant View of Ripon. *Watercolour, 8in. x 11¾in.*
A more standard work, but nonetheless good, and one showing that Cox was not alone in the painting of wind.
(Lawrence of Crewkerne)

DIGHTON, Richard (1795-1880)
A Shopkeeper. *Pencil and watercolour heightened with gum arabic, 9⅞in. x 6⅝in.*
Dighton is best, as here, in the earliest part of his long career.
(Andrew Wyld)

DIGHTON, Robert (1752-1814)
South View of the Church of St. Pancras, Middlesex. *Inscribed, and with the address of Carington Bowles, on the reverse, pen and black ink and watercolour, 10¼in. x 15½in.*
Even in his topographical and landscape watercolours, Dighton was more often than not working with prints in mind. Bowles' print shop features in what is probably Dighton's best known work — illustrated in Williams: *Early English Watercolours.* *(Sotheby's)*

DILLON, Frank (1823-1909)
Apsley House. *Signed, pencil and watercolour, 10in. x 15in.*
This was for Plate I in *Apsley House and Walmer Castle*,
1853, the memorial to the Duke of Wellington which
provided Dillon with one of his first important commissions.
His drawings actually replace one or two by Boys in this. See
also BOYS, T.S. on page 113. *(Sotheby's)*

DIGHTON, Robert (1752-1814)
Margaret Nicholson attempting to assassinate George III.
*Signed and indistinctly inscribed, pen and black ink and
watercolour, 10½in. x 14¼in.*
Dighton's rendering of background architecture — here the
Chapel Royal at St. James's — is always accurate.
(Sotheby's)

DIXON, Charles Edward (1872-1934)
The Liner she's a Lady. *Signed and dated 1920, watercolour, 27in. x 53in.* *(Sotheby's Sussex)*

DIXON, Robert (1780-1815)
Outside a Country Inn. *Pen and ink and monochrome wash, size unknown.* (Anthony Reed)

(Below) DODGSON, George Haydock (1811-1880)
A Lock Gate. *Signed and dated 1861, and inscribed on the reverse, watercolour, 8¼in. x 17¾in.*
I note that thanks to a happy gremlin this artist's middle name appears as 'Haycock' in the entry in Volume I of this *Dictionary*. This work was one of a group in a volume presented by members of the O.W.S. to their lawyer and great supporter Edwin Wilkins Field. He was a particular friend and sketching companion of Dodgson. (Sotheby's)

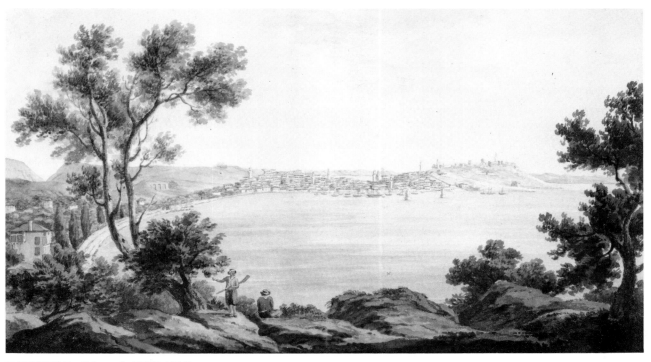

DODWELL, Edward (1767-1832)
Mitilini, on the Island of Lesbos. *Signed with initials, pedantically inscribed and dated 'Nov 1801', pencil and watercolour, 10in. x 17½in.* *(Sotheby's)*

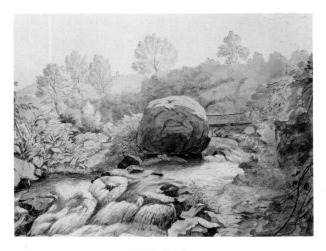

DOWNMAN, John (1750-1824)
A Rocky Stream in Italy. *Pen and black ink and watercolour, 14½in. x 19¼in.*
This dates from the Italian tour of the 1770s. *(Andrew Wyld)*

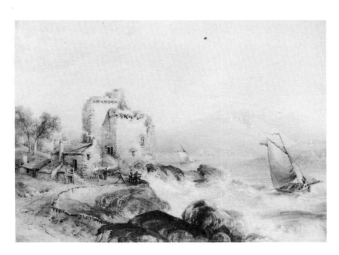

DONALDSON, Andrew (1790-1846)
Crawford Castle, Arran beyond. *Pencil and watercolour heightened with white, 15½in. x 20½in.* *(Sotheby's)*

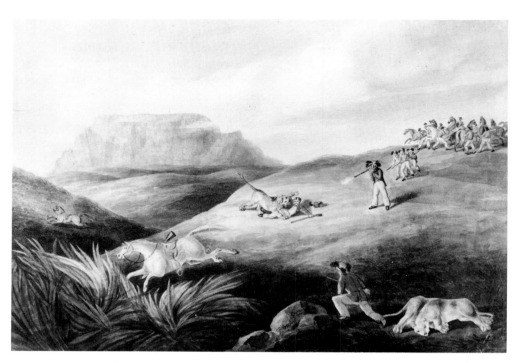

D'OYLY, Sir Charles, 7th Bt. (1781-1845)
Lion Shoot at the Cape. *Inscribed 'Cape Town' and dated 1st June 1832, watercolour, 11½in. x 16¾in.*

The spelling of the family name is as above, not with an intrusive 'e' as in Volume I. There are several more artists on the branches of this family tree, including Sir John Hadley D'Oyly, 8th Bt. (1794-1869), brother of Sir Charles, and Sir Hastings Hadley D'Oyly, 11th Bt. (1864-1948), sometime Assistant Commissioner in the Andaman and Nicobar Islands and Captain in the Behar Light Horse. *(Sotheby's)*

D'OYLY, Major-General Sir Charles Walters, 9th Bt. (1822-1900)
Government House, Calcutta. *Signed and dated 1855, water and bodycolour, 13¼in. x 19⅝in.*
The son of the 8th and uncle of the 10th Bt., Sir Charles served in the Gwalior campaign and in the Indian Mutiny. In retirement he was a J.P. for Dorset. *(Spink & Son)*

152

DUDLEY, Robert Charles (1826-1900)
Tell's Chapel, Lake Lucerne. *Signed and dated 1876, and signed and inscribed on a label, pencil and watercolour heightened with white and gum arabic, 13in. x 20in* (Sotheby's)

DUFF, John Robert Keitley (1862-1938)
Kandersteg. *Signed with monogrammatic signature, pencil and watercolour, 14in. x 18in. (Simon Carter)*

EDRIDGE, Henry (1769-1821)
Brighton Beach. *Watercolour, 6in. x 14in.* *(Charles Chrestien)*

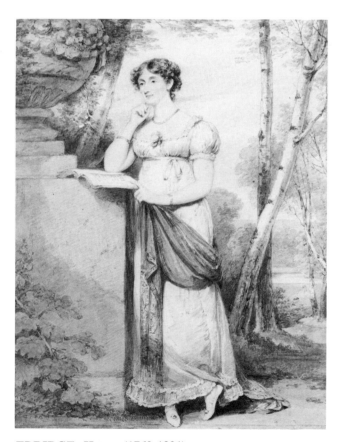

EDWARDS, Edward (1738-1806)
Durham. *Pencil, pen and brown ink, brown and grey washes, approx. 5in. x 7in.* *(Private Collection)*

EDRIDGE, Henry (1769-1821)
Portrait of Catherine Matilda Methuen of Corsham. *Pencil, pen and grey ink and watercolour, 13½in. x 10in.*
(Christie's)

EMES, John (-c.1809)
Iver Church, Middlesex. *Pencil and watercolour, with scratching out,*
8¼in. x 12½in. *(Sotheby's)*

ELGOOD, George Samuel (1851-1943)
Flags. *Signed and dated 1904, watercolour, approx.*
6in. x 6½in. *(Chris Beetles)*

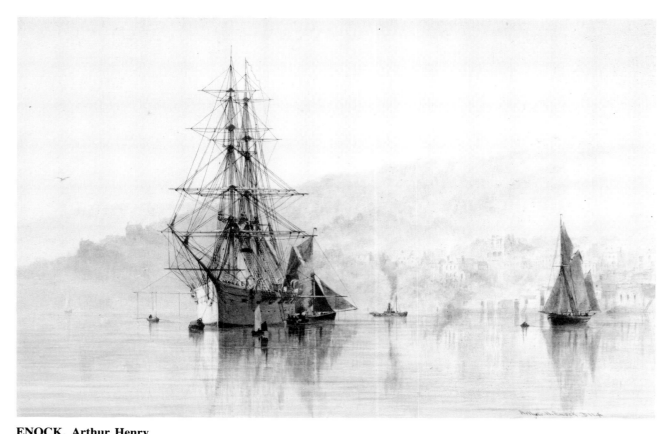

ENOCK, Arthur Henry
HMS *Enterprise* in Dartmouth Harbour, Misty Morning. *Signed, inscribed on attached sheet, watercolour, 15¾in. x 23½in.*
Here the 'Artist of the Misty Dart' has really outdone himself. *(Sotheby's)*

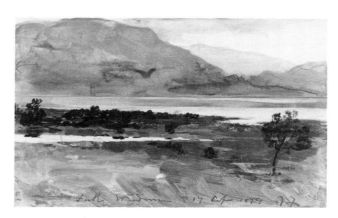

FAED, Thomas (1826-1900)
Lake Windermere. *Signed with initials, inscribed and dated 17 Sepr 1879, pencil, water and bodycolour, 4¾in. x 7in.*
(Spink & Son)

FANE, Maj. Gen. Walter (1825-1885)
Bell Tower, Yeddo. *Inscribed on the reverse, watercolour, 13½in. x 11½in.* *(Martyn Gregory)*

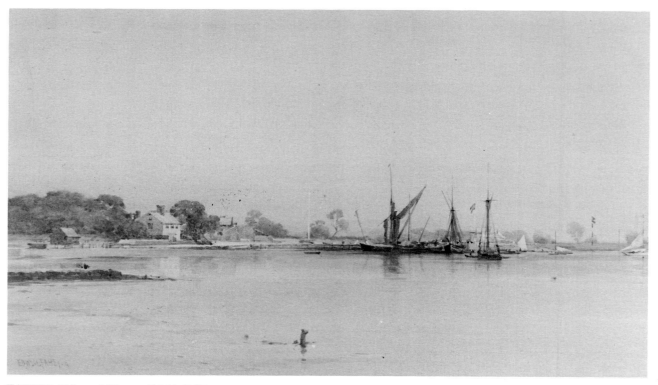

FAHEY, Edward Henry (1844-1907)
An East Anglian Port. *Signed and dated 79, watercolour, 12in. x 18in.* *(Simon Carter)*

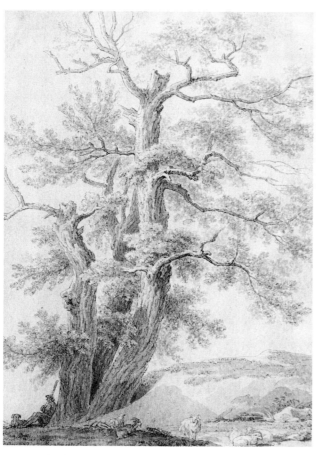

FARINGTON, Joseph (1747-1821)
A Shepherd beneath an Oak. *Pen and ink and grey wash,
7in. x 12in.* *(Simon Carter)*

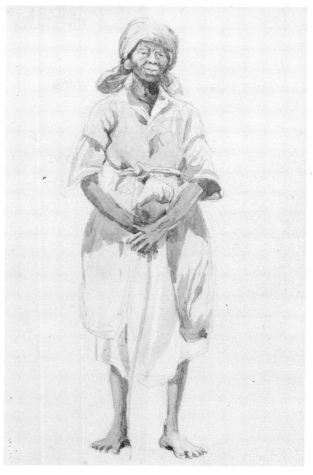

FAWKES, Col. Lionel Grimston (1849-1931)
Standing Negress. *Pencil and watercolour, 6¼in. x 4in.*
(Morton Morris)

**FAULKNER,
John
(c.1830-1887)**
Kenilworth.
*Signed and
inscribed, pencil
and watercolour,
26½in. x 46¼in.*
(Sotheby's)

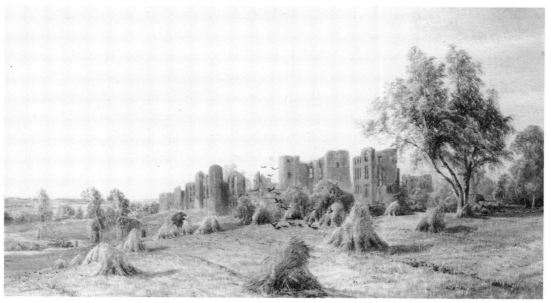

157

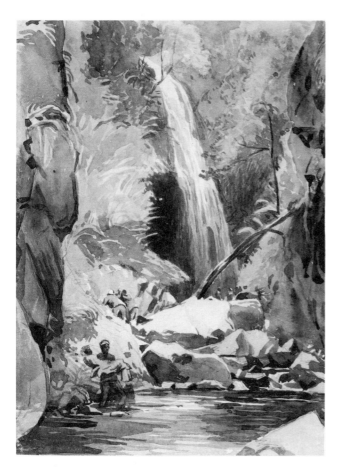

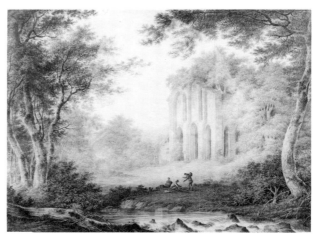

FERNYHOUGH, William
Holme Abbey, Cumberland. *Dated 1804, watercolour, 16½in. x 21½in.* *(Moss Galleries)*

FAWKES, Col. Lionel Grimston (1849-1931)
The Falls of Baleine, St. Vincent. *Pencil and watercolour, 8¾in. x 5¾in.*
One of the figures clambering up the stream is Major-General Gamble, Commander of the British forces in the West Indies, to whom Fawkes was A.D.C. from October 1878 until the end of 1883. *(Morton Morris)*

FIELDING, Theodore Henry Adolphus (1781-1851)
The Wreck of the *Carn Brae Castle* off the Needles. *Signed with initials and dated 1829, and inscribed on the reverse, pencil and watercolour with stopping out, 19¾in. x 28in.*
(Sotheby's)

158

FINCH, Francis Oliver (1802-1862)
Loch Lomond. *Watercolour heightened with white, size unknown.*

(Andrew Wyld)

FLINT, Sir William Russell (1880-1969)
A Breakfast Table, Amalfi. *Signed, and signed, inscribed, numbered 12 and dated May 1913 on the reverse, inscribed yet again on label, watercolour with touches of bodycolour, 13¾in. x 19⅞in.*
If there were any financial justice in the world this would be worth far, far more than Flint's three-quarter-face with several-bare-breasts-and-muscular-thighs formula, which becomes tedious even to the most heterosexual lover of watercolours. The man could have been an artist had he wished.

(Spink & Son)

FINN, Herbert John (1861-c.1935)
Durham. *Signed and dated 1924, watercolour, 26½in. x 35in.*

(Christie's South Kensington)

FORBES, Elizabeth Adela Stanhope (1859-1912)
Mother and Child. *Charcoal and watercolour, size unknown.*
(David Messum)

FORTESCUE, Henrietta Anne, the Hon. Mrs (c.1765-1841)
Geneva. *Signed, inscribed and dated Jul. 20 1818, pencil, pen and brown wash and watercolour, 13in. x 19½in.*
Mrs Fortescue supplied Francis Nicholson with drawings from her Continental tours. He both worked them up and made aquatints from them. *(Sotheby's)*

FORD, Frederick (perhaps the same as FORD, F.J.)
Deal. *Watercolour, 3½in. x 9in.*

(Simon Carter)

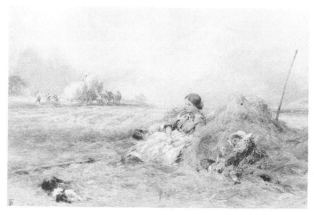

FOSTER, Myles Birket (1825-1899)
A Long Day's Evening. *Signed with monogram, water-colour, 7½in. x 10½in.* (Bearne's)

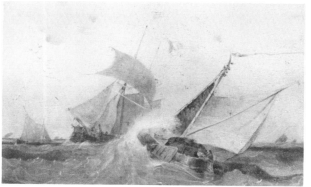

FRANCIA, Alexandre Thomas (c.1815-1884)
Dutch Shipping in a Breeze. *Signed, pen and brown and reddish ink and watercolour, 5⅞in. x 8¾in.*
(Anthony Reed)

FOX, Henry Charles (1860-p.1913)
Cottages near the Avon. *Signed and dated 1917, watercolour heightened with white, 14¼in. x 21¼in.*
If this untidy date is to be accepted, it extends Fox's known working life by four years. (Sotheby's Chester)

161

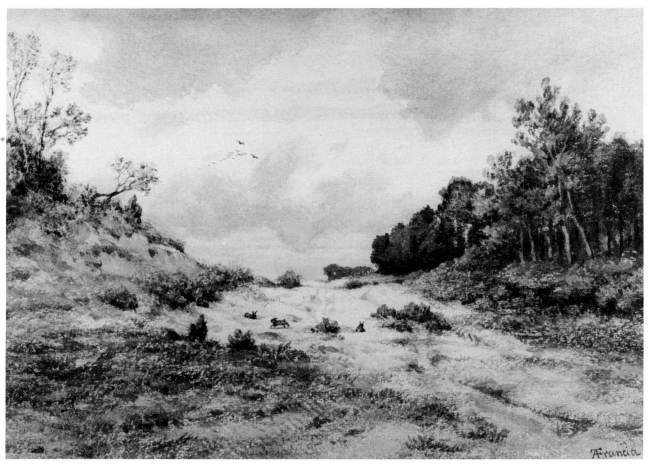

FRANCIA, Alexandre Thomas (c.1815-1884)
A Sandy Ride on the Edge of a Wood, with Rabbits. *Signed, pencil and watercolour, 9⅞in. x 13⅛in.*
This strong drawing, with the monogramatic signature, has a sketch of cows on the reverse, together with the inscription
'Etude dans la Huyette'. *(Anthony Reed)*

FRANCIA, François Louis Thomas (1772-1839)
A stricken Vessel in a Gale. *Signed and dated 1830, pencil, pen and reddish-brown ink and watercolour, 12¾in. x 18¼in.* *(Anthony Reed)*

FRANCIA, François Louis Thomas (1772-1839)
Wrecks stranded after a Storm. *Signed, pencil and watercolour, 6½in. x 12⅛in.*
This drawing dates from around 1808, and it is signed, typically, with linked 'LF' initials. *(Anthony Reed)*

FRANCIA, François Louis Thomas (1772-1839)
An Abbey beside a River with a Barge. *Signed and indistinctly dated, pen and reddish-brown ink and watercolour, 11⅛in. x 17¼in.*
It is likely that the date of this example is 1836.

(Anthony Reed)

FRASER, Garden William, 'W.F. Garden' (1856-1921)
St. Ives. *Signed and dated 1891, pencil and watercolour, 7½in. x 10¾in.* (Sotheby's)

FRASER, Garden William, 'W.F. Garden' (1856-1921)
Shooting on the Snow. *Signed and dated '88, watercolour, 7¼in. x 14½in.*
How unusual in subject matter and season, and yet how like in style, all that one expects from W.F.G. It was on an evening such as this that his poor brother G.G. Fraser fell through the ice. (Chris Beetles)

163

FRIPP, Alfred Downing (1822-1895)
Pomegranates. *Signed, inscribed 'Naples' and dated 1893, water and bodycolour, 9¾in. x 11¾in.*
(William Drummond)

(Left) FRASER, George Gordon (1860-1895)
Primroses. *Signed, watercolour, 7in. x 12in.*
(Simon Carter)

FULLEYLOVE, John (1847-1908)
Stratford-on-Avon. *Signed, inscribed and dated 24 May 1900, pencil and water-colour. 7½in. x 11in.*
(Charles Chrestien)

FUSSELL, Joseph (1818-1912)
Still Life. *Signed and dated 1874, watercolour, 10in. x 16in.* *(Simon Carter)*

GAINSBOROUGH, Thomas (1727-1788)
An Upland Landscape. *Black and white chalks, grey washes, 11⅛in. x 14½in.*
This is in the *catalogue raisonné* as Hayes 495. *(Agnew)*

GAINSBOROUGH, Thomas (1727-1788)
A Shepherd by a Rocky Track. *Pen, black and grey washes and white chalk, 11⅛in. x 13½in.*
This study is datable to the 1780s. *(Agnew)*

165

GARDNER, William Biscombe (1847-1919)
Spring Tide on the Rother, before Rye, Sussex. *Signed, and inscribed on artist's board, watercolour, 5in. x 8in.*
(Chris Beetles)

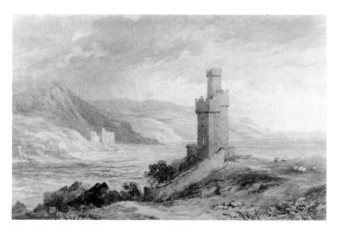

GASTINEAU, Maria (-1890)
On the Antrim Coast. *Signed and dated 1865 on the reverse, watercolour, 8½in. x 12½in.*
Maria was accompanied on this Irish tour by her father John.
(Sotheby's)

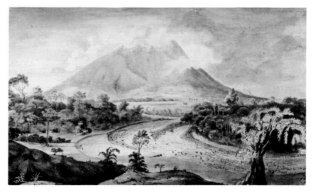

GEORGE, Lt. Col. James (1782-1828)
The Chidami River and Gunang Gedeh, Java. *Inscribed on the reverse, pen and brown ink and watercolour, 11¼in. x 18in.*
(Martyn Gregory)

166

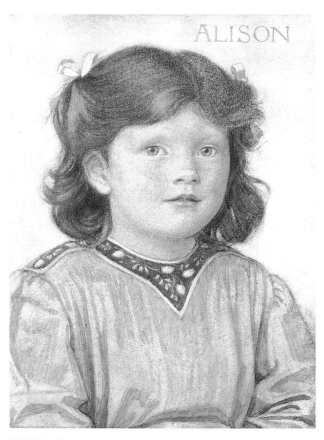

GERE, Charles March (1869-1957)
Alison. *Inscribed in gold, water and bodycolour, 6¾in. x 5in.*
In style this Alison is a daughter of Jane Morris.
(Chris Beetles)

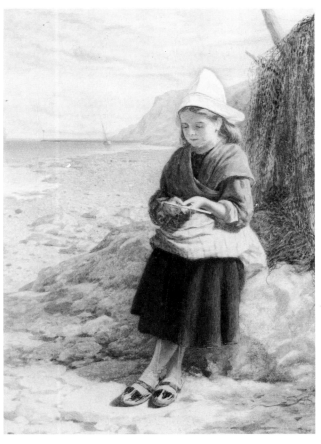

GIBSON, Joseph Vincent
Mending Nets. *Signed and dated 1867, water and bodycolour, 15in. x 10½in.* *(Sotheby's)*

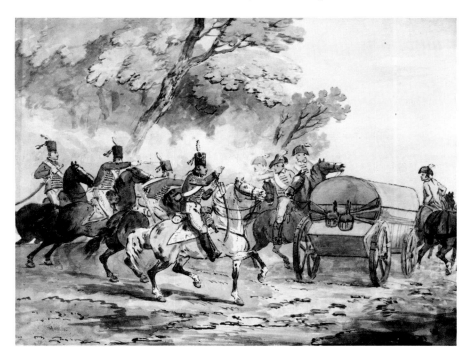

GESSNER, Johann Conrad (1764-1826)
Saxon Hussars. *Inscribed on label, pencil and watercolour, 16¾in. x 21¾in.* *(Sotheby's)*

167

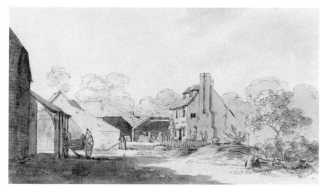

GILDER, Henry (attrib)
Farm Buildings. *Pencil, pen and ink and watercolour, 6¾in. x 11½in.* (Martyn Gregory)

GILLRAY, James (1757-1815)
Cymon and Iphigenia. *Pen and brown ink and watercolour, 9½in. x 8¼in.*
This subject was engraved and published by Mrs Humphrey in 1796. (Sotheby's)

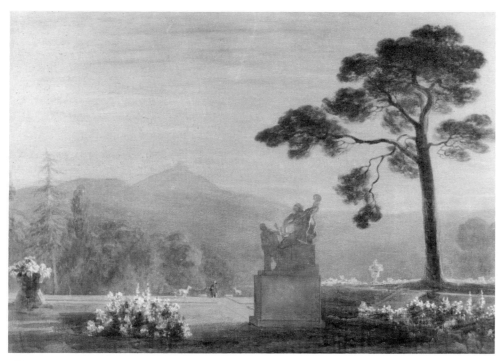

GILES, James (1801-1870)
A Design for the Gardens at Powerscourt, County Wicklow, the Great Sugarloaf beyond. *Pencil and watercolour heightened with white, 13¼in. x 17¼in.*
Giles never actually visited Ireland, and since the gardens at Powerscourt are one of the landscape glories of Europe it is just as well that his replacement scheme was not accepted by Lord Powerscourt, who is seen climbing to the terrace. The design, in fact, is virtually Giles' layout of the terraces at Haddo House, Aberdeen, transferred across the Irish Sea.
(Private Collection)

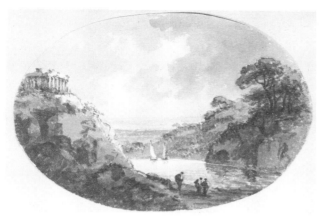

GILPIN, The Rev. William (1724-1804)
A Romantic Lanskip with a Temple. *Reed pen and brown ink, brown wash. Oval, approx., 5½in. x 7¾in. (Christie's)*

GLENNIE, Arthur (1803-1890)
Cottage interior at Dulwich. *Inscribed on old mount, water and bodycolour, 4in. x 6½in.* (Martyn Gregory)

GLOVER, John (1767-1849)
Upland Herds. *Watercolour, 17in. x 27⅝in.*

(Andrew Wyld)

GOFF, Frederick Edward John (1855-1931)
Winchester Cathedral. *Signed and inscribed, watercolour, 5in. x 7in.* *(Leger Galleries)*

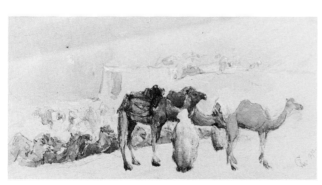

GOFF, Col. Robert Charles (1837-1922)
Camels. *Signed with monogram and dated 1875, pencil and watercolour, 3in. x 6in.*

GOODALL, Edward Angelo (1819-1908)
A Grandfather Clock. *Watercolour, 10¾in. x 9¼in.*
(Martyn Gregory)

GOODWIN, Albert (1845-1932)
A Creek near the South Coast. *Signed and dated /86, pencil and watercolour, 8½in. x 11in.* (Charles Chrestien)

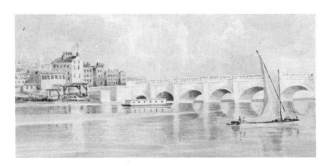

GORDON, Julia Isabella Levinia, Lady (1772-1867)
On a French River. *Signed and dated 1808 on the mount, pencil and watercolour, 4¾in. x 9⅝in.* (Andrew Wyld)

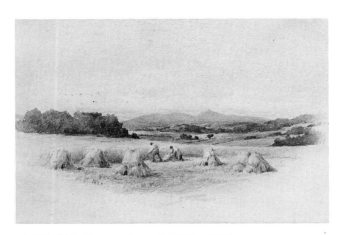

GOWANS, George Russell (1843-1924)
Bennachie. *Signed and dated 1888, watercolour, 4in. x 7in.*
(Simon Carter)

171

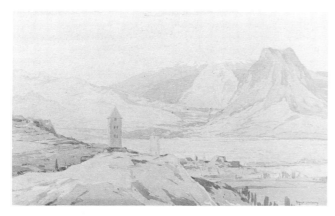

GRAHAM, George (1881-1949)
Tarascon. *Signed, watercolour, 6in. x 12in.* (Simon Carter)

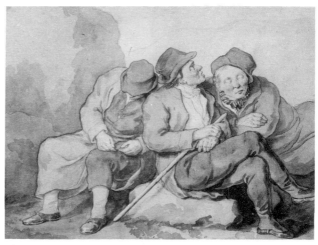

GRATTAN, George (1787-1819)
Sleeping it off. *Signed, pencil, pen and ink and watercolour, approx. 6in. x 8½in.* (Anthony Reed)

GRATTAN, William (see under GRATTAN, George, in Vol.I)
A Farm Hand. *Signed, pencil and watercolour, 17in. x 14¾in.* (Sotheby's)

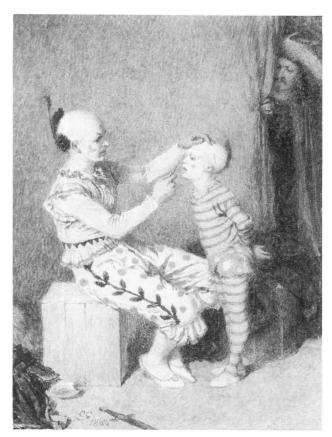

(Above) GREEN, Charles (1840-1898)
Preparing for the Kill. *Signed with initials and dated 1867, pencil and watercolour heightened with white, 6⅜in. x 4⅜in.* (*J.S. Maas & Son*)

(Above right) GREEN, Charles (1840-1898)
The Family Business. *Signed with initials and dated 1868, watercolour heightened with white, 6⅝in. x 4⅝in.*
Green was particularly keen on backstage scenes and clowns, of which he produced both watercolours and impressive oil paintings. (*Anthony Reed*)

GREEN, Charles (1840-1898)
Will he come? *Signed with initials and dated 1881, watercolour, 8in. x 4in.*
Green was probably at his strongest in the contemporary and theatrical scenes, rather than this vein in which he harks back to the Regency. (*Simon Carter*)

GREEN, Henry Towneley (1836-1899)
Skating. *Signed and dated /94, watercolour, 9in. x 13in.* (Simon Carter)

GREEN, James (1771-1834)
A Beach Party. *Signed, pencil, pen and ink and watercolour, 4¼in. x 7in.* (Anthony Reed)

GREEN, James (1771-1834)
Portrait of a Country Gentleman. *Signed and dated 1805, watercolour, 10in. x 8in.*
This is the sort of workmanlike production by which Green generally made his living. For more fanciful productions, see Part I and Volume II. He could also be rather less formal.
(Simon Carter)

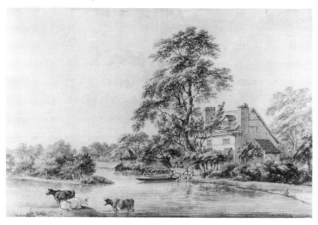

GRESSE, John Alexander (1741-1794)
By the Alde near Framlingham. *Signed, inscribed and dated 1781, pencil, pen and black ink and watercolour, 10in. x 14in.* *(Sotheby's)*

GRIFFITH, Moses (1747-1819)
A Mouse. *Signed, pen and ink and grey wash, 4in. x 4¼in.* This was engraved for one of Pennant's publications, and — despite the perspective — it shows that Griffith was by no means always primitive. *(Agnew)*

GRIERSON, Charles MacIver (1864-1939)
Held by a Thread. *Signed and dated 1894, watercolour, 24½in. x 31½in.*
The stomachs of the Naughty Nineties were even stronger than one might expect. *(Sotheby's)*

175

HAAG, Carl (1820-1915)
A Camel. *Signed and dated 'Cairo 11:12:58', pencil and watercolour on buff paper, 7in. x 12in.* *(Sotheby's)*

HAAG, Carl (1820-1915)
An Artist sketching Peasants. *Signed and dated 1879, watercolour, approx. 23½in. x 15½in.* *(Andrew Wyld)*

HALFPENNY, Joseph (1748-1811)
Windermere. *Signed with initials and dated 1791, signed and dated again and precisely inscribed on a label, water and bodycolour, 19¼in. x 26in.* *(Sotheby's)*

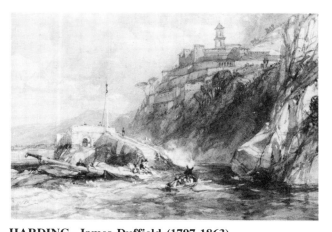

HARDING, James Duffield (1797-1863)
Persano, Bay of Naples. *Pencil, water and bodycolour, 4⅞in. x 7in.*
This watercolour was engraved for T. Roscoe: *The Tourist in Italy*, in the *Landscape Annual* for 1832. *(Spink & Son)*

HALSWELLE, Keeley (1832-1891)
A Child's Christmas Dream. *Signed, inscribed and dated 1858, pen and ink and watercolour, 30½in. x 25½in.*
(Chris Beetles)

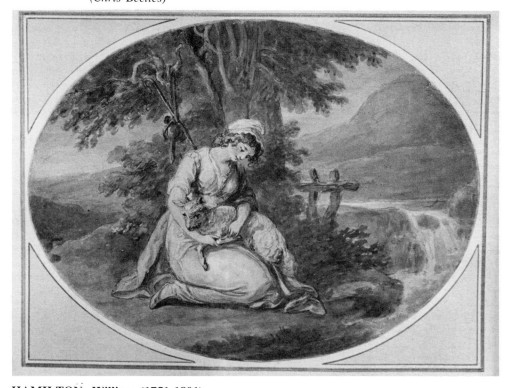

HAMILTON, William (1751-1801)
The Shepherdess Urania. *Pen and grey ink and watercolour, 13in. x 14in.*
This subject was engraved. *(Simon Carter)*

177

HARDING, John (c.1777-1846)
A Gypsy Family. *Dated 1795; pen and ink and watercolour, 9½in. x 11¾in.*
While the techniques are those of Harding's master Sandby, the theme is Morland's. *(Martyn Gregory)*

HARDWICK, William Noble (1805-1865)
A Bothy. *Signed with initials, watercolour, 10in. x 14in.*
Hardwick was a pupil of Turner, who certainly taught him technique, as in the dry brush-dragging. *(Simon Carter)*

HARDY, Thomas Bush (1842-1897)
Boats to Let. *Signed and dated 1870, water and bodycolour, 11¼in. x 15¼in.*
In his earlier days Hardy was quite commendably like early Birket Foster. *(Chris Beetles)*

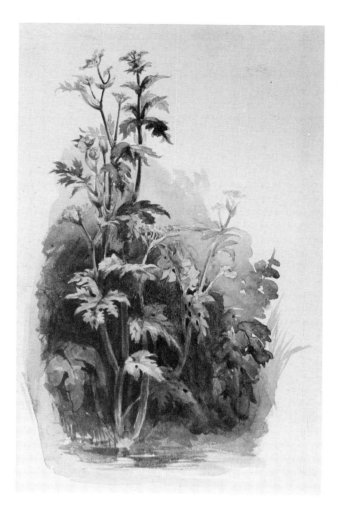

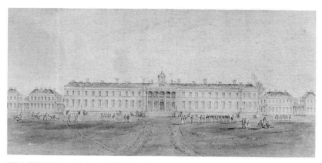

HASSELL, John (1767-1825)
Sandhurst. *Signed and dated 1823, pen and ink and water-colour, 16½in. x 25in.* *(Simon Carter)*

HARGITT, Edward (1835-1895)
Cow Parsley. *Watercolour, 12in. x 7½in.* *(Martyn Gregory)*

HARTLAND, Henry Albert (1840-1893)
The Last Ray of Evening — Shannon Bridge. *Signed and dated 1876, watercolour, 23in. x 40½in.*
(Victoria and Albert Museum)

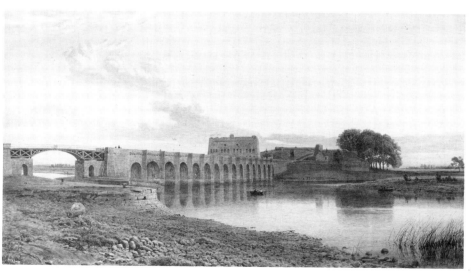

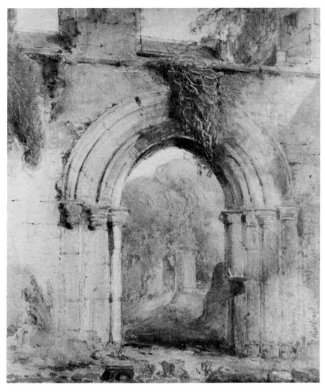

HASTINGS, Captain Thomas
A ruined Abbey. *Signed, watercolour with scratching out,*
9in. x 7in. (Simon Carter)

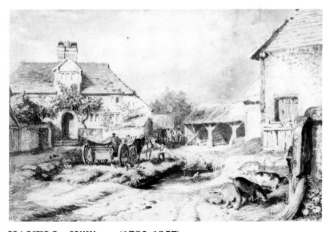

HAVELL, William (1782-1857)
A Farmyard. *Signed and dated 1856, watercolour, 11in. x*
15¼in.
At the end of his career Havell's manner had become much
more loose than formerly. (Sotheby's)

HAY, James Hamilton (1874-1916)
St. Ives. *Signed, inscribed and dated 1907, pencil and water-*
colour heightened with white, 9in. x 3in. (Simon Carter)

HAYES, Michael Angelo (1820-1877)
Sackville Street and the Pillar. *Signed, watercolour, 21¼in. x 30¾in.*
(National Gallery of Ireland)

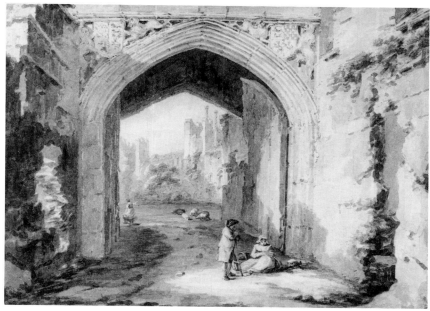

HEARNE, Thomas (1744-1817)
The Gate of Framlingham Castle.
Pencil, grey and brown washes, 7in. x 9½in. *(Martyn Gregory)*

HEATHCOTE, John Moyer (1800-1892)
Tummel Bridge. *Inscribed and dated, pencil and watercolour, 11½in. x 18in.*
It is often difficult to differentiate between the work of the better De Wint pupils, especially when, as here, one ventures onto the natural territory of another — Lord M.W. Graham. It was among a group of watercolours by Heathcote which were variously dated between 1852 and 1856. The date of death given here is correct, rather than 1890 as in Volume I. *(Sotheby's)*

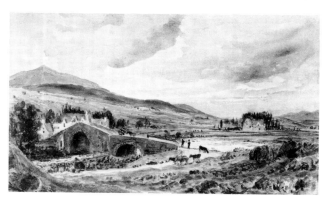

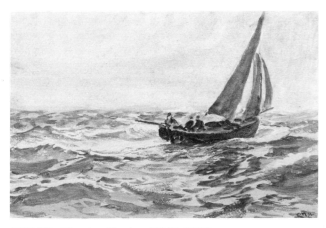

HEMY, Charles Napier (1841-1917)
The Artist's Fishing Boat. *Signed with initials, pencil and watercolour heightened with white, 9⅜in. x 13⅜in.*
An example of Hemy's free impressionism, which he adopted in the latter part of his career. He has done wonders by dragging to suggest light on the waves.
(Private Collection)

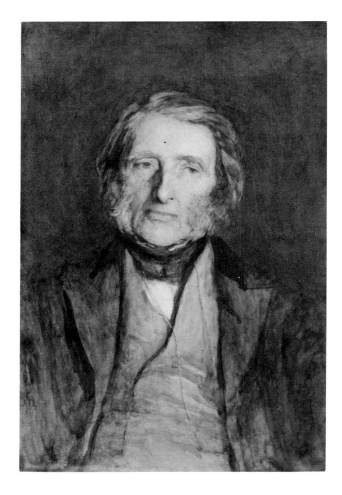

HERKOMER, Sir Hubert von (1849-1914)
John Ruskin, 1879. *Watercolour, size unknown.*
(National Portrait Gallery)

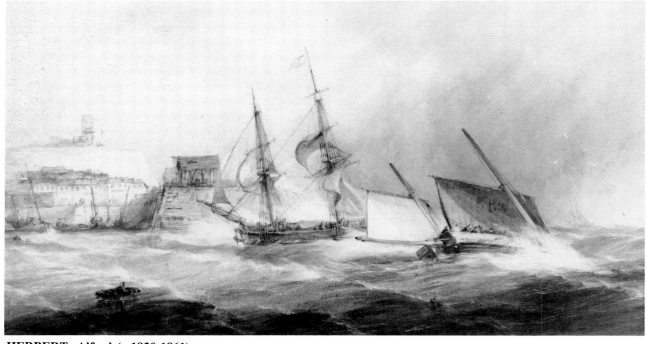

HERBERT, Alfred (c.1820-1861)
A Collier and a Boulogne Fishing Boat off Folkestone. *Signed, watercolour, 15¾in. x 26¼in.* *(Charles Chrestien)*

182

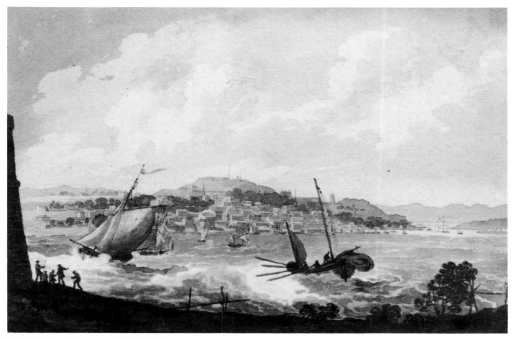

HERIOT, George (1766-1844)
Halifax, Nova Scotia. *Pencil and watercolour, approx. 4in. x 6½in.* *(Anthony Reed)*

HILTON, William (1786-1839)
Bedtime Pleasures. *Pencil and watercolour, approx. 3¾in.
x 4½in.* *(Andrew Wyld)*

HINE, Henry George (1811-1895)
A Fellow of the Society of Antiquaries. *Signed, watercolour,
10in. x 7in.*
This was exhibited at the R.A. in 1851. It has a certain
amount in common with Charles Keene's watercolours.
(Moss Galleries)

HOLLAND, James (1800-1870)
Rotterdam. *Signed with initials, dated Sept 25th, and inscribed with colour notes, pencil and watercolour heightened with white, approx. 8in. x 4in.*
This typical free sketch, with the equally typical monogram, dates from 1845. *(Martyn Gregory)*

(Above left) HINES, Frederick
Spring Dreams. *Signed, watercolour heightened with white, 11in. x 7in.* *(Simon Carter)*

(Left) HOLIDAY, Henry James (1839-1927)
Woglinde. *Signed, inscribed and dated 1877, watercolour with rubbing out, 6in. x 4½in.*
The first Wagner performances in London were given in 1877, perhaps not to universal acclaim. *(Moss Galleries)*

HOLLAR, Wenceslaus (1607-1677)
A Prospect of the Lands and Forts...
before Tangier. *Signed, inscribed and
dated September 1669, pen and brown
ink and watercolour, 11¹/₁₆in. x 40¼in.*
(*British Museum*)

HOLMES, James (1777-1860)
Henry and Frank Parker. *Signed,
addressed, inscribed and dated 1837,
watercolour, 15in. x 12in.*
(*Moss Galleries*)

HULL, Edward, the Elder
Postillions in training, France. *Signed with initials, water-
colour, 5⅞in. x 8⅛in.* (*William Drummond*)

HULME, Frederick William (1816-1884)
A Torrent. *Signed and dated Oct 9, and with composition notes on the reverse, pencil and watercolour heightened with white,*
9¾in. x 13¼in.

HUNT, William Henry (1790-1864)
Still Life. *Signed, pencil and watercolour heightened with*
white, 9¾in. x 15in. (Sotheby's)

HUNT, William Henry (1790-1864)
Eel Traps. *Signed, pencil and watercolour with touches of*
bodycolour, 9¾in. x 14½in.
The transitional period of rustic figures in landscapes.
(Martyn Gregory)

186

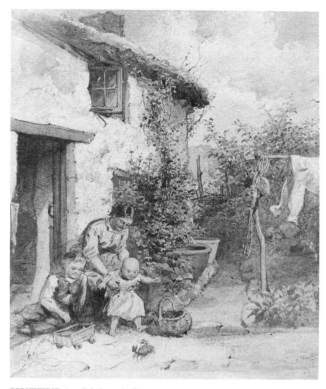

HUTTULA, Richard C.
First Steps, *Signed and dated 1869, watercolour with stopping and rubbing out, 8in. x 5in.* (Simon Carter)

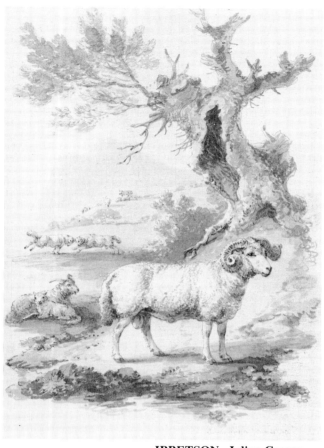

IBBETSON, Julius Caesar (1759-1817)
Rams. *Signed and inscribed 'ad nat del¹', grey wash, 8¼in. x 5¾in.*
(Martyn Gregory)

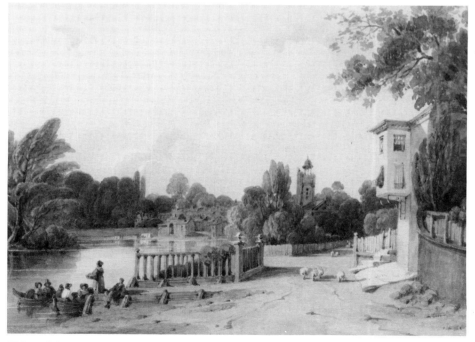

IBBETSON, Sir John Thomas Selwin (1789-1869)
At Isleworth. *Pencil and watercolour, 7½in. x 9¾in.* (Sotheby's)

187

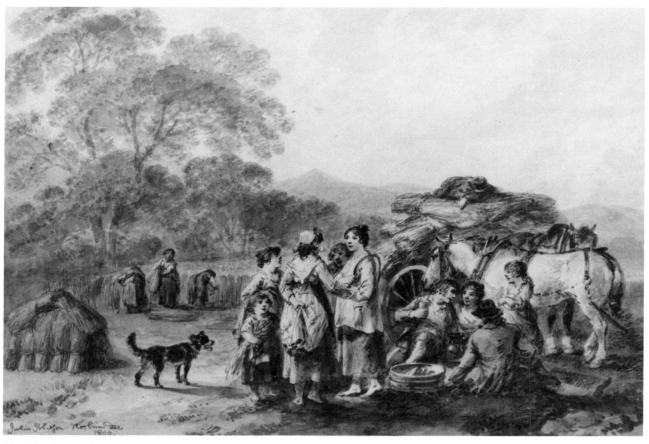

IBBETSON, Julius Caesar (1759-1817)
Harvesters. *Signed, inscribed 'Roslin Dee' and dated 1800, pen and brown ink and watercolour, size unknown.* *(Bonham's)*

INCE, Joseph Murray (1806-1859)
Fishing Craft. *Signed and dated 1829, watercolour, 4⅜in.*
x 7¾in. *(William Drummond)*

INCE, Joseph Murray (1806-1859)
An old Farmhouse. *Signed with initials and dated 1841,*
watercolour, 6in. x 10in. *(Simon Carter)*

IRTON, Lt. Col. Richard (-1847)
The Erechtheum. *Pencil and watercolour with stopping out, 10½in. x 14½in.*
This drawing was engraved for C. Wordsworth's *Greece,* 6th ed. 1858. *(Sotheby's)*

JACKSON, Samuel (1794-1869)
Dolbadern Castle. *Pencil and watercolour heightened with*
white, 7½in. x 11½in. *(Martyn Gregory)*

JACKSON, Samuel (1794-1869)
The Lodge, Broomwell House, Brislington. *Watercolour, 8⅞in. x*
12⅞in.
This drawing is one of a series dating from around 1824 and showing
the house and surroundings which had been bought by the Bristol
School patron G.W. Braikenridge in 1823. For a discussion of this and
other Bristol works, see the admirable *The Bristol Landscape,* 1986, by
F. Greenacre and S. Stoddard. *(Bristol Museum and Art Gallery)*

JACKSON, Samuel Phillips (1830-1904)
An old Overshot Mill. *Signed, pencil and watercolour, 13½in.*
x 19¾in. (Charles Chrestien)

JENKINS, Joseph John (1811-1885)
Haybarges. *Pencil, water and bodycolour, 9in. x 18¾in.* (Sotheby's)

JOHNSON, Cyrus (1848-1925)
By a French River. *Watercolour with scratching out, 6in. x*
10in. (Simon Carter)

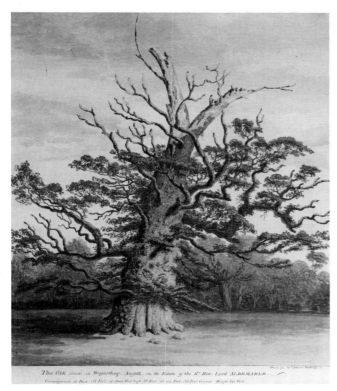

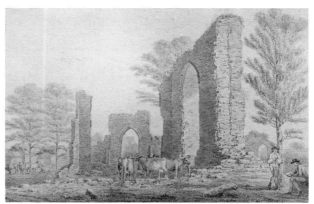

JOHNSON, Isaac (1754-1835)
Leiston Priory. *Watercolour, 8in. x 11½in.*
Very much the drawing of an antiquary. *(Simon Carter)*

JOHNSON, Isaac (1754-1835)
An Oak at Winfarthing, Norfolk. *Signed, inscribed and dated 1785, watercolour, 10in. x 7in.* *(Simon Carter)*

JOHNSON, James (1803-1834)
Granby Hill, Bristol. *Pencil and watercolour, 7¼in. x 11¼in.* *(Andrew Wyld)*

191

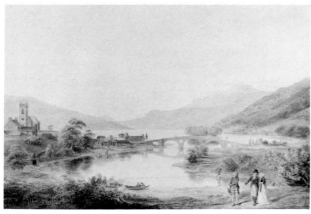

JOHNSON, Robert (1770-1796)
A Settlement near Dunkeld. *Signed and dated 1796 on the reverse, pencil and watercolour, 5¼in. x 7¾in.*
This 'Settlement' is surely Kenmore at the head of Loch Tay, where Johnson died in 1796. *(Martyn Gregory)*

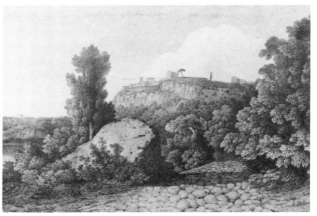

JONES, Thomas (1742-1803)
Lake Nemi. *Inscribed, watercolour, 11in. x 16⅜in.*
Painted in the spring of 1777 when Jones was in the area with his friend Pars. *(Agnew)*

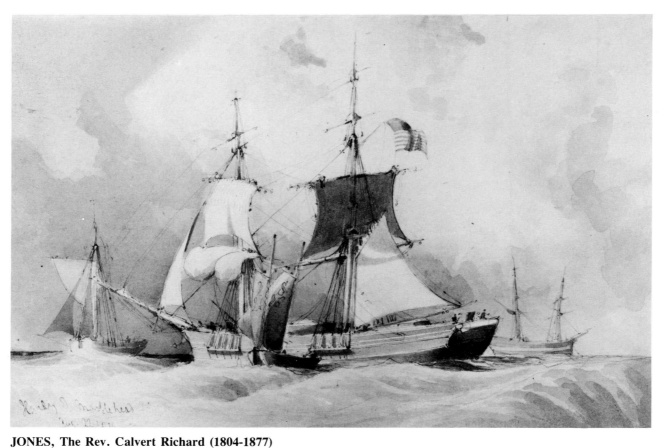

JONES, The Rev. Calvert Richard (1804-1877)
An American Brig, the *Hardy of Marblehead. Inscribed and dated Aug 22 1834, and with a pencil sketch on the reverse, pen and brown ink and watercolour, 7in. x 10½in.* *(Martyn Gregory)*

192

JOY, John Cantiloe (1806-1866)
A Packet making into a Channel Port. *Watercolour, 7in. x 10½in.*
This gets away from the family style, and looks to Bentley and the Anglo-French school — with perhaps a glance at Turner in the heap of fish on the pier. *(Sotheby's)*

KEATE, George (1729-1797)
Margate — Customs House Corner. *Pen and black ink, grey wash and watercolour, 6¾in. x 9¾in.*
Although this watercolour was catalogued as 'signed with initials' when at auction, the monogram on the gun carriage looks more like the Royal 'G.R.'. Keate could be very like Nixon and other antiquarian amateur watercolourists in style. *(Sotheby's)*

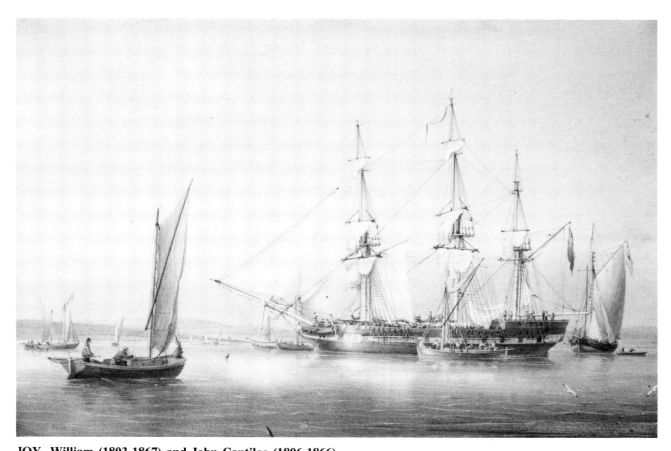

JOY, William (1803-1867) and John Cantiloe (1806-1866)
A Transport preparing to disembark Troops. *Pen and brown ink and watercolour, 11in. x 15¾in.*
Here we are back in the smooth factory manner of the Joy brothers. *(Sotheby's)*

KEATE, George
(1729-1797)
From the Library Window,
Margate. *Pen and grey ink
and watercolour, 9in. x
9½in.*
He could also be rather
adventurous. His son-in-law
was John Henderson
(see Part I).
(Andrew Wyld)

KEELEY, John (1849-1930)
Arthog. *Signed and
inscribed, watercolour, 7in. x
12in.* *(Simon Carter)*

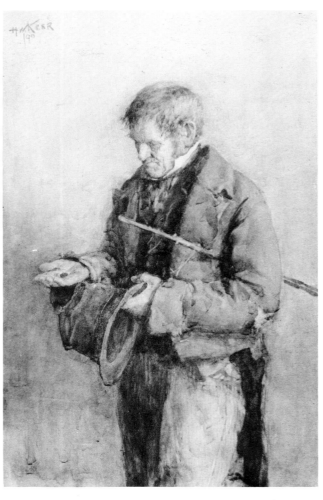

KEENE, Charles Samuel (1823-1891)
Portrait of a young lady. *Dated June 16 1857, pencil and watercolour, 4¾in. x 3⅜in.* (*Charles Chrestien*)

(Above right) KERR, Henry Wright (1857-1936)
Rent Day; the Lucky Penny. *Signed and dated /90, watercolour, 17½in. x 13in.* (*Moss Galleries*)

KEYS, John (1798-1825)
Lilies. *Pencil and watercolour, approx. 11in. x 8½in.* (*Sotheby's*)

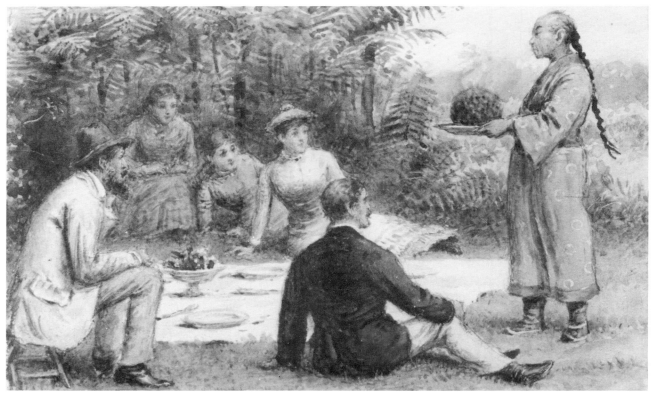

KILBURN, George Goodwin (1839-1924)
English in the Far East — Christmas Cheer. *Pencil and watercolour, 3in. x 4½in.* (Martyn Gregory)

KNELL, William Adolphus (c.1805-1875)
Ryde, Isle of Wight. *Signed with initials, pen and brown ink and watercolour, 5in. x 8in.* (Simon Carter)

KNIGHT, Ellis Cordelia (1757-1837)
The Colosseum. *Inscribed, and inscribed on the reverse, black chalk, pen and grey ink and watercolour, 12⅝in. x 18¼in.* (Christie's)

LAMBERT, George (1710-1765), and ZUCCARELLI, Francesco (1702-1788)
Un Ponte che sta fuori di Civia Castellano. *Inscribed on the mount: 'The outline by Lambert & work'd by Zucarrelli', pen and brown ink, grey and brown washes, 11½in. x 18½in.*
According to Williams four of these Italian landscapes were formerly in the collection of Christopher Morris, and all were inscribed as above. They were drawn by the two artists for the dealer Kent. Another of them, *Porte de Terni per La strada di Loreto,* 14½in. x 20½in. was at Christie's, March 21, 1989. *(Sotheby's)*

LAMBERT, George (1710-1765)
A House in a Wood. *Grey wash with touches of water-colour, approx. 5in. x 7¾in.* *(Anthony Reed)*

LAMBERT, James (1725-1788)
Bramber Castle, Sussex. *Inscribed, pen, brush and water-colour, 7¾in. x 6¼in.* *(British Library)*

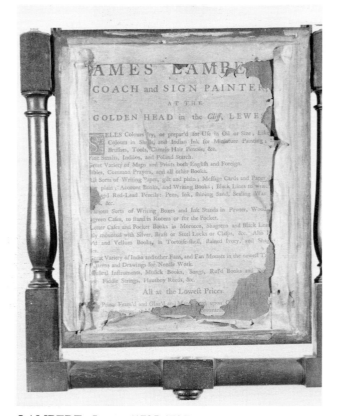

LAMBERT, James (1725-1788)
His trade label, pasted to the back of a Zograscope. This was a combination of mirror and magnifying glass by which a printmaker could see how his finished work would look while preparing a plate — which was of course reversed. *(Christie's South Kensington)*

(Right) LANDSEER, Sir Edwin Henry (1802-1873)
The Head of a young Stag. *Signed with monogram, pencil and watercolour, 8¼in. x 6in.*
Landseer's drawings, often in coloured chalks, are common enough, but his watercolours are quite rare. *(Sotheby's)*

LAMONT, Thomas Reynolds (1826-1898)
Off to Work. *Signed and dated 1868, water and body-colour, size unknown.* *(Charles Chrestien)*

LANGLEY, Walter (1852-1922)
Whisperings of the Past. *Signed, watercolour, approx. 18in. x 26in.*
This was exhibited, and won a prize, at Wolverhampton in 1888. *(David Messum)*

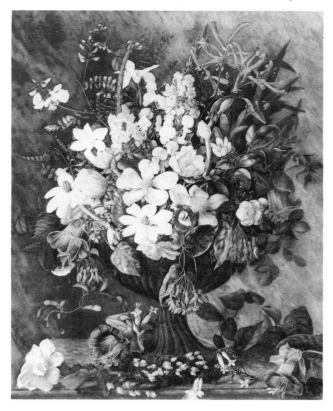

LAW, David (1831-1901)
An Angler. *Signed and dated '75, watercolour, 12¾in. x 20in.*
A typical subject for Law, and one that might have provided him with a later engraving. In his field, or rather on his beat, he is a precursor of Cameron. *(Sotheby's)*

LAWRENCE, Mary, Mrs KEARSE
Still Life of Wild Flowers. *Signed and dated 1807, water and bodycolour heightened with gum arabic, 23½in. x 18½in.*
Although Miss Lawrence — she married in 1813 — has been criticised for inaccuracy, this example looks as if it should satisfy any but the most pedantic botanist.
(Sotheby's)

LEAR, Edward (1812-1888)
An Overview of Nice. *Signed, inscribed and dated 1864, pen and brown ink and watercolour, 4in. x 7in.*
Apart from being by Lear, who spent the winter of 1864 in Nice, this is of interest from a topographical point of view since it shows the long covered-in river. Another early visitor to the Riviera to paint it was R. Streatfeild (q.v.).

(Spencer's of Retford)

LEAR, Edward (1812-1888)
The Citadel of Corfu. *Signed, inscribed and dated 1858, pencil, pen and brown ink and watercolour, size unknown.*
For a much later treatment of this subject, see *Volume II.*

(Christie's)

LEECH, John (1817-1864)
Piscator (loquitor) 'Oh! here's a bite at last!' *Signed with initials and inscribed, pen and brown ink and watercolour, 8in. x 10½in.* *(Charles Chrestien)*

LENS, Bernard, II (1659-1725)
A Panoramic View of Plymouth. *Signed, inscribed and numbered 11, pen and grey ink and grey wash, 16⅜in. x 35⅞in.*
(Spink & Son)

LE PIPER, Francis (-1695)
Grotesque Heads. *Pen and grey ink and grey wash, each 1⅜in. diameter.*
I once illustrated these heads (which are now in the British Museum) in a national newspaper and received a furious letter to the effect that it was a hoax, as they were quite obviously by Mervyn Peake. *(Anthony Reed)*

LENS, Bernard, III (1682-1740)
Handle your Slings. *Etched outline and watercolour, 12in. x 7¼in.*
This is one of a set of 17 watercolours of 'The Granadiers Exercise of the Granade, 1735', which belonged to the Duke of York. The only other known sets are in the Royal Collection and National Army Museum — but beware. Lens' son Andrew Benjamin published a set of engravings after them in 1744. *(Andrew Wyld)*

LEWIS, Charles James (1830-1892)
Shanklin, Isle of Wight. *Signed and dated 1866, water and bodycolour heightened with gum arabic, 9in. x 19¾in.*
(Sotheby's)

LINDSAY, Thomas (1793-1861)
The Isle of Dogs from Greenwich. *Signed, inscribed and dated 29 Aug 1836, pencil and watercolour, 7⅝in. x 12⅛in.*
A fine free drawing, which could not be omitted nowadays because of the added financial interest given to it by the rapidly
and richly changing topography of the area. *(Christie's)*

LINDSAY, Thomas (1793-1861)
At Brighton. *Signed, inscribed and dated 1837, pencil and watercolour, 8¾in. x 13in.* The topography of Brighton, of course, has been valuable ever since the change in the name from Brighthelmstone. *(Sotheby's)*

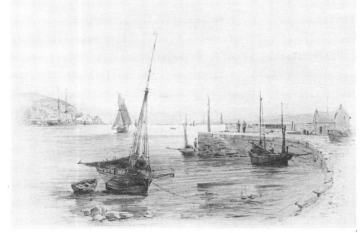

LLOYD, Robert Malcom
Appledore. *Signed and dated 1884, watercolour, 4in. x 7in.*
(Simon Carter)

LINNELL, John (1792-1882)
An Oak. *Pen and ink and watercolour, approx. 13in. x 9½in.* *(Anthony Reed)*

203

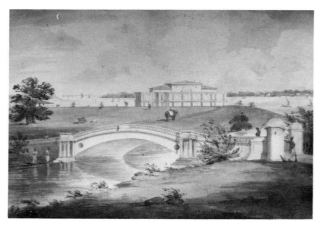

LOCKER, Edward Hawke (1777-1849)
The Governor's Villa, Barrackpore. *Signed, inscribed and dated 1808, pen and brown ink and watercolour, 11½in. x 16½in.* (Sotheby's)

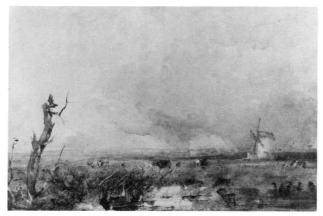

LOUND, Thomas (1802-1861)
Rain on the Heath. *Watercolour, approx. 6in. x 8in.*
(Charles Chrestien)

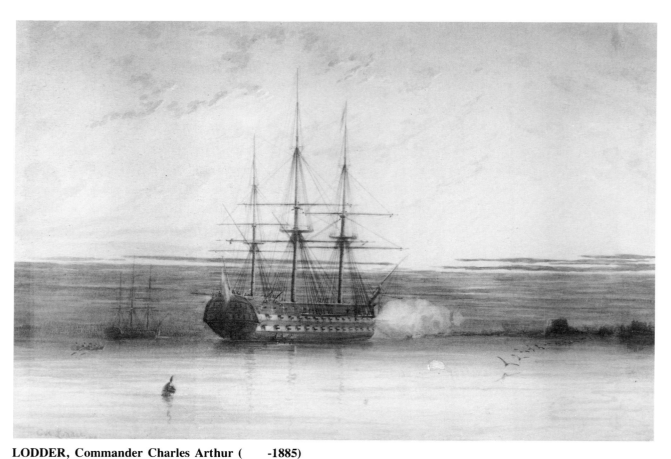

LODDER, Commander Charles Arthur (-1885)
The Evening Gun, Portsmouth. *Signed and dated 1850, watercolour heightened with white, 12¾in. x 18¾in.*
This is one of the drawings made while he was still a serving officer. Towards the end of his life, when long retired, he exhibited landscapes.
(Sotheby's)

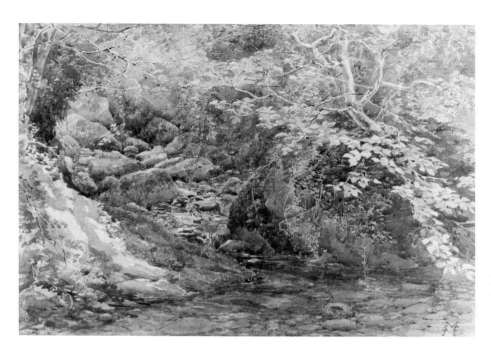

McCLOY, Samuel (1831-1904)
Strickland's Glen, Bangor, Co.
Down. *Signed with monogram,
watercolour, size unknown.*
(Ulster Museum)

MACMASTER, James (1856-1913)
Montrose. *Signed and inscribed, watercolour,
7in. x 5in.*
This dates from 1899. It is evident from the
signature (as for MacLeay below) that there
should be an 'a' in Mac. *(Martyn Gregory)*

MacLEAY, Kenneth (1802-1878)
A Girl on the Terrace. *Signed and dated 1845,
watercolour heightened with white, 15in. x 20½in.*
(Martyn Gregory)

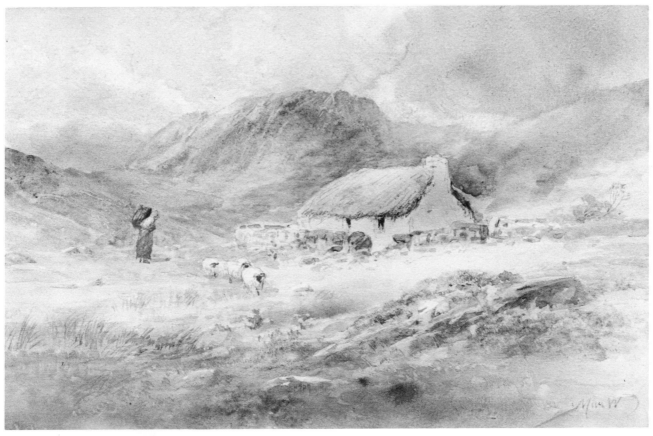

MacWHIRTER, John (1839-1911)
Scotch Mist. *Signed with initials, pencil and watercolour, 4in. x 7in.* *(Simon Carter)*

MAHONEY, James (1816-1879)
Lunch Break. *Signed and with monogram and dated 1868, water and bodycolour, 5in. x 6¼in.* *(Sotheby's)*

MANNING, R H
Walensee, Switzerland. *Pencil and water and bodycolour, 17in. x 24in.*
Although Manning's address when exhibiting in the 1840s was Kensington, it is possible that he was the stockbroker Robert H. Manning who was living in Clapham at a later date. *(Sotheby's)*

MANSON, George (1850-1876)
Head of a Fisherboy. *Signed with initials, inscribed 'Sark' and dated '74, watercolour with traces of gum arabic, 4¾in. x 4in.* (Martyn Gregory)

MARLOW, William (1740-1813)
Powys Castle, Montgomery, with a Drover. *Inscribed with attributions on original wash-line border, pencil, pen and grey ink and watercolour, 10¾in. x 16⅜in.*
This watercolour belonged to Iolo Williams. There are four other versions of the composition, one oil painting and three watercolours. One of the latter, in the collection of the Society of Antiquaries, is dated 1761. (Spink & Son)

MARSHALL, Herbert Menzies (1841-1913)
The White Hart, Sonning. *Signed and dated 1876, watercolour, 11in. x 15½in.* (Moss Galleries)

MARTIN, John (1789-1854)
The Plains of Calypso. *Signed and dated 1833, pencil, watercolour, gum arabic and oil paint, 21½in. x 32⅛in.*
(Agnew)

MELVILLE, Arthur (1855-1904)
Henley Regatta by Night. *Signed, inscribed and dated 89, watercolour, 14⅞in. x 21¾in.* *(Fine Art Society)*

MELVILLE, Arthur (1855-1904)
Puerta de Pallajes. *Signed, pencil and watercolour heightened with white, 18½in. x 22⅞in.* *(Fine Art Society)*

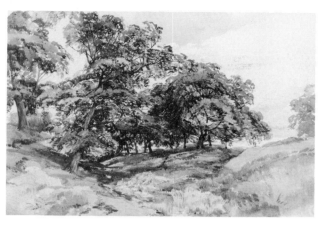

MIDDLETON, John (1827-1856)
Trees and Heath. *Dated July 3/55, pencil and watercolour heightened with white, 13½in. x 19½in.* (Martyn Gregory)

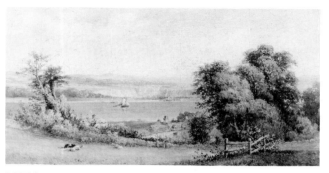

MITCHELL, Philip (1814-1896)
The Dart at Dittisham. *Signed, pencil and watercolour heightened with white, 15in. x 29in.*
This is a precise, almost finicky, work for Mitchell, who employed a variety of styles, but is often more free. He also had a liking for blue paper. (Sotheby's)

MOLE, John Henry (1814-1886)
Young Love in the Heather. *Signed and dated 1854, watercolour heightened with white, 17in. x 23in.*
Although always drawn with sugared water, just occasionally Mole's figures are really very good.
(Christie's South Kensington)

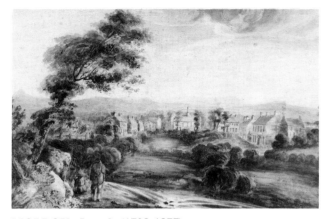

MOLLOY, Joseph (1798-1877)
Grace Hill Moravian Settlement, Ballymena, County
Antrim. *Inscribed in a later hand, and dated 1823 on a
label, watercolour, 17½in. x 26½in.*
An engraving was made from this drawing by the younger
Robert Havell in 1829. *(Sotheby's)*

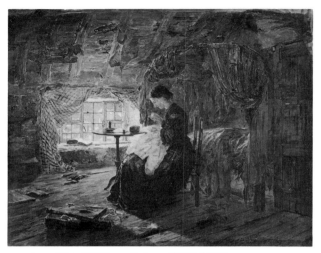

MUCKLEY, William Jabez (1837-1905)
The Song of the Shirt. *Signed and indistinctly dated, water-
colour, size unknown.* *(City of Birmingham Art Gallery)*

MOORE, Henry (1831-1895)
Seascape. *Watercolour, 7½in. x 12¾in.*
More and more in Moore's work the sea takes command. In his early days there are coasts, then there are ships, then there
is at least *a* ship on the horizon, then there is only the sea, and perhaps a bird or two. This is not, of course, a cast-iron
chronology. *(Chris Beetles)*

MULLER, William James (1812-1845)
A Fishing Boat making for Home. *Pen and brown ink heightened with white, 8¼in. x 14⅜in.* (Spink & Son)

MULLER, William James (1812-1845)
Angers. *Signed, inscribed and dated 1840, pencil and watercolour, 11¾in. x 16⅛in.*
In the Victoria and Albert Museum there is an upright view of the same group of buildings from the other side of the bridge. (Anthony Reed)

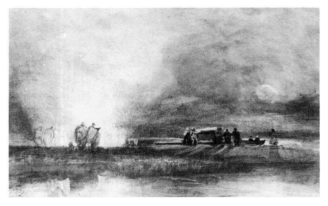

MULLER, William James (1812-1845)
A Welsh Funeral. *Signed and indistinctly inscribed on the reverse, with a pencil sketch of a tree, brown and grey washes with stopping out, 5¾in. x 9in.*
In 1900 this drawing made 10/6d in a sale at Christie's.
(Spink & Son)

MUNN, Paul Sandby (1773-1845)
Westall Hill. *Signed and dated 1811 (? on the reverse), watercolour, 12in. x 18in.*
Dear Munn is generally so old-fashioned and touchingly loyal to godfather, although under Cotman's influence he blossomed for a while around 1802. *(Simon Carter)*

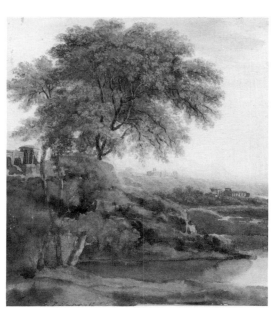

NASMYTH, Patrick (1786-1831)
Classical Landscape. *Signed, and signed on the reverse, pencil and watercolour with stopping out, 7½in. x 6¾in.* *(Sotheby's)*

MURRAY, Frank Stuart (1848-1915)
An old House. *Inscribed with name and address on old artist's label, watercolour, 17½in. x 10¼in.*
The 'Stuart' is spelt as above, rather than 'ew'. *(Martyn Gregory)*

212

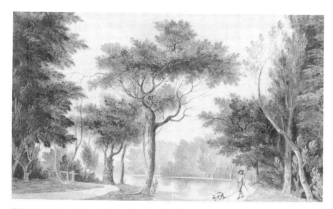

NATTES, John Claude (c.1765-1822)
Blundeston, Suffolk. *Black crayon, water and bodycolour,*
11¾in. x 18¾in.
(Sotheby's)

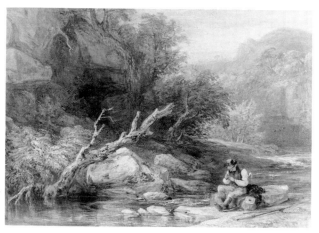

NESFIELD, William Andrews (1793-1881) and
CATTERMOLE, George (1800-1869)
An Angler. *Pencil, water and bodycolour with scratching,*
11in. x 14¾in.
Cattermole's landscape work is sometimes mistaken for
that of Cox, who admired it. Nesfield was a keen fisher-
man, and a great man for waterfalls and rivers.
(Martyn Gregory)

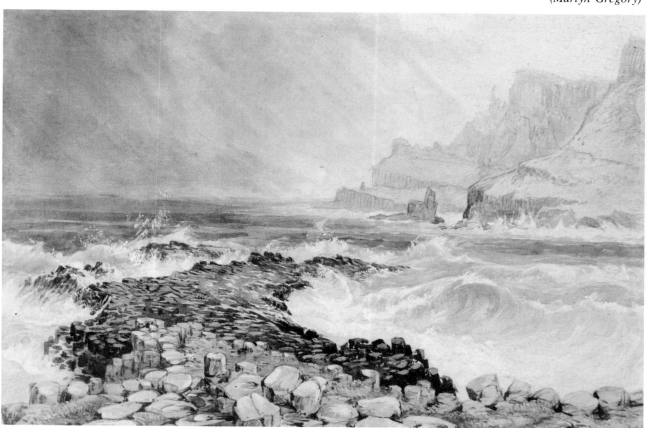

NESFIELD, William Andrews (1793-1881)
The Giants' Causeway at Low Tide. *Pencil, water and bodycolour, 7¼in. x 10½in.*
Presumably this dashing sketch dates from Nesfield's Irish tour in 1841.
(Martyn Gregory)

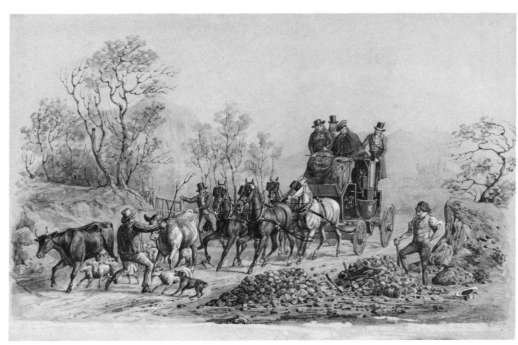

NEWHOUSE, Charles B (1805-1877)
An Incident on the Road. *Signed, inscribed and dated 1833, pen and reddish-brown ink and watercolour heightened with white, 9½in. x 13¼in.*
(Charles Chrestien)

(Below) NICOL, Erskine (1825-1904)
A Young Irishman. *Inscribed 'Wicklow' and dated 1849, pencil and watercolour heightened with white on buff paper, 13¾in. x 8½in.*
(Sotheby's)

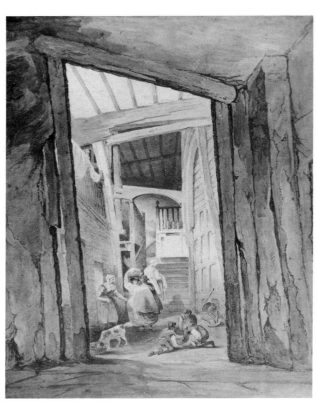

NICHOLSON, George (1787-1878)
A Picturesque Bit. *Signed, pen and ink and watercolour, 14in. x 9in.*
This is presumably by Francis Nicholson's nephew, rather than his brother or the unrelated George S. Nicholson. Nephew George followed Francis in having a daughter called Marianne. His married the Assistant Under-Secretary for War, Sir Douglas Galton. *(Simon Carter)*

214

NICOL, Erskine (1825-1904)
No Place like Home. *Signed and dated 1885, water and bodycolour heightened with gum arabic, 10in. x 14in.* (*Sotheby's*)

OAKLEY, Philip
An old Farmhouse. *Watercolour, 5in. x 8in.* (*Simon Carter*)

OAKLEY, Octavius (1800-1867)
Sally Forbes Bonita. *Signed, inscribed and dated 1851. Pen and ink and watercolour, 17in. x 11½in.*
This drawing of a little girl brought to England from Dahomey was in one of Queen Victoria's albums. (*Sotheby's*)

OBEN, or O'BRIEN, James George (a.1779-p.1819)
The Franciscan Friary and Desmond Castle, Adare. *Signed and dated October 1783, size unknown.* *(Private Collection)*

OLDFIELD, John Edwin
On the Lynn, Devon. *Signed and dated 1853, and inscribed on the reverse, watercolour heightened with white, 11¾in. x 16¾in.* *(Chris Beetles)*

OGLE, John Connell
The Citadel, Corfu. *Signed and dated '1851 Corfu', pencil and watercolour heightened with white on grey paper, 6¾in. x 10in.*
It seems from the signature that there were two 'l's to his middle name. In any case he deserves to be better known.
(Sotheby's)

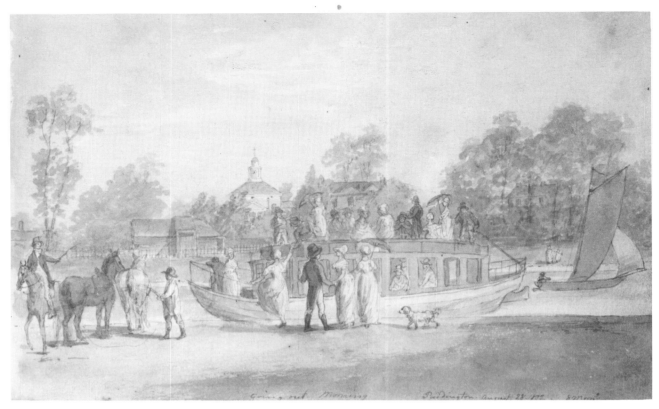

ORME, ?Daniel (c.1766-c.1832)
The Canal at Paddington. *Inscribed and dated 'August 28 1802. 8 Morng.', pen and ink and watercolour, 5⅞in. x 9¾in.*
This drawing was in a sketchbook with a Mr Orme's bookplate. The auctioneers attributed it to Daniel, but of course it might as well be by one of his brothers, Edward and William. *(Christie's)*

OSBORNE, Walter Frederick (1859-1903)
The House Builders. *Signed and dated 1902, watercolour, 18¾in. x 23⅛in.*
(National Gallery of Ireland)

PAGE, William (1794-1872)
Kenilworth. *Watercolour with dragging, 9in. x 6in.*
In his unpretentious way Page is a very satisfying painter.
(Simon Carter)

PALMER, Hannah (1818-1893)
A Rocky Stream. *Signed, watercolour heightened with white, 10½in. x 7¼in.*
This watercolour, which is now at Yale, is very much in Samuel's Italian manner, and may derive from a sketching trip to North Wales. *(Andrew Wyld)*

PALMER, Harry Sutton (1854-1933)
Sherwell Rocks on the Wye. *Signed and dated 1875, watercolour, 16in. x 26in.*
An archetypal work.
(Christie's South Kensington)

218

PALMER, Harry Sutton (1854-1933)
A Summer's Day. *Signed, watercolour, 6½in. x 9½in.*
Also untypical, in a mood which harks back to Cox and De
Wint. *(Chris Beetles)*

PALMER, Harry Sutton (1854-1933)
Bee Skeps in a Cottage Garden. *Signed and dated 82,
watercolour, approx. 14in. x 10in.*
This is less typical, being a good example of the jolly
hollyhocks school.

PALMER, Samuel (1805-1881)
In the Campagna. *Pencil and watercolour heightened with white, 5½in. x 15½in.* *(Christie's)*

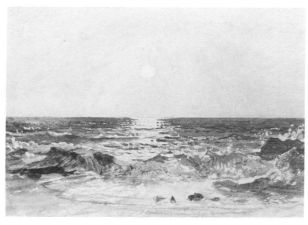

PALMER, Samuel (1805-1881)
Sunrise over the Sea, Cornwall. *Black and blue chalks and watercolour heightened with white, 5¼in. x 7¼in.*
(Christie's)

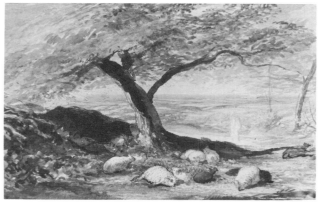

PALMER, Samuel (1805-1881)
Sketch for 'Sheep in the Shade'. *Pencil and watercolour, 6in. x 9in.*
The finished watercolour, which was exhibited in 1851, measures 15in. x 21in. (*Martyn Gregory*)

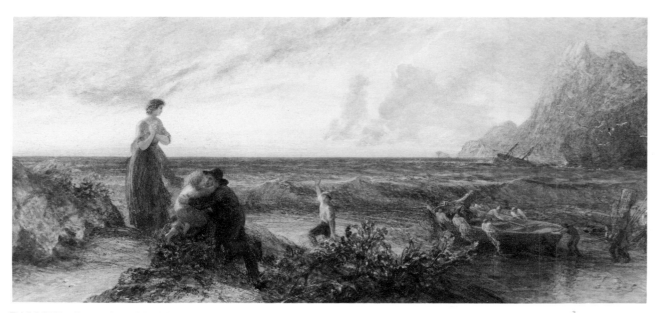

PALMER, Samuel (1805-1881)
After the Storm. *Signed and dated 1861, pencil and watercolour, 12¾in. x 27½in.* (Christie's)

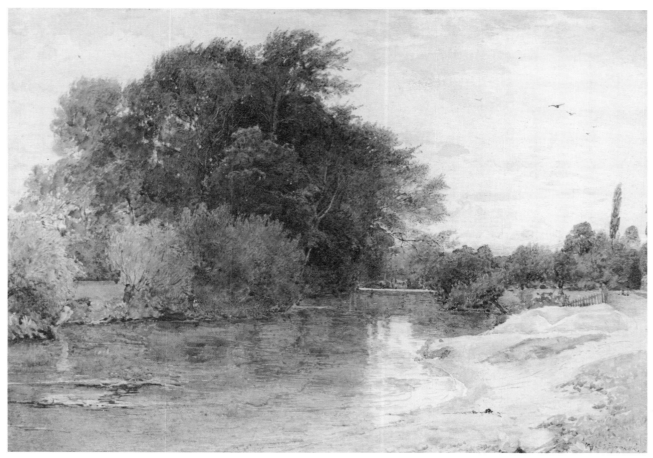

PARKER, John (1839-1915)
A River in Summer. *Signed and dated 83, watercolour, 10¼in. x 14in.*
The signature might be expected to read Sutton Palmer.

(Charles Chrestien)

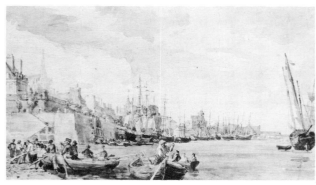

PARROTT, William (1813-1869)
St. Malo. *Pencil and watercolour, 5¼in. x 8½in.*
Some of the nice, loose sketches in this series of Northern
French ports are signed on fishing boats. *(Martyn Gregory)*

PARSONS, Alfred William (1847-1920)
Farm at Sunset. *Signed, water and bodycolour, 8¼in. x 14in.*
It is a pity that Parsons wasn't a great man for dating his
works. Does this sequence of three run from spare to lush,
or vice versa? *(Chris Beetles)*

221

PARSONS, Alfred William (1847-1920)
H.M.S. *Inflexible. Signed, watercolour, 10½in. x 14½in.*

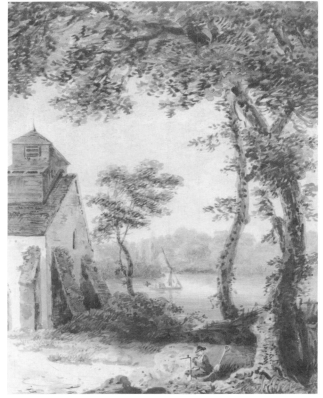

PAYNE, William (1754/5-1833)
A Surveyor by a River. *Watercolour, 12¾in. x 9¾in.*
(Sotheby's)

PARSONS, Alfred William (1847-1920)
Mrs. Bodenham's Orchard, Hereford. *Signed, and inscribed on the reverse, water and bodycolour, 9½in. x 21in.*
(Chris Beetles)

PEARSON, John (1777-1813)
Chester. *Signed and dated March 9th 1802, pencil and watercolour, 10½in. x 14½in.*
This certainly shows the Nicholson influence. *(Sotheby's)*

PENLEY, Aaron Edwin (1807-1870)
Patmos. *Signed, inscribed and dated 1856, pencil and watercolour heightened with white and with scratching, 9½in. x 14in.*
Although I know of no visit to the Dodecanese by Penley, the topography here is accurate enough in parts to suggest that he might have made one. However he has altered a number of features for picturesque effect. *(Sotheby's)*

PENLEY, Aaron Edwin (1802-1870)
Llanberris Guide. *Inscribed on the reverse by a later hand, pencil and watercolour, 6½in. x 9½in.* *(Martyn Gregory)*

223

PEPPERCORN, Alfred Douglas (1847-1924)
Sheep. *Signed, watercolour, 6in. x 9in.*
Peppercorn has his admirers, but he has also been described as
the dullest Englishman ever to wield brush. *(Simon Carter)*

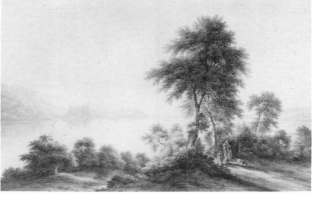

PICKERING, George (1794-1857)
Conway Castle. *Signed with initials and dated 1816, and
inscribed on the reverse, pencil and watercolour heightened
with gum arabic, 16¾in. x 24¾in.*
Lots of Glovery split-brush. *(Sotheby's)*

PETRIE, Graham (1859-1940)
Trattoria all 'Eroe dei due Monde. *Signed, watercolour, 10in. x 14¼in.* *(Charles Chrestien)*

224

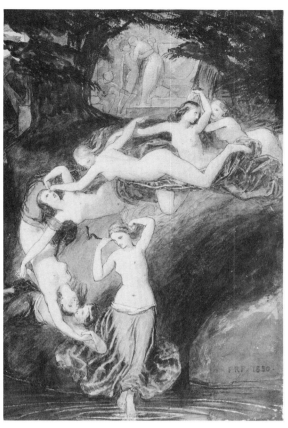

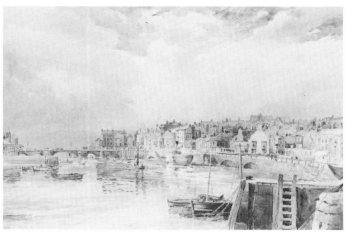

PIGOTT, William Henry (c.1810-1901)
The River Esk at Whitby. *Pencil and watercolour, 13¼in. x 20in.* This painter should be spelled with two Ts rather than one as in Volume I. *(Sotheby's)*

PICKERSGILL, Frederick Richard (1820-1900)
Water Nymphs. *Signed with initials and dated 1850, pen and ink and watercolour, 11in. x 6in.* *(Simon Carter)*

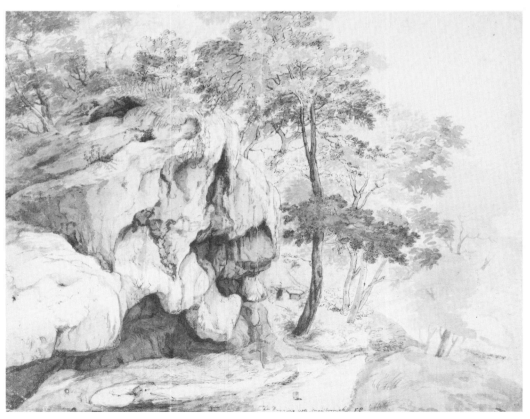

PLACE, Francis (1647-1728)
The Droping Well, Knaresborough. *Signed with initials and inscribed, pen and brown ink, grey wash, 12¾in. x 16¹/₁₆in.* A century later the 'Droping', or Dripping Well became a favourite subject for Francis Nicholson, who produced an aquatint as well as numerous drawings.
(British Museum)

225

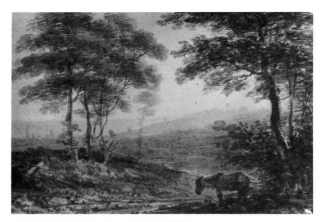

POCOCK, Nicholas (1740-1821)
Ashore — a distant View of Bristol. *Watercolour, 6½in. x 9in.*
Despite Reynolds' wise advice to Pocock to 'unite landscape to ship painting', this is actually a jolly good pure landscape. *(Martyn Gregory)*

PLAYFAIR, John Charles
Solitude. *Signed and dated /71, watercolour, approx. 12in. x 8in.* *(Charles Chrestien)*

POCOCK, Nicholas (1740-1821)
At Sea. *Pencil and watercolour, 8¼in. x 11¼in.* *(Martyn Gregory)*

POTTER, Helen Beatrix (1866-1946)
Linyphia Triangularis. *Signed and inscribed, watercolour,*
approx. 6in. x 8in. (Victoria and Albert Museum)

POTTER, Helen Beatrix (1866-1946)
Yus, yus,. They eat and they do eat. *Pen and brown ink and*
watercolour, 8in. x 6½in.
This watercolour, which is a variant on the version in the
Tate Gallery, and the published illustration to *Pigling Bland*,
was owned by Winifred Warne, later Mrs Boultbee, who
would have been Beatrix Potter's sister-in-law, had not her
fiancé and publisher Norman Warne died before the
marriage could take place. (Christie's South Kensington)

POUNCEY, Benjamin Thomas (-1799)
From Margate to Reculver. *Pen and ink and watercolour, approx. 11in. x 16in.* (Anthony Reed)

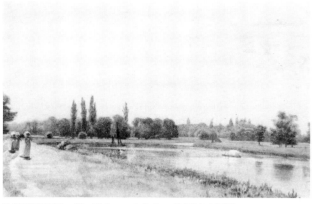

POYNTER, Sir Edward John (1836-1919)
A Summer Day. *Signed with monogram, watercolour, 6¾in. x 9¾in.*
Poynter's comparatively rare watercolours are generally fairly precise in technique, although as a young man he experimented with different styles. However, this one, which would appear to date from the turn of the century, is hazy to accord with the mood of a hot day by the Thames.
(Sotheby's Chester)

PRICE, William Lake (1810-1891)
Design for All Saints', Camden Town, 1839. *Pen and grey ink and watercolour, 15¼in. x 31¼in. (Gallery Lingard)*

PRINSEP, Emily Rebecca (1798-1860)
A Lady sketching in the Drawing Room of 4 Seamore Place. *Signed, inscribed and dated June 1836, pen and grey ink and watercolour, 7in. x 10¼in.*
Emily Rebecca was by no means the least talented of the eleven children of John Prinsep. Her only sister, Sophia, Mrs Haldimand, is known to have made unambitious attempts at Italian views in watercolour, but her main interest was as a collector (see Part I).
(Sotheby's)

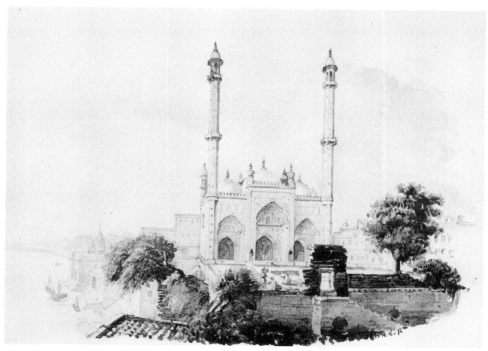

PRINSEP, James (1799-1840)
At Benares. *Signed, and inscribed on the mount, watercolour, 5¼in. x 7in. (Martyn Gregory)*

PRITCHETT, Robert Taylor (1828-1907)
Skye, Glasnakil. *Signed, inscribed and dated 1865, water-colour, 8¾in. x 12¼in.*
One of Queen Victoria's watercolours. *(Sotheby's)*

PROUT, John Skinner (1806-1876)
The Outback. *Watercolour, 11¼in. x 9¼in.*
(Charles Chrestien)

229

PROUT, Samuel (1783-1852)
The Molo and the Doge's Palace. *Signed with monogram,
reed pen and watercolour, 17¾in. x 23¾in.* (Bearne's)

PYNE, James Baker (1800-1870)
The Entrance to Knowsley Hall. *Pencil, pen and brown ink
and watercolour heightened with bodycolour and gum
arabic, 7¼in. x 11in.* (Spink & Son)

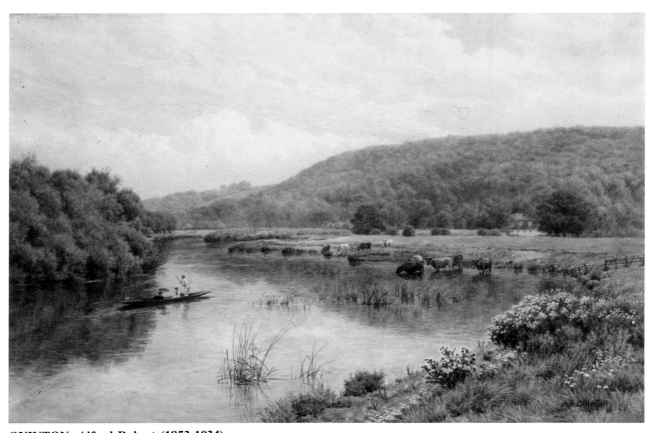

QUINTON, Alfred Robert (1853-1934)
Backwater and Quarry Woods, Great Marlow. *Signed and inscribed on a label, watercolour with scratching, 16in. x 24in.*
For information on this artist, one can now consult A.C. Jenkins: *A.R. Quinton's England*, 1987. (Sotheby's)

230

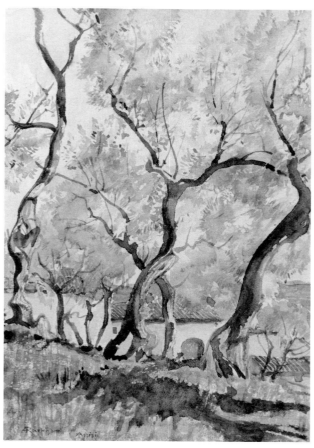

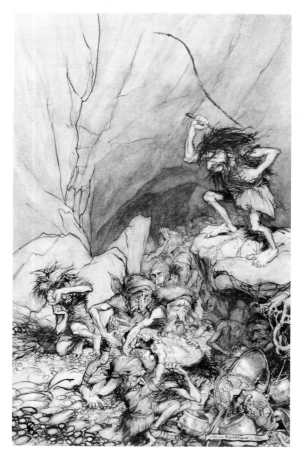

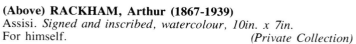

(Above) RACKHAM, Arthur (1867-1939)
Assisi. *Signed and inscribed, watercolour, 10in. x 7in.*
For himself. *(Private Collection)*

(Above Right) RACKHAM, Arthur (1867-1939)
Alberich drives in a Band of Niebelungs laden with Treasure. *Signed and dated 1910, pen and black ink and watercolour, 10¼in. x 7in.*
And for his public. *(Chris Beetles)*

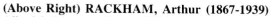

RAINEY, William (1852-1936)
Interior, Volendam. *Signed, watercolour, 19½in. x 13in.*
(Moss Galleries)

RAWLE, Samuel (1771-1860)
The Old Schools, Harrow. *Inscribed on the reverse, pen and black ink and watercolour, 4in. x 5¾in.* (Sotheby's)

RAYNER, Louise J. (1829-1924)
Haddon Hall. *Signed, pencil and watercolour thickly heightened with bodycolour, 9in. x 12⅞in.*
It is rather strange, given the quaint ancientness which Miss Rayner gives so many of her townscapes, and the propensity of so many of her contemporaries to use Haddon as a stage set for their costume pieces, that she has painted this as a straightforward view of a country house of her own time. *(Spink & Son)*

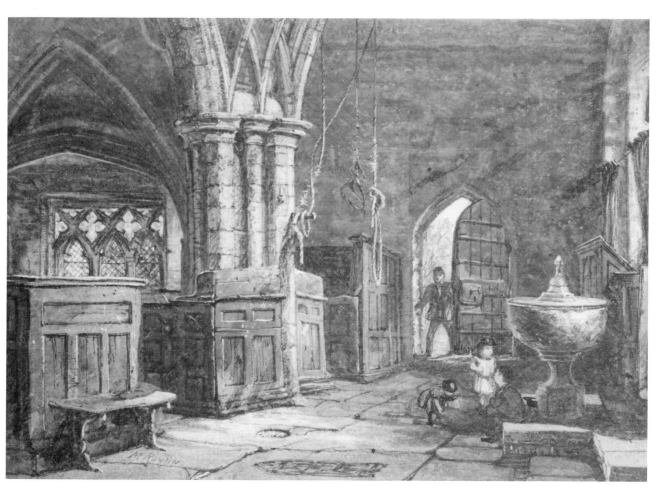

RAYNER, Margaret
Playing by the Font. *Signed, water and bodycolour, 11½in. x 15¾in.* *(Lawrence of Crewkerne)*

232

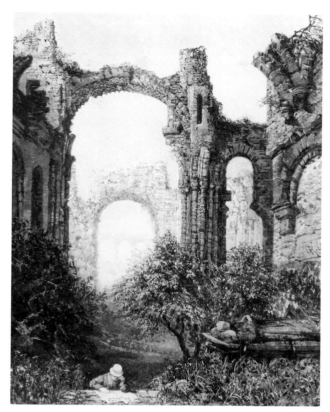

READ, Lt. Col. William (c.1782-1828)
A Port in the Peninsula. *Pen and ink and watercolour, squared for transfer, size unknown.*
Read, who I have listed inaccurately as Major L.F. Reid in Volume I, was commissioned as an ensign in the Royal Staff Corps in 1800. He was promoted lieutenant the following year and captain in 1803. Ten years later he was made up to brevet major and permanent Assistant Quarter-Master General, without regimental commission. In 1824 he was promoted Lieutenant Colonel and appointed QMG for the East Indies, a post he still held at his death. The drawing illustrated here dates from around 1812.
(Private Collection.
Photograph: Courtesy of the National Army Museum)

RAYNER, Samuel (-1874)
Reading among romantic Ruins. *Signed with initials and dated '68, signed on backing, water and bodycolour, 14½in. x 12½in.*
Rayner liked to take his subjects from literature, notably Scott. This young man, lost in his book in the ruins of an abbey, while the modern world of steam train and aqueduct passes him by, could almost be a hero in a novel of Disraeli.
(Sotheby's)

READ, David Charles (1790-1851)
A Mediterranean Port. *Watercolour, 5in. x 10¾in.*

(Simon Carter)

REDGRAVE, Richard (1804-1888)
By a Mill. *Signed and with studio stamp, pencil and watercolour heightened with white and scratching, 9¾in. x 12½in.*
Very often Redgrave uses lovely, rich greens. *(Sotheby's)*

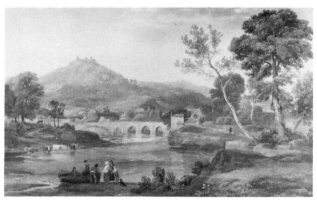

REINAGLE, Ramsay Richard (1775-1862)
The Marches of Wales. *Signed and dated 1814, watercolour, 11⅛in. x 17½in.* *(Charles Chrestien)*

REID, John Robertson (1851-1926)
A Lass who loves a Sailor. *Signed and dated 1902, and signed and inscribed on an old label, watercolour heightened with white, 14⅛in. x 20½in.*
Reid is a most interesting painter, in both oil and watercolour. He is not perhaps as well known as he deserves because he was on the fringes of several well known groups, rather than at the centre of any one. He produced Scottish Impressionist and Cornish coast subjects (as here), but was also very impressive with rustic realism. *(Private Collection)*

234

REPTON, Humphrey (1752-1818)
Design for Panson Cottage, near Hereford. *Pencil and watercolour, 14in. x 22¼in.* *(Sotheby's)*

RICH, Alfred William (1856-1921)
A Pool at Croydon. *Signed, inscribed and dated 1895,*
watercolour, 6in. x 9in. *(Simon Carter)*

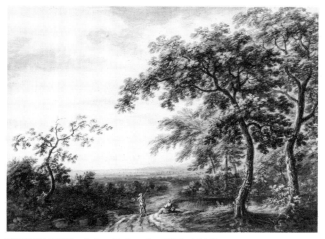

RICHARDS, John Inigo (c.1720-1810)
Landscape with Figures by a Pool. *Bodycolour, 10¼in. x*
13¾in.
It is quite possible that these bodycolour drawings are in fact
by a different 'J. Richards'. They are often signed on the
reverse. *(Sotheby's)*

235

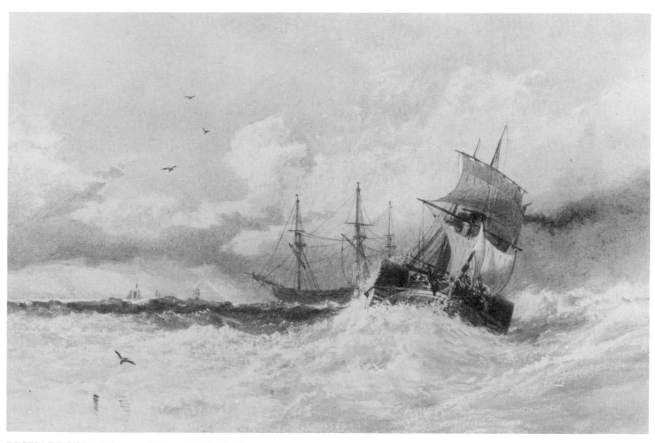

RICHARDSON, Thomas Miles (1784-1848)
Homeward bound. *Pencil and watercolour heightened with gum arabic and with scratching, 5⅜in. x 7⅝in.*
Both in subject matter and style — the darker band for distant water — this could easily be a product of the Anglo-French
school, a Callow or Bentley, for instance. *(Spink & Son)*

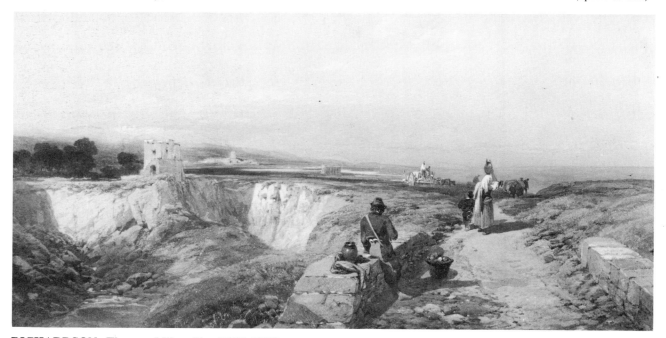

RICHARDSON, Thomas Miles, Yr. (1813-1890)
Figures in an extensive Italian Landscape. *Signed, watercolour, 13in. x 26½in.* *(Sotheby's Sussex)*

RICHMOND, George (1809-1896)
William Wilberforce. *Signed and dated 1877, water-colour, 17¼in. x 13in.* (Sotheby's Sussex)

RICHMOND, George (1809-1896)
Toads. *Pen and brown ink and watercolour, 10⅜in. x 6¾in.* (Spink & Son)

RICHTER, Henry James (1772-1857)
A Picture of Youth — or the School in an Uproar. *Signed, watercolour heightened with gum arabic, 18½in. x 23½in.*
This is a duplicate watercolour of a subject which was published as one of a pair of engravings in 1822. (Sotheby's)

RIGAUD, Stephen Francis Dutilh (1777-1861)
The Virgins consoling Malvina for the Death of Oscar —
from Ossian. *Signed and dated 1812, inscribed verso, pencil
and watercolour, 12¼in. x 16¼in.* *(Andrew Wyld)*

RIPPINGILLE, Edward Villiers (1798-1859)
The Cheat Detected. *Signed and inscribed on a label: 'A
Gaming House Scene in which are the portraits of three
notorious Swindlers. E.V. Rippingille 76 Long Acre', pencil
and watercolour heightened with white and gum arabic,
11⅛in. x 13⅛in.*
Rippingille exhibited an oil painting of the same subject at
the R.A. in 1814. The left-hand print on the wall probably
shows the fight between Tom Cribb and the American Tom
Molineaux in September 1811. *(Spink & Son)*

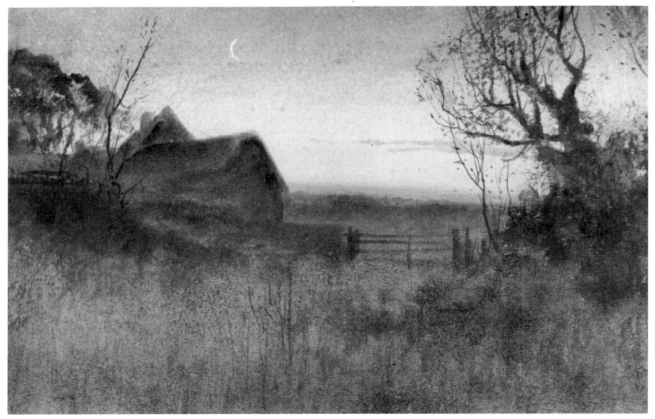

RIVERS, Leopold (1850-1905)
Evening at Haslemere. *Watercolour, 7¾in. x 12in.* *(Charles Chrestien)*

ROBERTS, David (1796-1864)
The Escorial. *Signed and dated 1836, watercolour, 10⅜in. x 15¼in.*
(Agnew)

ROBERTS, David (1796-1864)
The Convent of the Terra Santa, Nazareth. *Inscribed and dated April 21st 1839, watercolour, 14in. x 19⅜in.*
This drawing was lithographed by Haghe for the *Holy Land.*
(Agnew)

ROBERTS, David (1796-1864)
Tsur ancient Tyre. *Signed, inscribed and dated April 27th 1839, pen and ink and watercolour heightened with white, 11⅜in. x 19⅜in.*
What a productive week! This was engraved for Volume II of the *Holy Land.*
(Martyn Gregory)

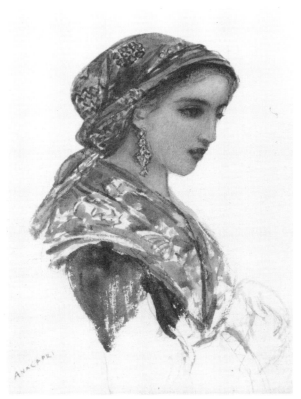

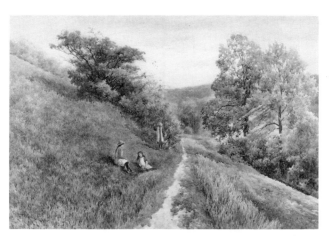

ROWBOTHAM, Claude Hamilton (1865-)
Blackberrying. *Signed, watercolour, 20¼in. x 28½in.*
Claude was the youngest of T.C.L. Rowbotham's six sons.
The others were 'Chas.', Leopold, Reginald, Francis and
Walter. *(Bearne's)*

ROWBOTHAM, Charles (1856-1921)
Contadina di Anacapri. *Inscribed, pencil and water-
colour, 7in. x 4⅝in.*
Charles' full names were Charles Edmund, but he was
known as 'Chas'. *(Charles Chrestien)*

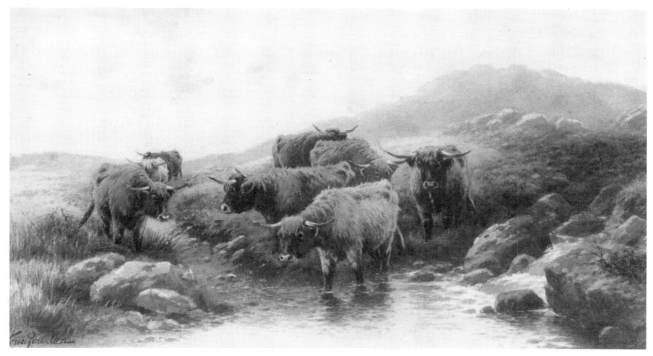

ROWDEN, Thomas (1842-1926)
Highland Cattle watering. *Signed, watercolour, 8in. x 13¾in.* *(Bearne's)*

240

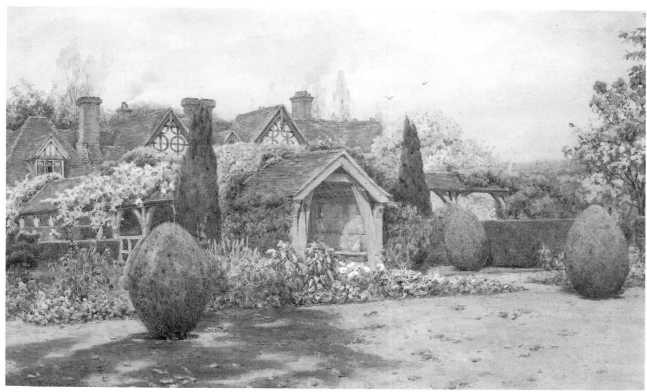

ROWE, Ernest Arthur (1863-1922)
The Gardens at Great Tangley Manor, Guildford. *Signed, watercolour, 9¾in. x 13¾in.*
This was an illustration for C. Holme: *Art In England during the Elizabethan, Edwardian and Stuart Periods,* 1908.
(Chris Beetles)

ROWE, Ernest Arthur (1863-1922)
Villa Carlotta Lake Como; Varenno in the Distance. *Signed and numbered 34, and inscribed on the reverse, watercolour, 9¾in. x 13¾in.* (Chris Beetles)

ROWLANDSON, Thomas (1756-1827)
A Mummy Pounder at Work. *Inscribed, pencil and brown ink and watercolour, 8¾in. x 7in.*
This drawing is a hit at insensitive artists. The 18th century black pigment known as 'Mummy' was exactly that: a bituminous pigment prepared from the bones and bodily remains of Egyptian mummies which had been embalmed in asphaltum. It was first used in England in the 16th century, when it must have been wickedly expensive. (Sotheby's)

241

ROWLANDSON, Thomas (1756-1827) Homage to Gainsborough. *Pencil, approx. 10in. x 14in.* Although this is not, strictly speaking, a watercolour, I include it to show how fragile are the boundaries between 'comic' and 'serious' artists. *(Anthony Reed)*

RUNCIMAN, Alexander (1736-1785) Sir Satyron. *Signed and inscribed, pen and brown ink and wash, 14in. x 9in.* *(Simon Carter)*

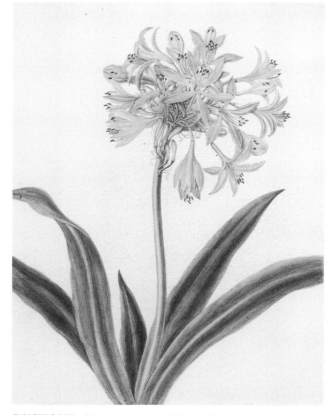

RUSHOUT, Hon. Anne (c.1768-1849) Flower Study. *Inscribed on the reverse, watercolour, 14in. x 10½in.* This comes from an album of studies which were on Whatman paper watermarked 1808 and 1815. *(Sotheby's)*

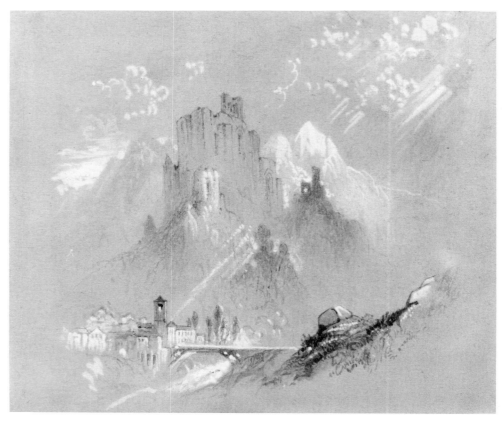

**RUSKIN, John
(1819-1900)**
An Alpine Theme. *Sepia
wash heightened with
white on blue-grey paper,
4¼in. x 5in.*
This is an early example,
rather in the J.D. Harding
or Henry Bright drawing
masterly style.
(Martyn Gregory)

**RYLAND, Henry
(1856-1924)**
By the Fountain. *Signed,
water and bodycolour,
14½in. x 21in.*
(Chris Beetles)

**RUSKIN, John
(1819-1900)**
The Spanish Steps, Rome.
*Inscribed, pencil and
watercolour, 8in. x 5in.*
There is a sketch of trees
on the reverse. This
drawing dates from the
winter of 1840-41. Ruskin
did not like Rome, but he
was keen about Keats.
(Martyn Gregory)

SALMON, John Francis (1808-1886)
Bristol. *Pen and ink and watercolour, 10½in. diameter.*
It is interesting to see St. Mary Redcliffe — 'the most splendid church in England which has always been parochial' — with its complete spire. *(Andrew Wyld)*

SANDBY, Paul (1725-1809)
The Encampment in Hyde Park after the Gordon Riots. *Inscribed on the original mount, pen and grey ink and watercolour, 8in. x 12in.*
This lovely drawing shows how, even in his most sophisticated work, the details of Sandby's figures are sometimes rather crude. But, what matters? *(Agnew)*

SANDBY, Thomas (1721-1798)
Entrance into the Devil's Hole in the Peak. *Inscribed, pen and black ink and watercolour, 7¾in. x 8¼in.*
(Private Collection)

244

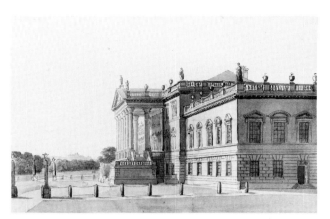

SANDBY, Thomas (1721-1798)
Wentworth House Ld Rockingham's. *Inscribed, pen and grey ink and watercolour, 8½in. x 12¼in.*
A coloured fair copy of this on the spot drawing is in the British Library (add. Ms 42232, f. 40) It is there attributed to Theodosius Forrest, one of Sandby's companions on a tour of Yorkshire in 1774, although it is quite remarkably close to Sandby's original.　　　　　*(Private Collection)*

SANDERS, Thomas HALE-
Victoria Tower and Westminster Abbey. *Signed and dated 1900, watercolour, 9¼in. x 13½in.*
(Christie's South Kensington)

SARJENT, Francis James (c.1780-1812)
Wheathampstead Church, Hertfordshire. *Pen and black ink and watercolour, 10in. x 16in.*
In these churchyard subjects one always hopes for the whimsy of a signature on a grave, but this does not appear to have one.　　　　　*(Simon Carter)*

SARJENT, Francis James (c.1780-1812)
Faringdon, Berkshire, from the North-East. *Pencil and watercolour, 14⅝in. x 21½in.* *(Spink & Son)*

SCHARF, George (1788-1860)
Detail from a drawing of Crooked Lane. *Signed and dated 1830, watercolour.* *(Guildhall Library)*

SCHARF, George (1788-1860)
Street Advertising. *Signed, inscribed and variously dated, pencil and watercolour, 5¼in. x 8⅝in.* *(British Museum)*

246

SCHETKY, John Christian (1778-1874)
The Yacht *Resolution. Pencil and watercolour, 8¾in. x 13in.*
The pair, *Off Cable island,* is inscribed and dated July 22/3.pm 1859. *(Sotheby's)*

SCHNEBBELIE, Robert Blemmel (-1849)
The Thames near Hammersmith Bridge. *Signed and dated
1838, watercolour, 14½in. x 22in.* *(Sotheby's)*

SCOTT, The Hon. Caroline Lucy, Lady (1784-1857)
The Lion Gate, Hampton Court. *Signed and inscribed on the
reverse, pencil and watercolour, 6½in. x 10in.* *(Sotheby's)*

247

SERRES, Dominic (1722-1793)
Men o'War. *Inscribed 'No.4' on the original mount, pencil and grey ink and watercolour, 5¾in. x 7⅞in.* (Spink & Son)

SERRES, John Thomas (1759-1825)
Ireland's Eye. *Inscribed and dated 25th July 87, pen and grey ink and watercolour, 9in. x 12½in.*
I include this not only for its merit, and to show the artist afloat, but also because Ireland's Eye (sometimes called with barbarous tautology Ireland's Eye Island) was a favourite spot of my childhood. It is of topographical interest to see that there was a turret of some sort at that date on the little ruined chapel.
(Sotheby's)

SERRES, John Thomas (1759-1825)
A Water-carter. *Signed and dated 1788, pen and ink and wash, 6¾in. x 9½in.* (Martyn Gregory)

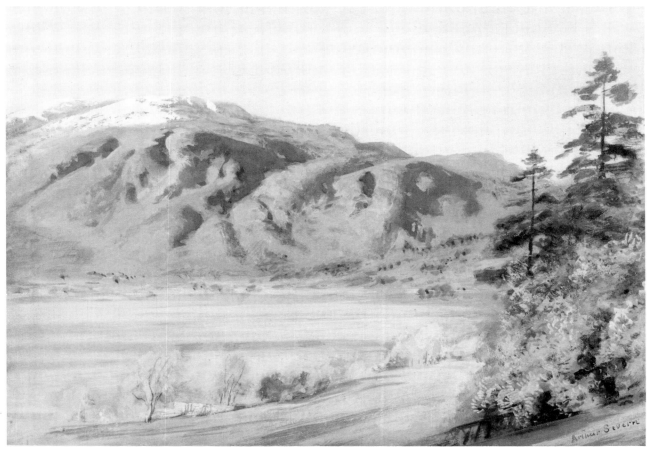

SEVERN, Joseph Arthur Palliser (1842-1931)
Head of Coniston. *Signed, pencil and watercolour heightened with white on card, 10½in. x 14½in.* (Spink & Son)

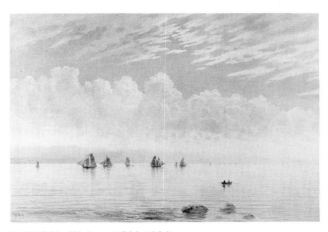

SEVERN, Walter (1830-1904)
Off Bute. *Signed, inscribed and dated 1877, watercolour, 20in. x 30in.* (Charles Chrestien)

SHEFFIELD, George, Yr. (1839-1892)
A fallen Tree. *Signed with initials, watercolour heightened with white, 14in. x 20in.*
This is an unusually colourful work for Sheffield.
(Moss Galleries)

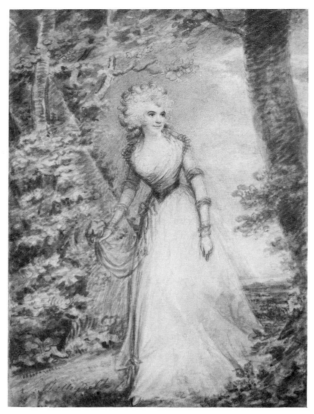

SHEPHERD, Frederick Napoleon (1819-1878)
The Metropolitan Tabernacle, Elephant and Castle. *Pencil and brown wash, 4in. x 5½in.*
F.N. Shepherd was the elder son of T.H. *(Gallery Lingard)*

SHELLEY, Samuel (1750-?1808)
Mrs. MacKinnon. *Signed, pencil and watercolour, 9⅛in. x 6½in.* *(Anthony Reed)*

SHEPHERD, George Sidney (1784-1862)
Castle Howard. *Signed and dated ?1812, pencil, pen and grey ink and watercolour, 4¼in. x 6½in. (Spink & Son)*

(Left) SHEPHERD, George Sidney (1784-1862)
Covent Garden Market. *Signed and dated 1829, watercolour, 22in. x 34in. (Charles Chrestien)*

250

SHERRIN, John (1819-1896)
Grapes and Plums. *Signed, watercolour, 4¾in. x 7¾in.*
(Sotheby's)

SHERLOCK, William, the Elder (c.1738-c.1806) see under SHERLOCK, William P. in Volume I
Hampstead Heath. *Inscribed on the original backing, pen and grey ink and watercolour, 5⅜in. x 7⅛in.*
This drawing can be safely attributed to Sherlock by comparing it to a similar work in the Victoria and Albert Museum. He was born in Dublin and studied at the St. Martin's Lane Academy and in Paris before making a career as a portrait and miniature painter and engraver in London. He exhibited at the S.A. and the R.A. from 1764-1806, for the last two years signing himself 'W. Sherlock, Sen.'
(Anthony Reed)

(Below) SHIELDS, Frederick James (1833-1911)
The Room in which Blake died, 3 Fountain Court, Strand. *Pencil and grey washes, 9in. x 12¾in.*
This was the result of Shields' fieldwork in about 1880 when preparing the illustrations for Gilchrist's *Life of Blake.*
(Sotheby's)

SIGMUND, Benjamin D.
Chicks. *Signed, watercolour heightened with white, 6in. x*
9in. *(Simon Carter)*

SILLETT, James (1764-1840)
Blackberries. *Watercolour, 6⅝in. x 4¾in.* *(Andrew Wyld)*

SIMPSON, William (1823-1899)
The Yangtse-Kiang at Hankow. *Signed, inscribed and dated 1873, pencil and watercolour, 13in. x 19¼in.*
Simpson went to China in 1872 to cover the Imperial wedding. *(Martyn Gregory)*

SMETHAM, James (1821-1889)
Sunset. *Signed, pencil, pen and brown ink and watercolour, 8¾in. x 12in.*
Smetham is an artistic chameleon. Here he is au Palmer. *(Martyn Gregory)*

SKENE, James, of Rubislaw (1775-1864)
The Plain of Athens from Hymettus. *Signed, inscribed and dated 22 Dec', pencil, pen and brown ink and watercolour, 8½in. x 19¼in.* *(Sotheby's)*

SMIRKE, Mary (1779-1853)
On the Thames near Barnes. *Pen and black ink and watercolour, 5¾in. x 9¼in.* *(Andrew Wyld)*

SMIRKE, Mary (1779-1853)
The Thames at Twickenham. *Pencil and watercolour, approx. 6in. x 9½in.* (Anthony Reed)

SMITH, Lt. Col. Charles Hamilton (1776-1859)
The Hay-maker's Piece. *Signed with initials and indistinctly inscribed, pen and brown ink and watercolour, 4in. x 8in.*
(Simon Carter)

SMIRKE, Sir Robert (1781-1815)
Proposed Gatehouse for Windsor Castle. *Signed and dated 1824, pen and grey ink and watercolour, 10½in. x 13¾in.*
This was part of Smirke's entry for the competition for the improvements at the Castle which was won by Wyatt. Most of Smirke's designs are in the RIBA Library, or at the Arts Club. (Sotheby's)

SMITH, Hely Augustus Morton (1862-1941)
Outward Bound. *Pencil and watercolour, 6in. x 9in.* *(Simon Carter)*

SMITH, Samuel
A Landscape Caprice. *Signed, watercolour, size unknown.*
A design very much derived from the porcelain works. In this vein Smith sometimes introduced fairies into his compositions.
(Private Collection)

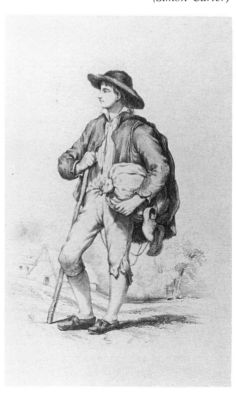

SMITH, Samuel
Leaving home. *Pencil and watercolour, size unknown.* Smith also produced Coxian landscapes, and straightforward (not to say upstanding) figures such as this.
(Private Collection)

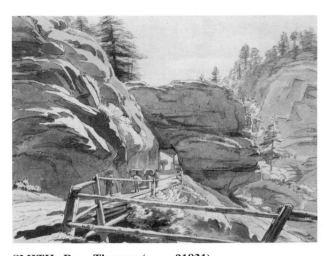

SMITH, Rev. Thomas (-?1831)
In the Alps. *Pen and grey ink and washes, 9in. x 11in.*
Since my revision of Volume I in 1986, it has been
discovered that the Thomas Smith who was travelling in Italy
in the 1780s and '90s was ordained. There are two possibilities
in the clergy lists: one was Rector of Bobbingworth, Essex
(patron Thomas Smith, Esq.) from 1812-1831; the other was
incumbent of Claycoton, Northamptonshire, from 1798 to
1851. At the beginning of his tenure the patron was T.
Belgrave, Esq., but from about 1844 he was his own patron.
However, as the second was born in 1774, and the artist is
said to have been in Italy by 1780, the Essex rector seems
the likely one. *(Anthony Reed)*

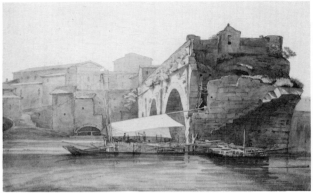

SMITH, Rev. Thomas (-?1831)
Ponte Rosso. *Pen and ink and watercolour, 9in. x 12in.*
 (Anthony Reed)

ROTTO, ROME

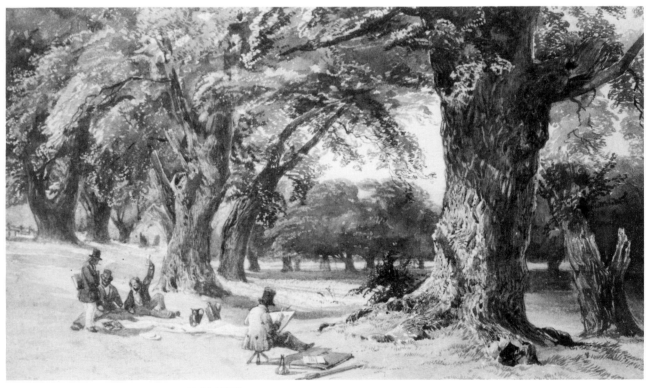

SMITH, William Collingwood (1815-1887)
A Sketching Party. *Water and bodycolour, 11½in. x 18¾in.*
 (Martyn Gregory)

256

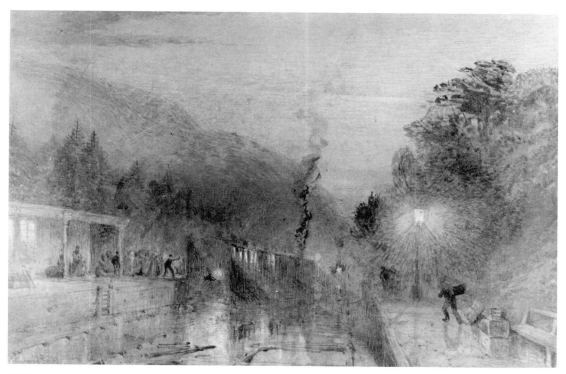

SMITH, William Collingwood (1815-1887)
The Dawn Train. *Signed, watercolour, approx. 8in. x 12in.* (Charles Chrestien)

SMYTH, Admiral William (-1877)
On the Point, Portsmouth. *Signed, and inscribed on the reverse: 'Modern Point (not lace) Point — at Portsmouth/Sept*[r]
1857 —', pencil and watercolour, 12in. x 18in.
(Sotheby's)

SPIERS, Benjamin Walter
Still Life. *Signed, inscribed and dated Dec. 1876 on reverse, water and bodycolour, 5in. x 7in.* (Sotheby's)

STANDLY, Persis
Insects from China, Ixia from the Cape of Good Hope. *Inscribed, water and bodycolour heightened with gum arabic, 11⅛in. x 9in.* (Sotheby's)

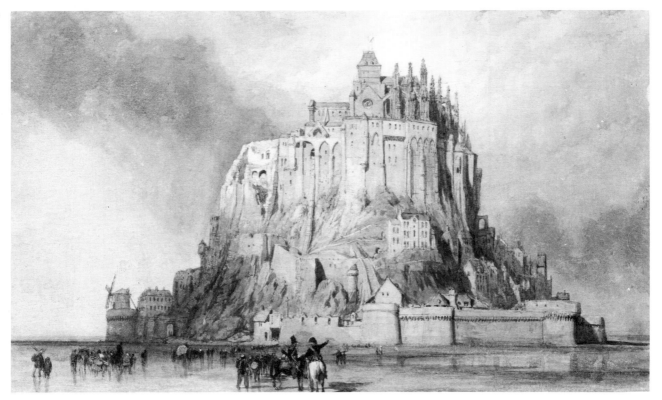

STANFIELD, Clarkson (1793-1867)
Mont Saint Michel, from the North West. *Pencil and watercolour heightened with white on buff paper, 7½in. x 11⅞in.* Cotman also made dramatic play with this subject — see Volume II. (Christie's)

STANFIELD, Clarkson (1793-1867)
The Shower. *Signed, watercolour heightened with white and scratching out, 5in. x 7⅜in.*
Here Stanfield could almost be imitating Boys.

(Christie's)

STANNARD, Henry John Sylvester (1870-1951)
Near Witley, Surrey. *Signed, watercolour, 13¼in. x 9½in.*
This sort of Stannard, which is not uncommon, makes one nostalgic for the precision and levels of accomplishment of the former inhabitants of Witley, Foster and Allingham.

(Sotheby's Chester)

STEER, Philip Wilson (1860-1942)
The Needles. *Signed and dated 1919, watercolour, 11¼in. x 15¼in.*

(Spink & Son)

**STEPHANOFF, Francis Philip
(1788-1860)**
The Death of Wolsey. *Signed, and inscribed on the
reverse, water and bodycolour, 9½in. x 12½in.*
(Sotheby's)

STEPHANOFF, James (c.1786-1874)
The Marriage of Othello and Desdemona. *Signed and dated 1835,
pencil and watercolour, 20½in. x 24½in.*
How strange that of all the characters in the drama, only the two
eponymous principals are immediately identifiable in this Carnival
scene. *(Sotheby's)*

STILLMAN, Maria (1844-1927)
Antigone burying Polyneices. *Signed and dated 1870, water-
colour, 24in. x 36in.* *(Simon Carter)*

STOPFORD, William Henry (1842-1890)
King Rock, Flamborough. *Signed and dated /70, watercolour,
size unknown.* *(British Museum)*

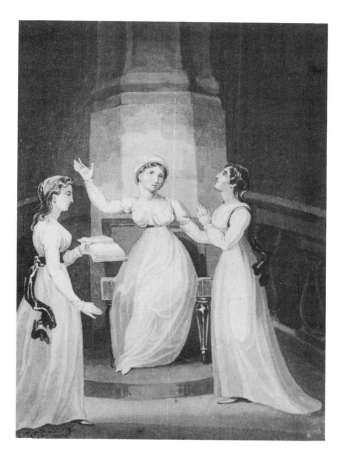

(Above) STOWERS, Thomas
Tales of the Wars. *Pen and ink and watercolour, 4½in. x 7in.* *(Martyn Gregory)*

(Left) STOTHARD, Thomas (1755-1834)
Three Graces. *Signed, pen and grey ink and wash, 3⅞in. x 2⅞in.* *(Private Collection)*

(Below) STREATFEILD, Commander Robert (1786-1852)
View over Nice. *Grey and blue washes, 5¾in. x 9⅛in.* For discussions of the life and work of this naval officer, who was a brother of the Rev. Thomas Streatfeild, see *Country Life*, May 12, 1988, and *Watercolours & Drawings*, Volume III, no.3. *(William Drummond)*

SWARBRECK, Samuel Dukinfield
A ruined Abbey. *Signed and dated Oct. 12 1840, pencil and watercolour heightened with white, 11¼in. x 16in.*
(Sotheby's)

STREATFEILD, Commander Robert (1786-1852)
The Vallon Obscure, near Nice. *Grey wash, 9in. x 6in.*
(William Drummond)

TAVERNER, William (1703-1772)
An Italian Landscape. *Pen and brown ink and watercolour, 11¾in. x 17in. (Sotheby's)*

THIRTLE, John (1777-1839)
The North Norfolk Coast. *Inscribed, pencil and watercolour, size unknown.*
In many moods Thirtle is an admirable artist — here he is doing a Holland — and he was a most sensitive maker of frames. *(Albany Gallery)*

THORBURN, Archibald (1860-1935)
The Tawny, Brown, or Wood Owl. *Signed, watercolour, 9⅞in. x 6⅝in.* *(Spink & Son)*

THORBURN, Archibald (1860-1935)
A Covey of Partridge. *Signed and dated 1909, watercolour heightened with white, 7¼in. x 10⅝in.* *(Phillips, Scotland)*

TILLEMANS, Peter (1684-1734)
A Race-meeting. *Pencil, pen and grey ink, water and bodycolour, 3½in. x 7⅜in.* *(Christie's)*

TRAILLE, Lt. Col. Peter
The Moorish Castle from the South. Crude and primitive but much what would have been needed to illustrate a report. *Pen and grey ink and watercolour, 11⅜in. x 25⅝in.* *(National Army Museum)*

TRESHAM, Henry (1750-1814)
Palermo from Monreale. *Pencil, pen and brown ink, grey and brown washes on Dutch paper, 12¾in. x 21in.*
Tresham went to Italy in 1776 with John Campbell, later 1st Lord Cawdor and himself a competent amateur, and he stayed
on the Continent until 1789. He was a member of the Fuseli set in Rome. *(Sotheby's)*

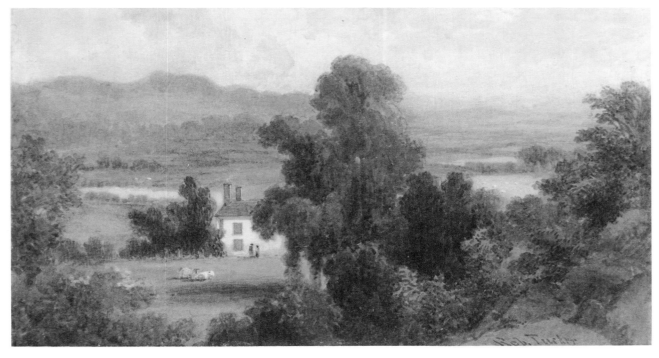

TUCKER, Robert (1807-1891)
Near Henbury, Gloucestershire. *Signed, and inscribed on the original mount, pencil, water and bodycolour, 4in. x 6⅜in.*
(Martyn Gregory)

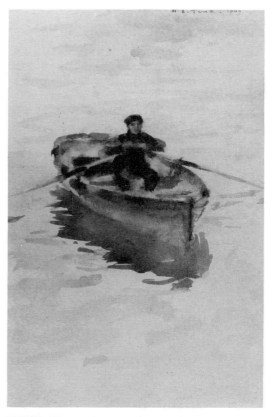

TUKE, Henry Scott (1858-1929)
Resting on his Oars. *Signed and dated 1909,
watercolour, 6in. x 3in.* *(David Messum)*

TUKE, Henry Scott (1858-1929)
Sailing Vessels at their Moorings. *Signed and dated 1919, water-
colour, approx. 12in. x 8in.* *(David Messum)*

TURCK, Eliza (1832-)
The Garden Path. *Signed and dated 1896, pencil and watercolour
heightened with white, size unknown.*
This watercolour extends Miss Turck's known working life by ten
years. *(Sotheby's)*

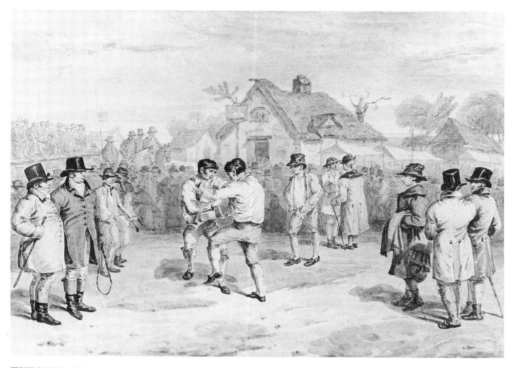

TURNER, Charles (1774-1857)
Wrestling. *Signed and dated 1810, etched outline and watercolour, 8in. x 11in.*
This is one of a pair of etched outline sporting subjects, the other being 'Broadswords'. No other versions are known in this form, but aquatints were made from them and published in 1825.
(Martyn Gregory)

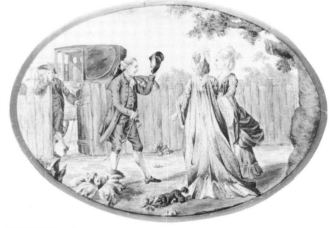

TURNER, George
Elegant Pursuits in Town and Country. *Pen and black ink and watercolour, oval 4¼in. x 5¾in.*
This drawing by the 18th/19th century George Turner is one of a set of nine. *(Sotheby's)*

TURNER, Joseph Mallord William (1775-1851)
The Palazzo Vecchio. *Pencil and watercolour, 14¾in. x 10¼in.*
This is a Monro School copy after J.R. Cozens. The original is shown in Volume II, p.350. *(Private Collection)*

TURNER, Joseph Mallord William (1775-1851)
Hampton Court, Herefordshire, from the South-East. *Signed, and inscribed on the backing paper, watercolour, 4⅜in. x 6¾in.*
In the 'South Wales Sketchbook' of 1795 is a list of Turner's 'Order'd Drawings'. There were five commissions for drawings of his seat by the future 5th Earl of Essex, and two more views of it were ordered by Sir R.C. Hoare. *(Spink & Son)*

TURNER, Joseph Mallord William (1775-1851)
Kidwelly Castle, South Wales. *Watercolour, 11⅝in. x 17⅛in.*
Another fruit of the 1795 tour. *(Christie's)*

TURNER, Joseph Mallord William (1775-1851)
Cologne with the Tower of St. Martin's and the Cathedral. *Watercolour, 9in. x 7½in.*
Turner toured Holland, the Meuse and Cologne in 1825 and 1826, and he re-used material from the trips for Charles Heath's *Rivers of France* scheme in the 1830s. The sale room history shows that this drawing has been a popular one even in unpropitious times. In 1887 it sold for 125 guineas; in 1946 for 140 guineas; and in 1978 for £9,500. *(Christie's)*

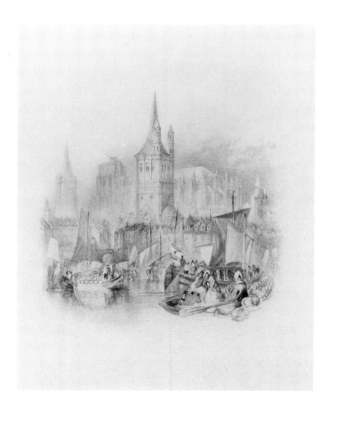

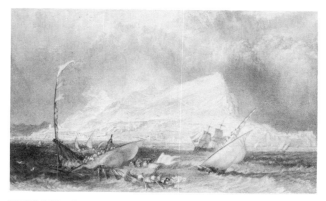

TURNER, Joseph Mallord William (1775-1851)
Gibraltar. *Pencil and watercolour with touches of body-colour and scratching out, 6¾in. x 10¾in.*
This drawing was engraved by Finden as the frontispiece for Murray's *Life and Works of Lord Byron,* 1833/4, with text by W. Brockedon. *(Spink & Son)*

TURNER, William, of Oxford (1789-1862)
View of the Vale of Belvoir with the Castle. *Pencil and watercolour heightened with white on Whatman paper watermarked 1841, 11⅜in. x 18⅜in.*
Turner's predecessor in practice at Oxford, Malchair, would surely have approved this rather dramatic viewpoint.
(Spink & Son)

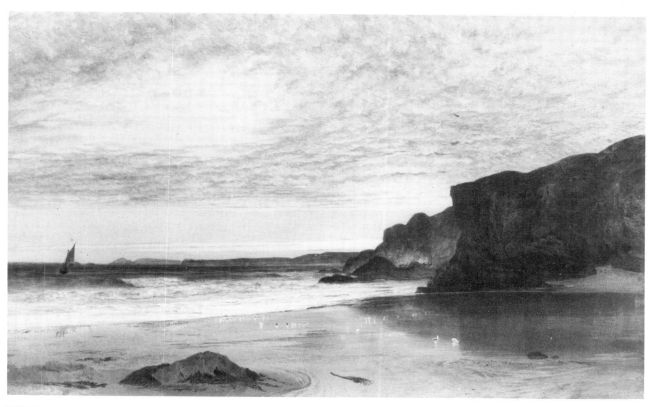

TURNER, William, of Oxford (1789-1862)
Changeable Weather on the Cornish Coast. *Water and bodycolour, 9⅞in. x 15⅜in.*
This drawing probably dates from the period 1845/50.

(Spink & Son)

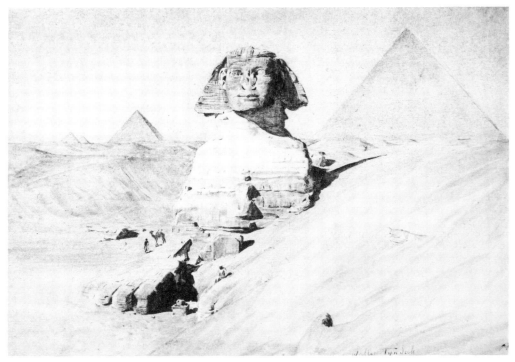

TYNDALE, Walter Frederick Roofe (1856-1943)
The Sphinx and Pyramids. *Signed, pencil and watercolour, 8½in. x 11¾in.* (Spink & Son)

UWINS, Thomas (1782-1857)
A Village Lace School sketched from nature at Quainton
Bucks. *Signed and inscribed, pen and brown ink and water-
colour, size unknown.*
Perhaps a stage in the same operation. *(Sotheby's)*

UWINS, Thomas (1782-1857)
Study for 'The Lacemakers'. *Pencil and watercolour,
7½in. x 6⅜in.* (Anthony Reed)

270

UWINS, Thomas (1782-1857)
Dance and Sport the Hours away. *Pencil, pen and brown ink and watercolour, 2in. x 3⅜in.*
This was drawn as the frontispiece to an edition of John Gay's libretto to Handel's *Acis and Galatea.* *(Anthony Reed)*

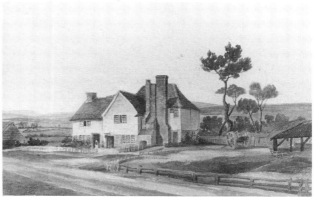

VARLEY, Cornelius (1781-1873)
Hampstead. *Signed and inscribed, watercolour, 11in. x 16¼in.* *(Martyn Gregory)*

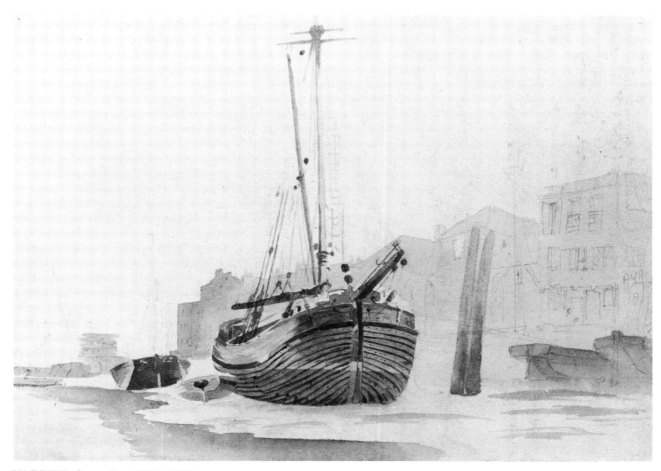

VARLEY, Cornelius (1781-1873)
A Barge on the Thames Mud. *Pencil and watercolour, 9½in. x 13in.* *(Martyn Gregory)*

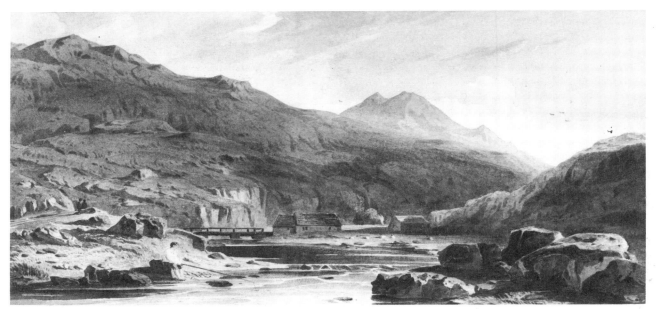

VARLEY, John (1778-1842)
Snowdon from Capel Curig. *Pencil and watercolour, 8⅞in. x 18¾in.*
It is likely that this watercolour derives from the summer tour of North Wales which Varley made with his brother Cornelius and Thomas Webster in 1802. The hills were a-jostle with watercolour painters that year, especially the inn at Capel Curig. Cotman and Munn were touring together, and Cristall (q.v.) and Havell were also there. *(Spink & Son)*

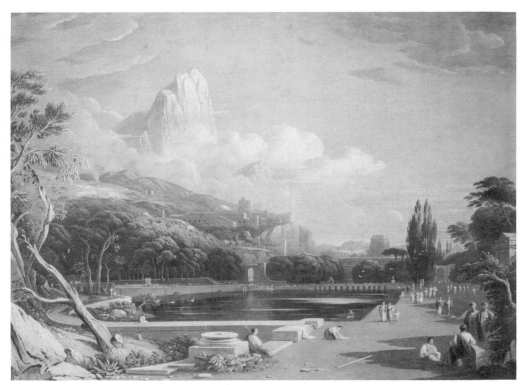

VARLEY, John (1778-1842)
A Classical, or Biblical, Composition. *Watercolour, 27in. x 40in.*
In the 1820s and '30s, alongside his decreasingly specific landscape compositions, Varley was still producing 'engines' for the exhibitions, often with Biblical subject matter. *(Bonhams)*

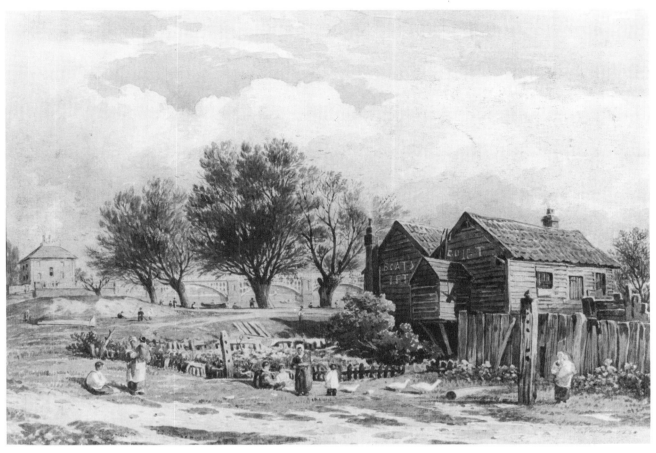

VARLEY, John (1778-1842)
Vauxhall Bridge. *Signed and dated 1830, watercolour, size unknown.*
He was also still doing very specific and charming topographical work.

(Bonhams)

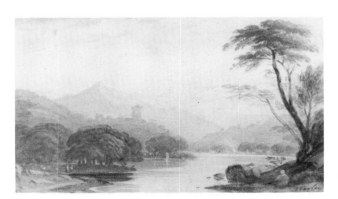

VARLEY, John (1778-1842)
Landscape Composition. *Signed, watercolour with scratching out, approx. 8in. x 12in.*
This generalised subject dates from the end of the 1830s, and it is surprising that there is no evidence of crackelure from the experimental use of honey, gin and so forth.

(Private Collection)

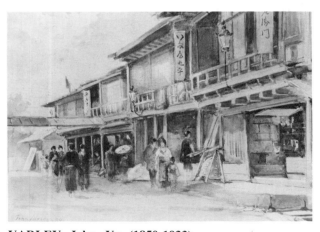

VARLEY, John, Yr. (1850-1933)
Zumoto, Japan. *Signed and dated 90, inscribed on the reverse, watercolour, 10¼in. x 14¼in.* *(Martyn Gregory)*

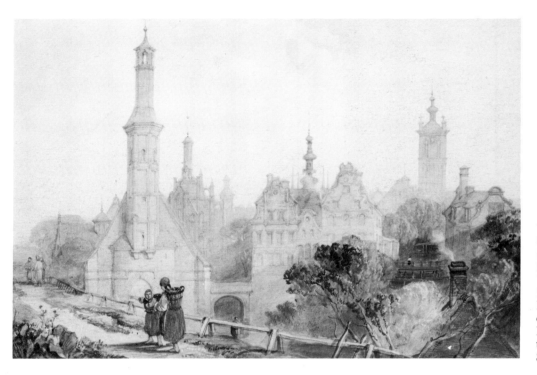

VICKERS, Alfred Gomersal (1810-1837)
Moscow, 1836.
Watercolour,
7in. x 11⅜in.
Here we see much evidence of Boningtonisme and the Anglo-French School. *(Agnew)*

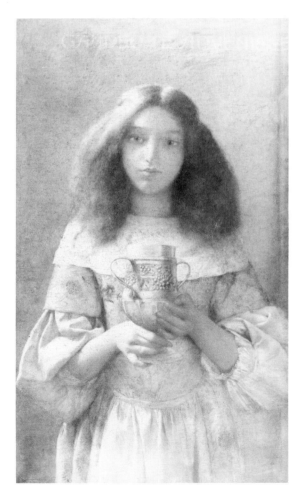

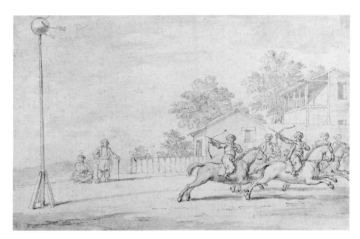

WALE, Samuel (c.1720-1786)
Turks shooting at a Popinjay. *Signed, pen and grey ink and wash, 3in. x 5in.* (Simon Carter)

WAINWRIGHT, William John (1855-1931)
Gaudeo Te Advenisse — The Grace Cup. *Signed and inscribed, water and bodycolour, 39in. x 21½in.* (David Messum)

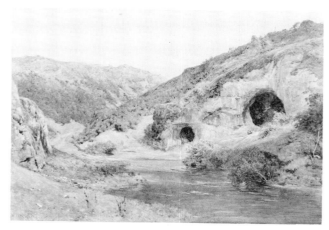

WALKER, William Eyre (1847-1930)
Dove Rocks, Derbyshire. *Signed and dated 1907, water-colour with touches of bodycolour, 13in. x 19in.*
(*Moss Galleries*)

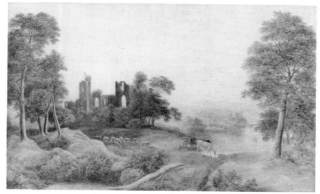

WALLIS, Joshua (1789-1862)
A ruined Abbey. *Watercolour heightened with gum arabic, 15in. x 22½in.*
(*Sotheby's*)

WARREN, Edmund George (1834-1909)
Harvest Time on the Dart. *Signed and dated 1888, watercolour, 23¾in. x 36in.*
(*Sotheby's Sussex*)

WATERFORD, Louisa Anne, Marchioness of (1818-1891)
Children fording a Stream. *Pencil and watercolour, 4¼in. x 6in.* (Martyn Gregory)

WATERFORD, Louisa Anne, Marchioness of (1818-1891)
Children gathering Faggots. *Watercolour, 7in. x 10in.*
Perhaps because of her own childlessness, Lady Waterford devoted much of her widowhood, and most of her working life, to children. This fine example was in the collection of Arthur Balfour. *(Moss Galleries)*

WATSON, Charles John (1846-1927)
Rotwijk am Zee. *Signed, inscribed and dated June 1889, watercolour with stopping out, approx. 8in. x 12in.* (Bearne's)

WATTS, James Thomas (1853-1930)
Beeches and Silver Birch in Autumn. *Signed, water and bodycolour, 10¾in. x 15½in.*
(Chris Beetles)

WEBB, James (1825-1895)
Barges on the Grosvenor Canal. *Pencil and watercolour with touches of bodycolour, 5⅞in. x 9in.*
This little sketch is of considerable topographical interest, since it seems to record two vanished features of London. The Grosvenor Canal ran up to Pimlico Wharf along what is now the rail approach to Victoria Station. Beyond, probably, is the Victoria Bridge, which was replaced by the present Chelsea suspension bridge in 1934.
(Spink & Son)

WEBB, Edward (1805-1854)
Dover. *Watercolour, 13½in. x 19½in.*

(Martyn Gregory)

WEBBER, John (1751-1793)
Captain Cook at a Human Sacrifice, Otaheite. *Signed and dated 1777, pen and wash and watercolour, 16⅜in. x 23⅜in.* Dear, dear. Even heroes have their feet at a clay oven.
(British Library)

WEIR, Harrison William (1824-1906)
Blackbird. *Signed and dated 1864, water and bodycolour heightened with gum arabic, 11⅜in. diameter.*
(Chris Beetles)

WEEDON, Augustus Walford (1838-1908)
Sonning Weir. *Signed and dated 1885, watercolour, 14in. x 20in.* *(Simon Carter)*

278

WEIR, Harrison William (1824-1906)
Lop-eared Rabbits. *Signed and dated 1866, watercolour,
10in. x 14in.* (Moss Galleries)

WEST, William 'Waterfall' (1801-1861)
Gigantic Idols in a sacred Grot. *Brown wash with scratching
out, 9¼in. x 11¾in.*
All very Danby. (William Drummond)

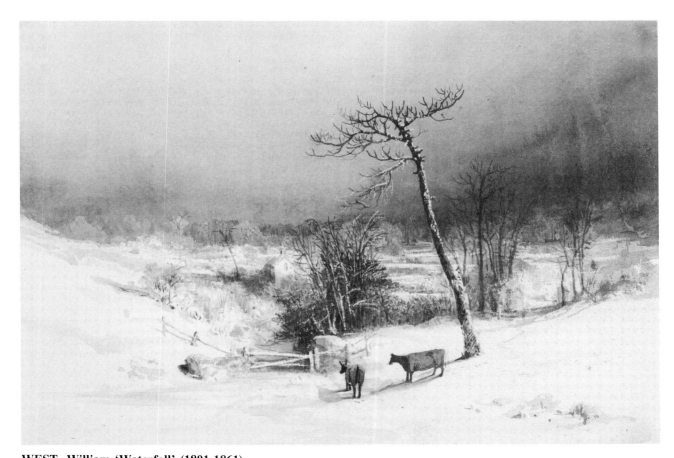

WEST, William 'Waterfall' (1801-1861)
Cattle in the Snow. *Grey wash and scratching out, 7¼in. x 10½in.*
How nice — not a waterfall in sight. Of course there may have been one in the incense smoke of the Grot above, but painters
did not *always* live up, or down, to their nicknames. (William Drummond)

WESTALL, Richard (1765-1836)
Threshing. *Signed with initials, pen and brown ink and watercolour, 3⅝in. x 5in.*
This would make a charming companion to the little scenes by W.H. Brook illustrated earlier. *(Private Collection)*

WESTALL, William (1781-1850)
Aborigines ambushing Settlers in the Outback. *Pencil and watercolour, 19¾in. x 23⅝in.* *(Spink & Son)*

WIDGERY, Frederick John (1861-1942)
The Moors near West Okement. *Signed, bodycolour, 20in. x 30in.* *(Bearne's)*

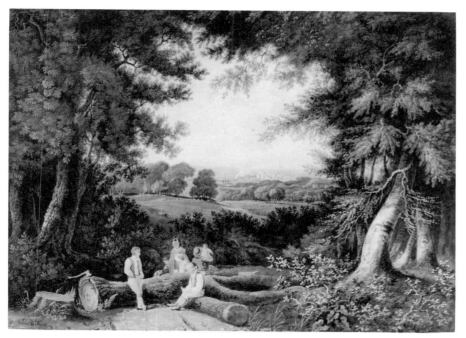

WHICHELO, C John Mayle (1784-1865)
Windsor. *Signed and dated 1824, watercolour heightened with gum arabic and stopping out, 18½in. x 24¾in.* *(Sotheby's)*

WILKIE, Sir David (1785-1841)
A Spaniel. *Signed and dated 1835, blue chalk, pen and brown ink, and brown wash heightened with white and red, 9⅝in. x 7⅞in.*
From the point of view of medium, this drawing has almost everything, and, surprisingly, it works. *(Anthony Reed)*

WIDGERY, William (1826-1893)
Pony by a Dartmoor Stream. *Signed, water and bodycolour, 9¼in. x 28¾in.* *(Bearne's)*

WILKINSON, Rev. Joseph (1764-1831)
Applethwaite Gill with part of Skiddaw. Inscribed on the reverse, pencil, pen and ink and watercolour, 9½in. x 13in.
(Moss Galleries)

WILKINSON, Rev. Joseph (1764-1831)
A View in the Lake District. *Watercolour, size unknown.* This came from an album of views by Wilkinson, some of which are dated 1795. Does it, or even the one shown previously, really deserve Wordsworth's crawling condemnation? *(Sotheby's)*

WILLIAMS, Alexander (1846-1930)
Dugort, Achill Island. *Signed and inscribed, pencil and watercolour heightened with white, 17¾in. x 23¼in.* *(Sotheby's)*

WILLIAMS, Penry (1798-1885)
Isola dei Pescatori, Lago Maggiore. *Dated 19 Sept/65, pencil and watercolour heightened with white, 7¾in. x 11in.*
The pencil drawing in this is so strong that it resembles penwork. *(Michael Bryan)*

WILLIS, Henry Brittan (1810-1884)
Ploughing. *Signed and dated 64, watercolour, approx. 5in. x 7in.*
(Martyn Gregory)

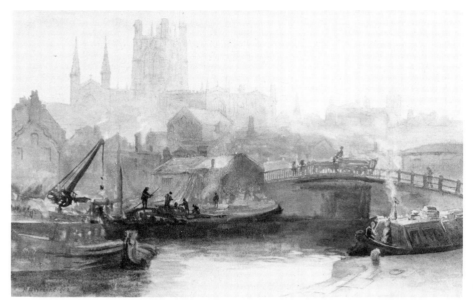

WRIGHT, Richard Henry (1857-1930)
Chester. *Signed and dated 1902, pencil and watercolour, 7in. x 10in.* *(Moss Galleries)*

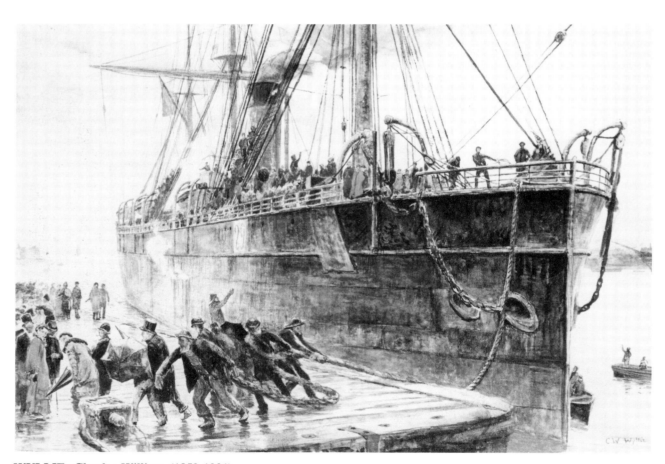

WYLLIE, Charles William (1859-1931)
The Arrival of a Troopship at Portsmouth. *Signed, watercolour, 10in. x 14in.*
This watercolour is thought to date from the 1890s, so the ship, which is no doubt identifiable, may well have come from the Sudan. *(Moss Galleries)*

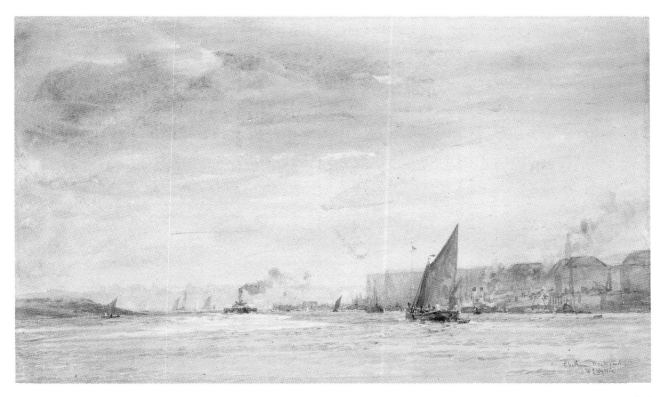

WYLLIE, William Lionel (1851-1931)
Chatham Dockyard. *Signed and inscribed, watercolour, 7½in. x 13in.*

YATES, Gideon
Mullingar Castle. *Signed with initials, inscribed and dated 1824 on the reverse, watercolour, 8½in. x 12¼in.*
If, as seems likely, the Lancaster and London G. Yates' were the same, this Irish view might explain the ten year or so
gap in his working life. *(Sotheby's)*

WOLLASTON, Rev. George Buchanan (1814-1899)
The Old Nunnery at Minehead, Somerset, 1881. *Pencil and watercolour, 10in. x 14in.* Wollaston was not in fact Rector of Chislehurst, as stated in Volume I, although he lived there. He was an architect before ordination, and he rebuilt the local church. *(William Drummond)*

WOOD, Thomas (1800-1873)
Folkestone, 1835. *Watercolour, 9in. x 12½in.* *(William Drummond)*

WOODFORDE, Samuel (1763-1817)
The Convent at Grotta Ferrata. *Signed, and extensively inscribed on the reverse, pencil and watercolour, 10in. x 14¾in.*
(William Drummond)

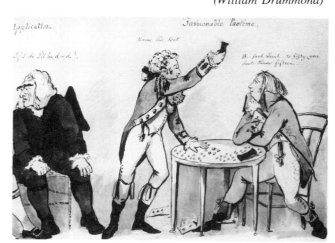

WOODWARD, George Moutard (1760-1809)
Fashionable Pastime. *Extensively inscribed, pencil, pen and grey ink and watercolour, 9¼in. x 13in.* (Spink & Son)

WOODLOCK, David (1842-1929)
Spinning Wool. *Signed, watercolour, 9in. x 8in.*
One hopes, for the sake of his sitter, that Woodlock was not much good with faces. (Chris Beetles)

287

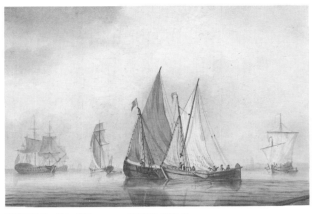

YATES, Lt. Thomas (1765-1796)
Coastal Shipping. *Signed and dated 1796, watercolour, 5in. x 8in.*
A calm work for a man who was shortly to die in a quarrel.
(Simon Carter)

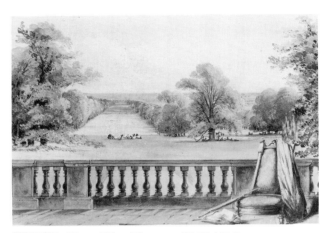

YORKE, Hon. Eliot Thomas (1805-1885)
The Avenue from the Terrace, Wimpole, Cambridgeshire. *Pen and ink and watercolour with scratching out, 9½in. x 13¼in.*
Yorke was M.P. for Cambridgeshire for eleven years, and his wife's family were neighbours of Wimpole. *(Sotheby's)*

YOUNGMAN, Annie Mary (1859-1919)
Dandelions. *Signed, watercolour, approx. 9in. x 14in.*
Miss Youngman is an example even to some of the 'liberated' female artists of today, in that she had no coy reluctance to disclose her date of birth. *(Charles Chrestien)*

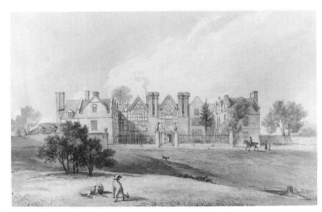

ZIEGLER, Henry Bryan (1798-1874)
Whitton Court, Shropshire. *Signed with initials, pencil, brown and grey washes, approx. 7in. x 10½in.*
This is one of a series of Shropshire views taken by the young Ziegler in 1821. *(Sotheby's)*

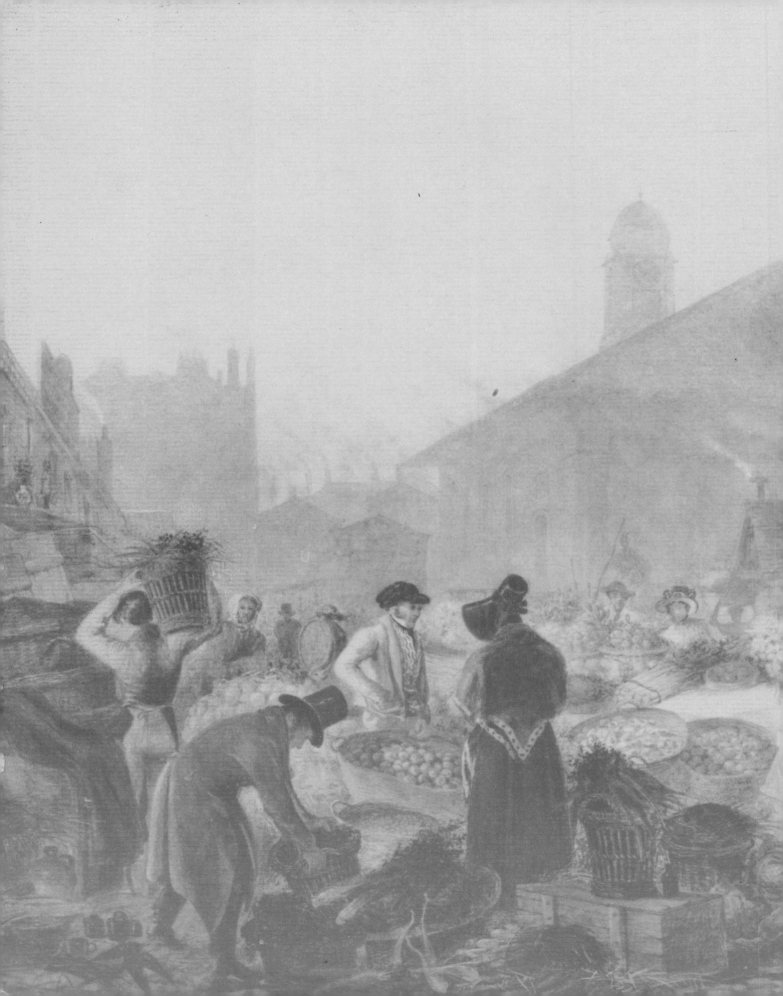